AMERICAN SCULPTURE

ART AND ARCHITECTURE INFORMATION GUIDE SERIES

Series Editor: Sydney Starr Keaveney, Associate Professor, Pratt Institute Library

Also in this series:

AMERICAN ARCHITECTS TO THE FIRST WORLD WAR—*Edited by Lawrence Wodehouse*

AMERICAN ARCHITECTS FROM THE FIRST WORLD WAR TO PRESENT—*Edite by Lawrence Wodehouse*

AMERICAN DECORATIVE ARTS AND OLD WORLD INFLUENCES—*Edited by David M. Sokol**

AMERICAN DRAWING—*Edited by Lamia Doumato**

AMERICAN PAINTING—*Edited by Sydney Starr Keaveney*

ANCIENT EGYPTIAN ART AND ARCHITECTURE—*Edited by Eleanore Wedge**

ARCHITECTURAL PRESERVATION AND RESTORATION—*Edited by Arnold L. Markowitz**

ART EDUCATION—*Edited by Clarence Bunch*

BRITISH ARCHITECTS, 1840-1976—*Edited by Lawrence Wodehouse**

COLOR THEORY—*Edited by Mary Buckley*

INDUSTRIAL DESIGN—*Edited by J. Roger Guilfoyle**

EUROPEAN PAINTING, 1870-1910—*Edited by Timothy Daum**

TWENTIETH-CENTURY EUROPEAN PAINTING—*Edited by Ann Marie Bergholtz**

POTTERY AND CERAMICS—*Edited by James E. Campbell**

STAINED GLASS I—*Edited by William Serban and Darlene A. Brady**

STAINED GLASS II—*Edited by William Serban and Darlene A. Brady**

VICTORIAN ART: ARCHITECTURE, SCULPTURE, DECORATIVE ARTS—*Edited by Marlene A. Palmer**

VICTORIAN ART: PAINTING, DRAWING, GRAPHIC ART—*Edited by Marlene A. Palmer**

*in preparation

The above series is part of the
GALE INFORMATION GUIDE LIBRARY

The Library consists of a number of separate series of guides covering major areas in the social sciences, humanities, and current affairs.

General Editor: Paul Wasserman, Professor and former Dean, School of Library and Information Services, University of Maryland

Managing Editor: Dedria Bryfonski, Gale Research Company

AMERICAN SCULPTURE

A GUIDE TO INFORMATION SOURCES

Volume 5 in the Art and Architecture Information Guide Series

Janis Ekdahl

Art Librarian, Vassar College
Poughkeepsie, New York

Gale Research Company
Book Tower, Detroit, Michigan 48226

Library of Congress Cataloging in Publication Data

Ekdahl, Janis.
 American sculpture.

 (Art and architecture information guide series ; v. 5)
(Gale information guide library)
 Includes indexes.
 1. Sculpture, American--Bibliography. I. Title.
Z5954.U5E37 [NB205] 016.73'0973 74-11544
ISBN 0-8103-1271-9

To My Parents

VITA

Janis Kay Ekdahl is currently art librarian at Vassar College Art Library. She received her B.A. in art history from Occidental College, California, and her M.S. in library science from Columbia University, New York. She is a member of Art Libraries Society/North America and of the College Art Association.

CONTENTS

ACKNOWLEDGMENTS

In the preparation of this bibliography I have utilized the resources of several libraries and librarians. To them all I extend my thanks: Museum of Modern Art Library, and Lamia Doumato; Whitney Museum Library, and Sue Liberman; Vassar College Library; Columbia University Libraries; Metropolitan Museum of Art Library; and New York Public Library.

I also want to thank Sydney Keaveney for her encouragement and useful suggestions.

Finally I must express my appreciation to my friends and family for their support and understanding throughout this very demanding year.

INTRODUCTION

Sculpture in America has taken many forms during the past 250 years, from bird decoys to heroic equestrian monuments, from realistic portraiture to nonobjective earthworks. This book attempts to provide annotated bibliographic guidance to the many facets of the field. Sections on folk art, happenings, and conceptual art reflect this broad interpretation of sculpture.

The adjective "American" has been defined to include the art created by artists, either native or foreign-born, who have lived and worked in the United States for a significant portion of their career and have contributed substantially to the art of America. These guidelines exclude Jacob Epstein, Carl Milles, and Ossip Zadkine, but they include Marcel Duchamp, Naum Gabo, Alexander Archipenko, and Laszlo Moholy-Nagy.

American sculpture has only recently been the object of scholarly research; hence, the number of full-length books devoted to individual sculptors is limited. Periodical articles as well as exhibition catalogs have, therefore, been included in this bibliography when they contained unique information or illustrations. Exhibition catalogs, although often difficult to locate, frequently contain material unavailable elsewhere. Important exhibitions are usually accompanied by reviews in major art publications; the ART INDEX and other periodical indexes (chapter 1) will help the researcher locate such reviews (as well as illustrations and further articles). The books and catalogs listed in the Key to Abbreviations (pp. xiii-xv) have extensive bibliographies through which a diligent researcher can often find further material. Unfortunately, up-to-date scholarly research has not been published on many sculptors; in such cases I have cited the most substantial article available and have directed the user to fuller bibliographic listings.

Those books which deal specifically with the subject of American sculpture and which would be appropriate in a small nonspecialized library are indicated by an asterisk.

Although the bulk of the research for this bibliography was completed before July 1975, a few items of major significance after that date are included. The annotations attempt to outline the scope and describe the principal features of an individual work.

KEY TO ABBREVIATIONS

Broder (see 58)

 Broder, Patricia Janis. BRONZES OF THE AMERICAN WEST. New York: Harry N. Abrams, 1973.

Brookgreen (see 141)

 Proske, Beatrice Gilman. BROOKGREEN GARDENS SCULPTURE. Brookgreen, S.C.: Brookgreen Gardens, 1968.

Craven (see 60)

 Craven, Wayne. SCULPTURE IN AMERICA FROM THE COLONIAL PERIOD TO THE PRESENT. New York: T.Y. Crowell, 1968.

14 Sculptors (see 257)

 Walker Art Center. 14 SCULPTORS; THE INDUSTRIAL EDGE. Minneapolis, Minn.: 1969.

Gerdts-Neoclassic (see 123)

 Gerdts, William H. AMERICAN NEO-CLASSIC SCULPTURE; THE MARBLE RESURRECTION. New York: Viking Press, 1973.

Giedion-Welcker (see 152)

 Giedion-Welcker, Carola. CONTEMPORARY SCULPTURE, AN EVOLUTION IN VOLUME AND SPACE. New York: George Wittenborn, 1955.

Hirshhorn (see 168)

 Solomon R. Guggenheim Museum (New York). MODERN SCULPTURE FROM THE JOSEPH H. HIRSHHORN COLLECTION. New York: 1962.

Abbreviations

Hunter (see 155)

> Hunter, Sam. MODERN AMERICAN PAINTING AND SCULPTURE. New
> York: Dell Publishing Co., 1959.

Hunter (see 156)

> Hunter, Sam, and Jacobus, John. AMERICAN ART OF THE 20TH CEN-
> TURY. Englewood Cliffs, N.J.: Prentice-Hall; New York: Harry N.
> Abrams, 1973.

Index-20th Cent. (see 33)

> INDEX OF TWENTIETH CENTURY ARTISTS. 4 vols. New York: Re-
> search Institute of the College Art Association, 1933-37.

Keaveney, AMERICAN PAINTING

> Keaveney, Sydney. AMERICAN PAINTING: A GUIDE TO INFORMA-
> TION SOURCES. Art and Architecture: An Information Guide Series,
> vol. 1. Detroit: Gale Research Co., 1974. xiii, 260 p. Index.

Newark-American Folk Sculpture (see 110)

> Newark Museum. AMERICAN FOLK SCULPTURE: THE WORK OF EIGH-
> TEENTH AND NINETEENTH CENTURY CRAFTSMEN. Organized by Hol-
> ger Cahill. Newark, N.J.: 1931.

Recent Am. (see 226)

> Jewish Museum (New York). RECENT AMERICAN SCULPTURE. Orga-
> nized and introduced by Hans Van Weeren-Griek. New York: 1964.

Recent Figure (see 222)

> Harvard University. William Hayes Fogg Art Museum. RECENT FIGURE
> SCULPTURE. Cambridge, Mass.: 1972.

Selz' New Images (see 250)

> Selz, Peter H. NEW IMAGES OF MAN. New York: Museum of Mod-
> ern Art, 1959.

Thorpe-Literary Sculptors (see 133)

> Thorpe, Margaret. THE LITERARY SCULPTORS. Durham, N.C.: Duke
> University Press, 1965.

Tuchman (see 239)

> Los Angeles County Museum of Art. AMERICAN SCULPTURE OF THE
> SIXTIES. Organized by Maurice Tuchman. Los Angeles: 1967.

UC Irvine (see 217)

California. University at Irvine. Art Gallery. ASSEMBLAGE IN CALI-
FORNIA; WORKS FROM THE LATE 50's AND EARLY 60's. Irvine, Calif.:
1968.

UC Kinetic (see 215)

California. University at Berkeley. Art Museum. DIRECTIONS IN
KINETIC SCULPTURE. By Peter Selz. Berkeley: 1966.

UCSB (see 180)

California. University at Santa Barbara. Art Galleries. 19 SCULPTORS
OF THE 40's. Organized by Phyllis Plous. Santa Barbara: 1973.

Walker-8 (see 255)

Walker Art Center. EIGHT SCULPTORS: THE AMBIGUOUS IMAGE.
Minneapolis, Minn.: 1966.

Washington-New Aesthetic (see 258)

Washington Gallery of Modern Art. A NEW AESTHETIC. Text by Bar-
bara Rose. Washington, D.C.: 1967.

Whitney-Light, Object, Image (see 260)

Whitney Museum of American Art (New York). LIGHT: OBJECT AND
IMAGE. Organized by Robert Doty. New York: 1968.

Whitney, 200 YEARS (see 86)

Whitney Museum of American Art (New York). 200 YEARS OF AMERICAN
SCULPTURE. Directed by Tom Armstrong. Boston: David R. Godine in
association with the Whitney Museum, 1976.

* An asterisk has been used throughout the text to indicate those books dealing
with the subject of American sculpture which would be appropriate in a small
nonspecialized library.

Section I

GENERAL RESEARCH TOOLS

Chapter 1

BIBLIOGRAPHIES, LIBRARY CATALOGS, AND INDEXES

Included in this section are separately issued bibliographies related to American sculpture; published library catalogs which are relevant to the topic; and indexing/abstracting services (issued periodically) which record books, exhibition catalogs, and magazine articles. Major bibliographies on general and specific aspects of American sculpture can also be found in the titles cited in the Key to Abbreviations.

1 ART INDEX. New York: H.W. Wilson Co., 1929/32- . Issued quarterly with annual cumulations.

> Invaluable reference tool which includes articles, illustrations, book reviews, and exhibition reviews in a wide variety of art and architecture periodicals. Entries are arranged by author and by subject and/or artist discussed. Covers all periods and media. Indexes English-language periodicals primarily. To locate periodical material published prior to 1929, consult any of the following citations: 3, 12, 13, 14, 15, 16.

2 Chamberlin, Mary Walls. GUIDE TO ART REFERENCE BOOKS. Chicago: American Library Association, 1959. 432 p. Index.

> A major annotated guide to the literature of art history. Covers all periods of art history and principal media. Includes only the most basic resources in the field of American art. No monographs on individual artists are listed.

3 Chicago. Art Institute. INDEX TO ART PERIODICALS. Compiled in the Ryerson Library of the Art Institute of Chicago. 11 vols. and supplement. Boston: G.K. Hall & Co., 1962.

> A subject index to material on art in over 350 periodicals during the nineteenth and twentieth centuries. Initially published in 1962, the Ryerson Library index provides access to periodical material not covered by ART INDEX (see 1) such as foreign titles, museum bulletins, irregular series, and pre-1929 materials. The index is continuing and one supplement (covering 1961-74) has been published.

4* Clapp, Jane. SCULPTURE INDEX. 2 vols. Metuchen, N.J.: Scare-
 crow Press, 1970–71.

 Volume 1: Sculpture of Europe and the contemporary Middle
 East. Volume 2 (in two parts): Sculpture of the Americas,
 the Orient, Africa, the Pacific area, and the classical world.
 Locates reproductions of sculptural work (prehistoric to con-
 temporary time/space experiments) in about 950 readily avail-
 able books. Each piece is entered under artist, title (if dis-
 tinctive), and subject. The entry for a specific sculpture
 lists the medium, original location, and current location.
 Dates for most of the artists are provided. A useful, but
 necessarily incomplete, guide.

5 Columbia University (New York). CATALOGUE OF THE AVERY MEMO-
 RIAL ARCHITECTURAL LIBRARY. 2d ed., enl. 19 vols. plus supple-
 ments. Boston: G.K. Hall & Co., 1968.

 A reproduction, in book format, of the card catalogs at Co-
 lumbia University's extensive architecture and fine arts librar-
 ies. The listings, entered by subject as well as by author,
 provide a useful guide to materials available.

6 Davis, Alexander, comp. ART PHOTO DESIGN. London: Alexander
 Davis. Distributed by Idea Books, London. 1973– . Issued annually.
 Index.

 The first volume of Davis's bibliography was called LOMA 69
 (LITERATURE ON MODERN ART. London: Lund, Humphries,
 1971) which indexed material published in 1969. Volumes 2
 and 3 of the bibliography were called ARTBIBLIOGRAPHIES
 MODERN (Oxford, England: ABC-CILO Press, 1972 and
 1973) and they carried material published in 1970 and 1971.
 Throughout the title/publisher changes, Davis has continued
 indexing material dealing with the arts of the late nineteenth
 and twentieth centuries. Several periodicals not covered in
 ART INDEX as well as books and exhibition catalogs are in-
 dexed. ART PHOTO DESIGN is especially thorough in the
 fields of design and photography, but excludes material on
 architecture unless it is related to interior design. The list-
 ings are in two sections: Artists and Subjects. Comprehensive
 index.

7 Harvard University. William Hayes Fogg Art Museum. CATALOGUE OF
 THE HARVARD UNIVERSITY FINE ARTS LIBRARY, THE FOGG ART MU-
 SEUM. 15 vols. Boston: G.K. Hall & Co., 1971.

 A reproduction, in book format, of the card catalog at this
 major university and museum art library. Since the Fogg
 Museum and the Fine Arts Library are strong in American art,
 the listings provide an especially useful subject bibliography.
 Volume 15 is devoted exclusively to a catalog of auction
 sales catalogs.

8 INDEX OF AMERICAN SCULPTURE. Established by Wayne Craven. Located at the University of Delaware, Department of Art History, Wilmington. 1964- .

> Not a publication but a unique visual archive of American sculpture from the seventeenth century to the present. Established by Wayne Craven in 1964, the index is still growing and now consists of (1) photo reproductions of nearly 3,000 works by American sculptors or sculptors who worked in America, (2) a card file listing American sculptors and their works, and (3) a collection of primary and secondary resources. The facilities of the index are open to serious scholars and students by appointment. Questions regarding reproductions of photographs in the archive should be directed to Craven or to the slide librarian at the University of Delaware.

9 INTERNATIONAL REPERTORY OF THE LITERATURE OF ART: REPERTOIRE INTERNATIONAL DE LA LITTERATURE DE L'ART (RILA). Williamstown, Mass.: 1973- . Semiannual.

> RILA is a new abstracting service for art history, sponsored by the College Art Association of America and the American National Committee for the History of Art. RILA offices are located at the Sterling and Francine Clark Art Institute in Williamstown, Mass. "Its purpose is to provide substantial abstracts and detailed subject indexes of scholarly publications on post-classical European art and post-Conquest American art in periodicals, books, Festschriften, congress reports, exhibition and museum catalogues, and dissertations." The demonstration issue for 1973 introduced the promising series; volume 1 (nos. 1/2) covering 1974, was published in 1976. Extensive index.

10 McCausland, Elizabeth. "A Selected Bibliography on American Painting and Sculpture from Colonial Times to the Present." MAGAZINE OF ART 39 (November 1946): 329-49.

> An informative guide to resources available before 1946.

11 Montgomery, Charles F. A LIST OF BOOKS AND ARTICLES FOR THE STUDY OF THE ARTS IN EARLY AMERICA. Winterthur, Del.: Henry Francis du Pont Winterthur Museum, 1970. 136 p. Paperback.

> An annotated bibliography covering arts (sculpture, painting, graphics) and crafts. Emphasizes the decorative arts of early America (to about 1860). Prepared while Montgomery was a research fellow at Winterthur, this list reflects the strengths of that specialized library.

12 New York. Metropolitan Museum of Art. LIBRARY CATALOG. 25 vols. plus supplements. Boston: G.K. Hall & Co., 1960.

Lists, in book format, the holdings of one of the major art
reference libraries in the world. Covers all subjects and peri-
ods of art history. Volumes 24 and 25 contain a listing of
sales catalogs. Prior to the publication of ART INDEX in
1929, the Metropolitan Museum Library included in its catalog
indexes to important articles in periodicals.

13 NINETEENTH CENTURY READERS' GUIDE TO PERIODICAL LITERATURE,
1890-1899. With supplementary index, 1900-1922. 2 vols. New York:
H.W. Wilson Co., 1944.

In 1944 the editors of READERS' GUIDE "back-indexed" mate-
rial in general magazines of the 1890-1922 period. The in-
dexing plan and subject lists are much more understandable and
usable than Poole's (see 14).

14 POOLE'S INDEX TO PERIODICAL LITERATURE, 1802-1906. 6 vols.
1882-1908. Reprint. New York: Peter Smith, 1938-58.

Poole indexed a number of major nineteenth-century periodicals
by title and subject. This reference is unique and invaluable
when researching a nineteenth-century artist. A CUMULATED
AUTHOR INDEX, edited by C. E. Wall (Ann Arbor, Mich.:
Pierian Press, 1971), greatly facilitates the use of these vol-
umes.

15 READERS' GUIDE TO PERIODICAL LITERATURE. New York: H.W.
Wilson Co., 1900/1904- . Issued 22 times a year. Cumulated annually.

An author and subject index to articles in a selection of popu-
lar, widely available magazines such as TIME, NEW YORKER,
SATURDAY REVIEW, etc. The art periodicals included in
READERS' GUIDE are also indexed in ART INDEX (see 1).

16 REPERTOIRE D'ART ET D'ARCHEOLOGIE. Paris: Centre National de la
Researche Scientifique, 1910- . Publishers vary. Abstracts in French.

Useful international bibliography of material (articles, books,
essays, exhibition catalogs) published in the various fields of
art history. Author and artist indexes are in every volume;
subject indexes are in only the more recent volumes. The
most important entries are abstracted. Especially helpful when
researching a European topic although American artists and art
are very definitely included. The REPERTOIRE has changed
its format and coverage several times since 1910--most recently
in 1973. (See ARLIS/NA NEWSLETTER 2, Summer 1974, for
Alex Ross' in-depth discussion of the REPERTOIRE.) At present
the computer-compiled index is issued four times a year.
Material about artists born after 1920 or work executed after
1940 has been excluded.

17 Whitehill, Walter Muir. THE ARTS IN EARLY AMERICAN HISTORY.
 Needs and Opportunities for Study Series. Chapel Hill: University of
 North Carolina Press for the Institute of Early American History and Cul-
 ture at Williamsburg, Virginia, 1965. 185 p. Index.

 An introductory essay by Whitehill, stressing the opportunities
 for study in the arts of early America, precedes the extensive
 annotated bibliography (pp. 35-151) compiled by Wendell
 Garrett and Jane N. Garrett. The bibliography focuses on
 the decorative arts with only two pages devoted exclusively
 to early sculpture.

18 Winterthur Museum Libraries. COLLECTION OF PRINTED BOOKS AND
 PERIODICALS. 9 vols. Wilmington, Del.: Scholarly Resources in co-
 operation with the Henry Francis du Pont Winterthur Museum, 1974.

 Lists, in book format, the holdings of one of the major refer-
 ence libraries devoted to the arts in early America. Especi-
 ally strong in the decorative arts, Winterthur's libraries reflect
 the museum's focus on all aspects of American art.

19 WRITINGS ON AMERICAN HISTORY. Washington, D.C.: American
 Historical Association, 1902-40, 1948-[61], 1973-74- . Publishers vary.
 Issued annually.

 An excellent annual bibliography and index of articles and
 books which relate to the history of the United States. Since
 the editors survey a large body of history publications, the
 items included in the "Arts-Sculpture" section are often not
 listed in the standard art history indexes. The entries are ar-
 ranged by topic with a name index in the back. The 1961
 volume, yet to be published, will complete the indexing be-
 gun in 1902 (with the exception of the 1941-47 period when
 no volume was published). The current annual volumes, com-
 piled and edited by James J. Dougherty, follow the same
 general format but with shorter annotations. There are no
 plans to index material published between 1961 and 1973.

Chapter 2

SOURCES OF BIOGRAPHICAL INFORMATION

This section includes only the reference works which are primarily devoted to biographical information. Books with lengthy and often useful biographical listings can be found elsewhere in this bibliography; Goode (see 67) and Proske (see 141) are especially valuable in this respect.

20 AMERICAN ART ANNUAL. 37 vols. Washington, D.C.: American Federation of Arts, 1898–1948.

> Although the coverage varies from year to year, these volumes can be depended upon to list and describe art associations, museums, and schools. They also include an obituary list (cumulated for individuals who died between 1897 and 1927 in volume 25 [1928] pp. 375–416). About every two years a sketchy "Who's Who" of living artists was published. Volumes 32 through 36 document the activities of the Work Progress Administration/Federal Art Project. In 1952 this publication was continued by two separate volumes: AMERICAN ART DIRECTORY (see 53) and WHO'S WHO IN AMERICAN ART (see 43).

21 Bénézit, Emmanuel, ed. DICTIONNAIRE CRITIQUE ET DOCUMENTAIRE DES PEINTRES, SCULPTEURS, DESSINATEURS ET GRAVEURS. New ed., exp. 10 vols. Paris: Grund, 1976. Illus. In French.

> Important biographical dictionary which provides information about artists in all western countries. The entries, varying in length and scope, often reproduce an artist's signature and give the location and/or prices paid for the major works. No bibliographical references.

22 BIOGRAPHY INDEX: A CUMULATIVE INDEX TO BIOGRAPHICAL MATERIAL IN BOOKS AND MAGAZINES. New York: H.W. Wilson Co., 1946/49- . Issued quarterly and cumulated into a three-year volume.

> Indexes publish biographical material about individuals,

living or dead, in all fields. An index to "Professions and Occupations" is contained in each issue.

23 Cederholm, Theresa Dickason. AFRO-AMERICAN ARTISTS: A BIO-BIBLIOGRAPHICAL DIRECTORY. Boston: Trustees of the Boston Public Library, 1973. 348 p. Paperback.

Pioneering compilation of biographical and bibliographical material on black artists of America, both past and present. Entries list principal works, location of works, awards, and abundant bibliographical sources. General bibliography (pp. 325-48) lists books, exhibition catalogs, and magazine and newspaper articles relating to more than one black artist.

24 Columbia University (New York). Avery Architectural Library. AVERY OBITUARY INDEX OF ARCHITECTS AND ARTISTS. Boston: G.K. Hall & Co., 1963. 338 p.

An extensive index to the obituary notices of architects and, less consistently, of artists. The obituary often carries the only printed biographical information on minor artists.

25 Cummings, Paul. DICTIONARY OF CONTEMPORARY AMERICAN ARTISTS. 2d ed. New York: St. Martin's Press, 1971. 383 p. Illus.

A selective dictionary, more carefully edited than WHO'S WHO IN AMERICAN ART, which provides the basic biographical information about leading "contemporary" artists--not all of whom are still alive. Occasional illustrations. The bibliography (pp. 343-68) is keyed to the reference notations in each entry.

26 CURRENT BIOGRAPHY YEARBOOK. New York: H.W. Wilson Co., 1940- . Issued monthly with annual cumulations. Cumulative index for the period 1940-70.

Biographical sketches of prominent contemporary individuals in all fields. An index by profession is provided, also a necrology. Bibliographical references.

27 DICTIONARY OF AMERICAN BIOGRAPHY. 11 vols. and supplement. Edited by Allen Johnson et al. New York: Charles Scribner's Sons under the auspices of the American Council of Learned Societies, 1961-67. (This is a reprinting of the original 20-vol. set and its two supplements issued between 1932 and 1958.)

Lengthy biographical entries on prominent Americans who died before 1946. Written by noted scholars, the entries provide bibliographical references. Only major artists are included.

28 DICTIONARY OF MODERN SCULPTURE. Edited by Robert Maillard.
 New York: Tudor Publishing Co., 1962. 310 p. Illus. Translated
 from the French.

 Although Maillard attempts to document the entire range of
 twentieth-century sculpture, the coverage of American artists
 is quite superficial. Each artist's work is informally discussed,
 and biographical information is incorporated into the brief
 paragraphs. One photograph accompanies each entry.

29 Dunlap, William. HISTORY OF THE RISE AND PROGRESS OF THE
 ARTS OF DESIGN IN THE UNITED STATES. 3 vols. New York:
 Benjamin Blom, 1965.

 An 1834 publication which provides documentary material about
 early artists who worked and/or lived in the United States.
 The 287 biographical notices, incorporating anecdotes and gos-
 sip, are lively personality sketches but factually unreliable.
 See the full annotation for this work, citation 62.

30* Fielding, Mantle. DICTIONARY OF AMERICAN PAINTERS, SCULPTORS,
 AND ENGRAVERS FROM COLONIAL TIMES THROUGH 1926. New
 York: Paul A. Strook, 1960. 433 p.

 Biographical dictionary initially published in 1926 which pre-
 ceded Groce and Wallace's DICTIONARY and still provides
 the best coverage for artists prominent between 1860 and 1926.
 The bibliography used by Fielding for his research is included
 (pp. 424-33) although the entries lack annotations. In 1974
 Genevieve C. Doran edited a new version of this book (Greens
 Farms, Conn.: Modern Books and Crafts) which deletes the
 bibliography but adds a list of "over 2500 seventeenth, eigh-
 teenth and nineteenth century American artists."

31* Groce, George C., and Wallace, David H. THE NEW-YORK HISTORI-
 CAL SOCIETY'S DICTIONARY OF ARTISTS IN AMERICA, 1564-1860.
 New Haven, Conn.: Yale University Press, 1957. 786 p.

 "Documented biographical dictionary of painters, draftsmen,
 sculptors, engravers, lithographers and allied artists, either
 amateur or professional, native or foreign-born who worked
 within the present continental limits of the United States be-
 tween the years 1564 and 1860." The documentation in each
 entry is keyed to the extensive "List of Sources" (pp. 713-59).
 The introduction provides suggestions for further research.
 This work, which includes about 10,500 names, is the most
 comprehensive guide available to the period and is essential
 in all libraries.

32 Havlice, Patricia Pate. INDEX TO ARTISTIC BIOGRAPHY. 2 vols.
 Metuchen, N.J.: Scarecrow Press, 1973. viii, 1,362 p.

An index to the location of artists' biographies in sixty-four
reference works. Like Mallett (see 35), Havlice includes
dates, nationality, and media for each artist. The coverage
is international and updates many of the entries in MALLETT.
Bibliography (pp. v-viii).

33 INDEX OF TWENTIETH CENTURY ARTISTS. 4 vols. New York: Re-
search Institute of the College Art Association, October 1933-April 1937.
Monthly. Reprint. (4 vols. in 1 with cumulated index.) New York:
Arno Press, 1970.

Extensive biographical and bibliographical information on over
100 American artists prominent in the 1930s. Lists affiliations,
awards, honors, exhibitions, bibliography, and reproductions.
Entries are arranged randomly, hence the index is invaluable
to locating all the material on a specific artist. (The index
for volumes 1, 2, and 3 is located in volume 3, no. 11/12.)

34 McCoy, Garnett. ARCHIVES OF AMERICAN ART: A DIRECTORY OF
RESOURCES. New York: R. R. Bowker Co., 1972. ix, 163 p. Index.

Describes 555 collections of personal papers and institutional
records of American artists, critics, organizations, and gal-
leries which have been deposited at the Archives of American
Art in Detroit, Michigan. In 1975 a more complete, less
descriptive, spiral-bound "Checklist of the Collection" was
published by the Archives' staff. This important documentary
material is available in microfilm at several locations (New
York, Washington, D.C., Boston, and San Francisco). Among
the many sculptors who have some papers in the Archives are
Baizerman, David Smith, and Zorach. The Archives also pub-
lishes a quarterly JOURNAL which contains scholarly articles
and a listing of dissertations-in-progress.

34a McSpadden, Joseph Walker. FAMOUS SCULPTORS OF AMERICA. New
York: Dodd, Mead & Co., 1924. Reprint. Plainview, N.Y.: Books
for Libraries, 1968.

Informal biographical sketches of sculptors of the late nine-
teenth and early twentieth centuries. See the full annotation
for this work, citation 139.

35 Mallett, Daniel Trowbridge. MALLETT'S INDEX OF ARTISTS. 1 vol.
Supplement. New York: R.R. Bowker Co., 1935 (supplement, 1940).

An international biographical index "including painters, sculp-
tors, illustrators, engravers and etchers of the past and the
present." Together these indexes provide access to informa-
tion on about 44,000 artists. Much of the material in
MALLETT'S can also be located in other reference works as
Bénézit, Groce and Wallace, and Thieme-Becker. The bib-
liographic abbreviations in each entry are keyed to the

"Sources of Bibliographical Information" in each volume.

36 NATIONAL CYCLOPAEDIA OF AMERICAN BIOGRAPHY. New York:
 David White Co., 1893- .

 The most comprehensive American biographical dictionary,
 issued in two parts (permanent and current volumes), which
 briefly identifies individuals without giving any bibliographi-
 cal citations. Consultation of the comprehensive index (names
 and subjects) is essential.

37 NEW YORK TIMES OBITUARIES INDEX, 1858-1968. New York: 1970.
 1,136 p.

 Indexes the obituary page of the NEW YORK TIMES. This
 volume is especially useful when seeking biographical informa-
 tion about an individual who lived or worked in New York
 City.

38 Smith, Ralph Clifton. A BIOGRAPHICAL INDEX OF AMERICAN ART-
 ISTS. Baltimore: Williams & Wilkins, 1930. x, 102 p.

 Locates biographical material for nearly 5,000 individual
 American artists, deceased and living. The forty-two bio-
 graphical sources which Smith indexed, although dated, are
 often still useful when searching for material on early artists.

39 Thieme, Ulrich, and Becker, Felix, eds. ALLGEMEINES LEXIKON DER
 BILDENDEN KUNSTLER. 37 vols. Leipzig, Germany: W. Engelmann,
 1907-50. In German.

 The most complete and authoritative general dictionary of
 painters, sculptors, engravers, etchers, and architects of all
 centuries. American artists are well represented. The bio-
 graphical entries are in simple German and the bibliographi-
 cal citations which document each entry are easily understand-
 able since they are in the language of their publication. The
 location of major works is noted. Continued by Vollmer
 (see 41).

40 Tuckerman, Henry T[heodore]. THE BOOK OF THE ARTISTS: AMERICAN
 ARTIST LIFE. New York: G.P. Putnam & Son, 1867. 639 p. Index.

 A unique anecdotal account of early American art and artists
 (primarily painters) by one who knew many of the artists
 personally. Tuckerman's biographical facts, however, are
 unreliable and his aesthetic opinions undefined. The chapter
 devoted to sculptors includes the major artists from Rush and
 Frazee to Story and Hosmer to Rinehart and Haseltine.

41 Vollmer, Hans, ed. ALLGEMEINES LEXIKON DER BILDENDEN KUNST-
 LER DES XX. JAHRHUNDERTS. 6 vols. Leipzig, Germany: Seemann,
 1953-62.

> Continuing the format of Thieme-Becker, Vollmer's focus is on
> twentieth-century artists (although he begins his coverage with
> artists of the late nineteenth century). Each entry provides
> bibliographical citations.

42 Waters, Clara Erskine Clement, and Hutton, Laurence. ARTISTS OF THE
 NINETEENTH CENTURY AND THEIR WORKS. 2 vols. in one. 1899.
 Reprint. New York: Arno Press, 1970. 412 p. Index.

> Originally published in 1879, this volume contains 2,050
> biographical sketches of artists of the nineteenth century.
> Critical evaluations of each artist's work are included in
> order to indicate the "average opinion" of this artist. The
> introduction describes the "Art Academies . . . in various
> countries." Indexes of "Authorities Quoted" and of "Places";
> also a general index.

43* WHO'S WHO IN AMERICAN ART. New York: R.R. Bowker Co. and
 the American Federation of Arts, 1936/37- .

> Biographical directory of living U.S. and Canadian artists,
> educators, critics, and historians. Major shows, publications,
> and reviews are listed along with biographical data and ad-
> dresses. Recent editions have been notoriously incomplete
> and incorrect. Issued irregularly, but never more frequently
> than every three years. Before 1952, the WHO'S WHO was
> published as part of the AMERICAN ART ANNUAL (see 20).

Chapter 3

ENCYCLOPEDIAS, DICTIONARIES, AND GLOSSARIES

44* BRITANNICA ENCYCLOPEDIA OF AMERICAN ART. A Chanticleer
 Press Publication. Chicago: Encyclopedia Britannica Educational Corp.,
 1973. Distributed by Simon & Schuster, New York. 669 p. 800 illus.

> An outstanding one-volume encyclopedia covering all periods
> of American art. The entries, written by thirty-two special-
> ists, are understandable. Many entries are illustrated with
> excellent photographs. In addition to cross-reference nota-
> tions within each entry, a "Guide to Entries by Arts" (pp.
> 624-26) helps one to locate all the material on a particular
> art form. The bibliography (pp. 628-33), prepared under the
> supervision of Eugene C. Goossen, is extensive. The first
> section of the bibliography cites general works on each period
> and medium; the second section provides the bibliography for
> the entries themselves. A helpful "Glossary" (pp. 634-37)
> and "Guide to Museums and Public Collections" (pp. 629-35)
> complete this extensive reference tool.

45 ENCYCLOPEDIA OF WORLD ART. 15 vols. New York: McGraw-Hill,
 1959. Illus. Index.

> Lengthy scholarly articles by recognized historians introduce
> large themes and topics in art history. The index volume
> (vol. 15) provides access to secondary topics and to material
> on individual artists. Definitely not a biographical diction-
> ary, but bibliographical notes are included with each article.
> Half of each of the fourteen text volumes is devoted to illus-
> trative plates. The article on American sculpture (vol. 1,
> columns 313-25) is composed of essays by Albert Ten Eyck
> Gardner, Dorothy Gees Seckler, and Bernard S. Myers.

46 Lemke, Antje, and Fleiss, Ruth. MUSEUM COMPANION: A DICTION-
 ARY OF ART TERMS AND SUBJECTS. New York: Hippocrene Books,
 1974. vii, 211 p. Illus.

> "Written to meet the needs of museum visitors and art students
> . . . [the book consists of] concise explanations of art terms

and subjects. It includes art movements, schools, styles, media, techniques, and subjects, especially in mythology and religion." The entries, arranged alphabetically, are elementary and simple with frequent cross-references. Selective lists of North American and foreign museums (pp. 151-200) and a selective reading list (pp. 201-11) complete this reference work.

47 McGRAW-HILL DICTIONARY OF ART. 5 vols. Edited by Bernard S. Myers. New York: McGraw-Hill, 1969. Illus.

A thorough introductory dictionary with concise entries covering all aspects of art history and art appreciation. Numerous excellent illustrations and brief bibliographies accompany a large proportion of the entries.

48 Mayer, Ralph. A DICTIONARY OF ART TERMS AND TECHNIQUES. New York: T.Y. Crowell, 1969. 447 p. Illus.

Covering painting, drawing, sculpture, printmaking, and ceramics, this dictionary explains "terms encountered in the study and practice of the visual arts and their literature." Each concise entry contains the "kinds of information appropriate to its subject, whether these be definitions, historical accounts, descriptions of periods, schools or styles of art, or explanations of technical processes and materials."

49 OXFORD COMPANION TO ART. Edited by Harold Osborne. Oxford, England: Clarendon Press, 1970. 1,289 p. Illus.

A useful introductory handbook to the visual arts. The reader is directed from each brief entry to the bibliography (pp. 1231-77) for additional material. American art and artists are covered adequately, not comprehensively.

50 PHAIDON DICTIONARY OF TWENTIETH CENTURY ART. London and New York: Phaidon, 1973. Distributed by Praeger Publishers, New York. 420 p. 65 plates.

One-volume dictionary which includes artists whose "major creative phases fall within this century, including those active at the present time. There are no entries on young painters and sculptors who are only now beginning to gain recognition." Entries are somewhat uneven in length and coverage yet most were written by art specialists and contain one or two bibliographical references. International in scope.

51 PRAEGER ENCYCLOPEDIA OF ART. 5 vols. Translated, with additional material, from the French DICTIONNAIRE UNIVERSEL DE L'ART ET DES ARTISTES. New York: Praeger Publishers, 1971. Illus.

Although covering architecture, painting, and sculpture of all periods, the English edition of this encyclopedia reveals a conscious effort by the editors to include material on the contemporary arts of Europe and the United States. Bibliographies accompany each entry.

52* Walker, John. GLOSSARY OF ART, ARCHITECTURE AND DESIGN SINCE 1945. London: Clive Bingley, 1973. 240 p. Index.

A list of 378 terms and labels describing art movements, styles, and groups which have entered the language since 1945. The paragraph-length definitions are "derived from the vocabulary of artists and critics." The source of each definition is cited at the end of the entry, providing a guide for further research. Brief general bibliography (pp. 214-15). Index to broad subjects and to individuals cited.

Chapter 4

DIRECTORIES

53* AMERICAN ART DIRECTORY. New York: R.R. Bowker Co. for the
 American Federation of Arts, 1952- .

 Continuing the AMERICAN ART ANNUAL (see 20), this direc-
 tory lists and describes "art museums, art organizations, univer-
 sities and colleges with art departments and museums, art
 schools and classes in the United States, Canada and abroad."
 Recent volumes contain a listing of scholarships and fellowships
 available to art students. Issued every three years.

54 INTERNATIONAL AUCTION RECORDS: ENGRAVINGS, DRAWINGS,
 WATERCOLORS, PAINTINGS, SCULPTURE. Compiled by E. Mayer.
 [France]: Editions Mayer, 1967- .

 Records, by medium and by artist, the prices paid for art
 works at the principal auctions, both in the United States
 and abroad. Covers the preceding calendar year.

55 INTERNATIONAL DIRECTORY OF ARTS. Berlin: Deutsche Zentraldruc-
 kerie, 1952/53- .

 This invaluable reference tool provides listings for art museums
 and galleries (their personnel and holdings), universities (their
 art personnel), associations concerned with the arts, as well
 as restorers, experts, antique dealers, commercial art galler-
 ies, auctioneers, art publishers, art periodicals, booksellers,
 artists, and collectors. The artist section, while lengthy,
 provides poor coverage of American artists. Extensive name
 index. One volume is published each year; each edition is
 composed of two volumes.

56* OFFICIAL MUSEUM DIRECTORY: UNITED STATES AND CANADA.
 Washington, D.C.: American Association of Museums, 1961- .

 Lists, state by state, the addresses, hours, personnel, facili-
 ties, and major collections of museums throughout the United
 States and Canada. A listing by category, i.e., art, natural
 history, historical, etc., is provided. Issued every two years.

Section II

HISTORY AND AESTHETICS
OF AMERICAN SCULPTURE

Chapter 5

SURVEYS OF AMERICAN SCULPTURE

57 THE ARTIST IN AMERICA. Compiled by the editors of ART IN AMERICA. New York: W.W. Norton, 1967. 256 p. Illus. Index.

> The introduction, "What is American?" by Lloyd Goodrich re-counts the history of significant styles and modes which have comprised American art. Although dealing primarily with painting, this volume is a readable introduction to the American tradition of art. Major critics and historians introduce early portrait painting and folk objects, as well as recent sculptural trends. Index of artists.

58* Broder, Patricia Janis. BRONZES OF THE AMERICAN WEST. New York: Harry N. Abrams, 1973. 431 p. 511 illus. Index.

> The first comprehensive survey of this specialized aspect of American sculpture. Broder's research has been extensive, but the presentation is often anecdotal and uncritical. Helpful research tools include "Index of Sculptors of American Western Bronzes" (pp. 401-4); "Index of American Western Bronzes" (gives locations of bronze sculptures in museum collections throughout the United States) (pp. 405-20); "Index of Monu-mental American Western Bronzes" (pp. 421-24); and an exten-sive selected bibliography (pp. 393-96).

59 Bullard, Frederic Lauriston. LINCOLN IN MARBLE AND BRONZE. New Brunswick, N.J.: Rutgers University Press, 1952. 366 p. Illus. Index.

> A publication of the Abraham Lincoln Association (Springfield, Ill.), this study outlines the circumstances surrounding the com-mission and execution of sixty-eight statues of Abraham Lin-coln. Sculptors whose works are illustrated include Ball, Bar-nard, Brown, French, Ream, Saint-Gaudens, Taft, and Wein-man. Bibliographies.

60* Craven, Wayne. SCULPTURE IN AMERICA FROM THE COLONIAL PERIOD TO THE PRESENT. New York: T.Y. Crowell, 1968. 742 p. 282 illus. Index.

The single most comprehensive history of American sculpture. A major source of scholarly information, comparable in scope and thoroughness to Taft's 1903 survey. Sculptors are grouped according to their styles and periods. Principal artists are discussed at length, minor ones may be mentioned only briefly. Index provides access to all the sculptors and sculpture included. Comprehensive collection of black-white illustrations, which are now located at the INDEX OF AMERICAN SCULPTURE (see 8). An excellent general bibliography precedes bibliographic citations for material on 106 individual artists (pp. 675-90).

61 Dover, Cedric. AMERICAN NEGRO ART. Greenwich, Conn.: New York Graphic Society, 1960. 186 p. Illus.

Presents American Negro art in its historical and sociological framework with a minimum of critical evaluation. One section of photographs on "Sculpture and Ceramics" (pp. 141-58) is followed by sketchy biographical outlines for the artists. Bibliography (pp. 57-60).

62* Dunlap, William. HISTORY OF THE RISE AND PROGRESS OF THE ARTS OF DESIGN IN THE UNITED STATES. 3 vols. Newly edited by Alexander Wyckoff, incorporating the notes and additions compiled by Frank W. Bayley and Charles Goodspeed. New York: Benjamin Blom, 1965.

This authoritative Wyckoff edition is based on Dunlap's 1834 publication with the Bayley-Goodspeed (1918) notes, index and corrections incorporated. The first historian of American art, Dunlap provides documentary material about early artists who worked and/or lived in the United States. Vividly reflects the cultural attitudes and milieu of the 1830s. The 287 biographical notices, incorporating anecdotes and gossip are lively personality sketches but often provide unreliable factual information. The bibliography, initially compiled in 1918 by Frank Chase, provides an exhaustive list of early sources of documentation (pp. 346-77B of volume 3).

63 Fairman, Charles E. ART AND ARTISTS OF THE CAPITOL OF THE UNITED STATES OF AMERICA. 69th Cong., 1st sess., S. Document 95. Washington, D.C.: Government Printing Office, 1927. 539 p.

This monumental work provides a complete, definitive history of government patronage during the building and decorating of the Capitol. Provides a unique study of the changes in public taste through several generations. See also citation 76 and the appendix of this bibliography for more material on sculpture in the District of Columbia.

64 Fairmount Park Art Association [Philadelphia]. SCULPTURE OF A CITY: PHILADELPHIA'S TREASURES IN BRONZE AND STONE. New York:

Walker & Co., 1974. 363 p. Illus. Index.

A unique study of Philadelphia's monumental sculpture reflecting nearly 200 years of civic pride and involvement. Chronologically organized into six sections, "sculptures of particular significance are described at essay length [by noted scholars] and illustrated in close detail. The provenance of other pieces are held to a single illustrated page. . . . Remaining sculptures are briefly listed in their respective periods and are accompanied by an identifying picture." Essays focus on Philadelphia work by such American sculptors as John J. Boyle, Alexander Milne Calder, Alexander Stirling Calder, French, Edward Kemeys, Lipchitz, Remington, Randolph Rogers ("Lincoln"), Rush, Saint-Gaudens, and Rudolf Siemering ("Washington Monument"). Among scholars contributing essays are Wayne Craven, Victoria Donohoe, John Dryfhout, George Gurney, Michael Richman, Charles Coleman Sellers, David Sellin ("The Centennial"), Lewis Sharp, John Tancock, and George Thomas ("Art Deco Architecture and Sculpture"). Contemporary Philadelphia photographers are responsible for the excellent illustrations throughout. Maps on endpapers. Bibliographical footnotes.

65 Garrett, Wendell D., et al. THE ARTS IN AMERICA: THE NINETEENTH CENTURY. New York: Charles Scribner's Sons, 1969. 431 p. Illus.

The introductory nature of this book is enhanced by an excellent selection of black-white illustrations with lengthy descriptive captions. Alan Gowans, in "Painting and Sculpture" (pp. 175-284) stresses the conflict between the American sense of self-sufficiency and the influences of European culture. Bibliography (pp. 385-90).

66 Gerdts, William H., Jr. THE GREAT AMERICAN NUDE; A HISTORY IN ART. New York: Praeger Publishers, 1974. 224 p. Illus. Index.

An entertaining study of this one aspect of American art. Gerdts discusses painted images primarily. However, he devotes one entire chapter to sculptured neoclassical nudes. Later examples of sculptured images are in the appropriate chronological chapters. Bibliography (pp. 216-19).

67 Goode, James M. THE OUTDOOR SCULPTURE OF WASHINGTON, D.C.; A COMPREHENSIVE HISTORICAL GUIDE. Washington, D.C.: Smithsonian Institution, 1974. Distributed by George Braziller, New York. 630 p. Illus. Index.

"Traces the history and significance of over 400 open-air sculptures in the metropolitan area, treating not only allegorical, portrait and equestrian statues and sculpture groups . . . but also fountain, animal, abstract, cemetery and architectural sculptures." Arranged geographically with accompanying maps

and photographs, this volume is intended to be a guidebook. Historical introduction by Goode is useful. "Selected Biographies" (pp. 543-605) and a thorough bibliography (pp. 609-15) make this a valuable reference source.

68 Goodrich, Lloyd. THREE CENTURIES OF AMERICAN ART. New York: Praeger Publishers for the Whitney Museum of American Art, 1966. 155 p. Illus. Index.

A brief, well-written introduction to the history of American art. Discusses selected individual artists in terms of the larger society and the trends in art history in which they participated. The book is based on the Whitney's 1966 exhibition, "Art of the United States, 1670-1966." One-quarter of the 140 illustrations are of sculpture.

69 Green, Samuel M. AMERICAN ART: A HISTORICAL SURVEY. New York: Ronald Press, 1966. xi, 706 p. Illus. Index.

An introductory text covering American art and architecture from colonial times until the present. Intended as a teaching tool, the text provides a great deal of detailed material without much discussion of overall trends and movements. The scarcity of illustrations hinders comprehension unless the companion slide set is immediately at hand. Sculpture since 1865 is reviewed and the major sculptors mentioned. Glossary (pp. 655-61). "Suggested Reading" (pp. 663-68).

70* Larkin, Oliver W. ART AND LIFE IN AMERICA. Rev., enl. ed. New York: Holt, Rinehart and Winston, 1960. 576 p. Illus. Index.

Perhaps the best introductory survey of the history of the arts in the United States. Explores the relationships between the arts and American lifestyles and ideals; material in each chapter is thoroughly integrated. The extensive bibliographical notes (pp. 491-525) are especially helpful when researching the developing cultural life of the United States.

71 Licht, Fred. SCULPTURE: 19TH AND 20TH CENTURIES. A History of Western Sculpture. Greenwich, Conn.: New York Graphic Society, 1967. 352 p. Over 350 illus. Index of sculptors. Illus.

Excellent and abundant photographs illustrate the highlights of the past 150 years of western sculpture. European in emphasis; the introductory text discusses the origins of the sculptural instinct and its development through history. Notes on the plates (pp. 305-47) provides more specific information and discussion.

72 McCoubrey, John W., ed. AMERICAN ART; 1700-1900; SOURCES AND

DOCUMENTS. Sources and Documents in the History of Art. Englewood Cliffs, N.J.: Prentice-Hall, 1965. xi, 226 p. Paperback.

Primarily includes excerpts relating to painting and painters in America. Two documents directly relevant to American sculpture: Alexander Evertt's "Greenough's Statue of Washington"; and Nathaniel Hawthorne's "A Visit to the Studio of Hiram Powers, 1858."

73 McLanathan, Richard. THE AMERICAN TRADITION IN THE ARTS. New York: Harcourt, Brace & World, 1968. 509 p. Illus. Index.

An introductory history of American taste in furnishings, architecture, painting, and sculpture since the first Spanish and French settlers. Attempts to "show the singular mixture of qualitites and modes that constitute the characteristic style and tradition in American art." Material on sculpture is scant, dealing primarily with folk carving and twentieth-century sculpture. A list of museums and other collections (pp. 465-70) is a useful guide to important collections of American art. The bibliography (pp. 471-78) is especially rich in cultural histories of the United States.

74 Mendelowitz, Daniel M. A HISTORY OF AMERICAN ART. 2d ed., rev. New York: Holt, Rinehart and Winston, 1973. x, 522 p. 695 illus. Index.

A standard textbook presenting "the history of the visual arts in the geographical area that now constitutes the United States." Beginning with pre-Columbian artifacts of Indian tribes, Mendelowitz traces American movements and trends up to the present. Such broad coverage, however, reduces the discussions of pretwentieth-century sculpture to a cursory introduction. Modern sculpture is surveyed thoroughly in a separate chapter. Bibliography (pp. 510-12).

75 Miller, Lillian B. PATRONS AND PATRIOTISM; THE ENCOURAGEMENT OF THE FINE ARTS IN THE UNITED STATES, 1790-1860. Chicago: University of Chicago Press, 1966. 350 p. Index.

"Examines the way in which Americans . . . defined [formal] art with respect to its mission and how they justified its promotion." Also outlines the introduction of art into the local communities through public or private institutions. Extensive notes. Bibliography (pp. 299-315).

76 Murdock, Myrtle Cheney. NATIONAL STATUARY HALL IN THE NATION'S CAPITOL. Washington, D.C.: Monumental Press, 1955. 128 p. Illus.

A guidebook to the personalities represented in Statuary Hall

in the Capitol building. Each work is illustrated and each sculptor identified; however, there is no further documentation of the sculpture as a piece of art. Another brief description of the hall can be found in Gerdts' NEO-CLASSIC SCULPTURE (see 123).

77* Newark Museum. A SURVEY OF AMERICAN SCULPTURE: LATE 18TH CENTURY TO 1962. Organized by William H. Gerdts. Newark, N.J.: 1962. 44 p. 36 illus. Index.

Catalog for the "first museum exhibition to attempt a general history of American sculpture." Gerdts' informative essay traces the development of sculpture from early medallions through colonial woodcarving up to Lachaise. The text and illustrations relating to the 1770-1872 period are excerpted in ANTIQUES 82 (August 1962). Bibliographical note (p. 38).

New York. Metropolitan Museum of Art. AMERICAN SCULPTURE; A CATALOGUE OF THE COLLECTION OF THE METROPOLITAN MUSEUM OF ART. 1965.

See Appendix of this bibliography for full annotation.

78* _____. NEW YORK CITY PUBLIC SCULPTURE BY 19TH CENTURY AMERICAN ARTISTS. Text by Lewis I. Sharp. New York: 1974. 67 p. Illus. Paperback.

This catalog details the history of twenty-two public sculptures in New York. Walking tours, devised by David W. Kiehl, describe the nineteenth-century sculpture found at 145 sites throughout the city. Bibliography.

79* _____. 19TH CENTURY AMERICA; PAINTINGS AND SCULPTURE. Text by John K. Howat et al. Greenwich, Conn.: New York Graphic Society, 1970. 160 p. 201 illus.

Exhibition catalog which marks the resurgent interest in American academic art of the nineteenth century. Although the selection is biased towards painting, there are forty sculpture entries. The text stresses the development of an American aesthetic growing out of European traditions. Thorough bibliography (pp. 187-88).

80* New York. Museum of Modern Art. AMERICAN PAINTING AND SCULPTURE, 1862-1932. Text by Holger Cahill. New York: W.W. Norton for the Museum of Modern Art, 1932. 46 p. 78 plates.

Catalog for an exhibition which reviewed seventy important years of American art. Dominated by painters, the exhibition included works by the following sculptors: Barnard, Ben-Shmuel, Cash, Davidson Diederich, Glenny, Lachaise, Laurent,

Manship, Noguchi, Remington, Rumsey, Saint-Gaudens, Sterne, Ward, G. Whitney, Williams, and Zorach.

81 Post, Chandler Rathfon. A HISTORY OF EUROPEAN AND AMERICAN SCULPTURE FROM THE EARLY CHRISTIAN PERIOD TO THE PRESENT DAY. 2 vols. Cambridge, Mass.: Harvard University Press, 1921. Illus. Index.

American sculpture is treated in the second volume under the headings "Neo-classicism--U.S." and "Modern Sculpture--U.S." Post, a noted American art historian, shows a marked prejudice against the neoclassical style, especially as exemplified by the Americans. His most laudatory essays focus on Saint-Gaudens and Barnard. Bibliography in volume 2, pages 271-89.

82 Read, Sir Herbert Edward. ART OF SCULPTURE. Bollingen Series, 35, no. 3. The A.W. Mellon Lectures in the Fine Arts, 1954. New York: Pantheon Books, 1956. 183 p. 225 illus.

Attempts to define the "essential nature of the art of sculpture" --an art distinct from painting and architecture. Read discusses and illustrates sculpture of all ages and countries, providing historical and theoretical support for his views.

83* Taft, Lorado. THE HISTORY OF AMERICAN SCULPTURE. Rev. ed. with supplementary chapter by Adeline Adams. New York: Macmillan, 1930. Reprint of 1924 ed. New York: Arno Press, 1969. 635 p. Illus. Index.

Initially published in 1903, this is the first scholarly history of American sculpture. The text still provides useful information, especially regarding the artists of the late nineteenth century who were Taft's contemporaries. Taft begins his coverage where Dunlap leaves off, i.e., with William Rush in 1834. He also provides a summary of the contributions of the early sculptors. Superceded in most respects by Craven (see 60). Bibliography (pp. 607-18).

84 Thurlow, Fearn. "Newark's Sculpture." THE NEWARK MUSEUM QUARTERLY 26 (Winter 1975): entire issue. Illus.

A survey of public monuments and memorial statuary in Newark, New Jersey. Twenty-eight works, dating from 1873 to 1972, are illustrated, documented, and described.

85 Whitehill, Walter Muir. BOSTON STATUES. Photographs by Katharine Knowles. Barre, Mass.: Barre Press, 1970. 120 p. Illus. Index.

Guidebook to the public statues in Boston. Each statue is photographed and described as to its subject and its creator. The sculptors whose works are represented include Ball, Dallin, French, Richard Greenough, Saint-Gaudens, and Story.

101479

86* Whitney Museum of American Art (New York). 200 YEARS OF AMERICAN SCULPTURE. Directed by Tom Armstrong. Boston: David R. Godine in association with the Whitney Museum of American Art, 1976. 365 p. 496 illus. 68 color plates. Index. Paperback.

> Outstanding book catalog to accompany a major exhibition of American sculpture. The seven sections of the book correspond to the periods of American sculpture. Each curator has introduced his or her period with a lengthy historical and critical essay: "Aboriginal Art" by Norman Feder; "Images of a Nation in Wood, Marble and Bronze: American Sculpture from 1776 to 1900" by Wayne Craven; "The Innocent Eye: American Folk Sculpture" by Tom Armstrong; "Statues to Sculpture: From the Nineties to the Thirties" by Daniel Robbins; "Magician's Game: Decades of Transformation, 1930-1950" by Rosalind E. Krauss; "Two Decades of American Sculpture: A Survey" (i.e., 1950-70) by Barbara Haskell; and "Shared Space: Contemporary Sculpture and Its Environment" by Marcia Tucker. In addition to the selected bibliography (pp. 249-53), Libby W. Seaberg has compiled a concise biography and bibliography for each of the 140 artists whose work was included in the exhibition. Each biography is accompanied by a photograph of the artist.

87 Whittemore, Francis Davis. GEORGE WASHINGTON IN SCULPTURE. Boston: Marshall Jones, 1933. 218 p. 47 illus.

> Describes the history and the appearance of forty-seven sculptured images of George Washington. Begins with early carvings by Rush and the Skillins and includes the neoclassical representations by Greenough and Crawford and the equestrian works by Brown and Ball. Early twentieth-century examples (A.S. Calder, French, etc.) are also introduced. Works by such foreigners as Canova, Carrachi, and Houdon are recognized for their important influence on American styles and ideals.

Chapter 6

FOLK, PRIMITIVE, AND NAIVE CARVING

In the seventeenth and eighteenth centuries, settlers of the colonies had little time or inclination to carve items other than those needed in everyday life. Folk sculpture of that period includes gravestones, decoys, toys, ship figure-heads, cigar-store figures, weathervanes, etc. The simple charm of these forms has made them a source of artistic inspiration--Nadelman is an example-- and recently an object of major research. The same is true of primitive sculpture, for instance, the Santos images. These religious carvings are unique, found only in the southwestern part of the United States. Also included in this chapter is information on the few nineteenth and twentieth-century naive artists who have ignored their cultural milieu and created a sculptural oeuvre very similar, stylistically and conceptually, to their primitive forebearers.

Individual bibliographies are included in section 3 for the following craftsmen whose work is usually regarded as primitive or naive: Samuel McIntire, Simon Rodia, William Rush, Clarence Schmidt, the Skillins, and Patience Wright.

88 ABBY ALDRICH ROCKEFELLER FOLK ART COLLECTION: A DESCRIPTIVE CATALOG. BY NINA FLETCHER LITTLE. Williamsburg, Va.: Colonial Williamsburg, 1957. Distributed by Little, Brown and Co., Boston. 418 p. 165 color illus. Index.

 Nicely illustrated catalog of the outstanding Rockefeller folk art collection which, until the late 1950s, was a part of the Colonial Williamsburg restoration. Now housed as a separate collection outside of the restoration. Brief documentation provided for each of the over 400 objects. Index of "Artists Represented." Excellent bibliography (pp. 393-94A).

89 Barber, Joel. WILD FOWL DECOYS. New York: Windward House, 1934. Reprint. New York: Dover Publications, 1954. 172 p. Illus.

 A classic work on the subject. Ranges from collectors' tales to construction techniques, to regional stylistic differences. Distinctive types of decoys are described and clearly illustrated.

90 Bishop, Robert. AMERICAN FOLK SCULPTURE. New York: E.P. Dutton, 1974. 392 p. Illus. Index.

Visual survey of American sculpture illustrating scrimshaw, religious objects, pottery, and firemen's sculpture, as well as examples of gravestones, weathervanes, decoys, and carved toys. The extremely brief introductions to each chapter are supplemented by lengthy descriptive captions accompanying each of the 726 plates. The selected bibliography surveys a large body of material (pp. 388–89).

91 Bolton, Ethel. AMERICAN WAX PORTRAITS. Boston: Houghton Mifflin Co., 1929. vii, 68 p. 16 illus.

A brief but thorough study of the artisans of wax portraits. Photographs illustrate this minor art form which was popular from the mid–eighteenth to mid–nineteenth centuries. Distinguishing characteristics of each artist's style are pointed out. A "Record of American Wax Portraits" (pp. 35–68) is invaluable for its comprehensive documentation.

92 Boyd, E[lizabeth]. SAINTS AND SAINT-MAKERS OF NEW MEXICO. Santa Fe, N.M.: Laboratory of Anthropology, 1946. vi, 139 p. 24 illus.

Anthropological and artistic study of the carved and painted Santos, i.e., images of saints or holy persons, produced in the southwestern United States between the mid–eighteenth and mid–nineteenth centuries. Boyd discusses specific examples in private and public collections. Bibliography (pp. 119–20).

93 Brewington, Marion V. SHIPCARVERS OF NORTH AMERICA. South Saint Barre, Mass.: Barre Publishing Co., 1962. Reprint. New York: Dover Publications, 1972. 187 p. 135 illus. Index.

Authoritative study of American shipcarvers and their craft. Covers the two centuries of their prominence. The work of Rush and the Skillins is well documented. Appendix includes a list of American shipcarvers and a brief history of the carvings on the frigate Constitution. Bibliography (pp. 147–53).

93a* Brooklyn Museum. FOLK SCULPTURE USA. Edited by Herbert W. Hemphill, Jr. Brooklyn: 1976. 96 p. Illus. Paperback.

Important exhibition catalog which substantially redirects the way American folk sculpture should be studied and evaluated. Pieces for the exhibition (which traveled to the Los Angeles County Museum of Art) were selected for their powerful and challenging presence rather than for their decorative qualities. Hemphill deals directly with the influences of "high" art on folk styles and he discusses the complex forms of contemporary folk sculpture. An interview between Sarah Faunce, of the Brooklyn Museum, and Michael D. Hall, a collector of folk sculpture, illuminates the passion which keeps collectors look-

ing for their next discovery. Michael Kan discusses "American Folk Sculpture: Some Considerations of Its Ethnic Heritage" focusing only on the Afro-American and Spanish-American (particularly Santos) traditions. Selected bibliography (pp. 93-95).

94* Christensen, Edwin O. EARLY AMERICAN WOODCARVING. Cleveland, Ohio: World Publishing Co., 1952. Reprint. New York: Dover Publications, 1972. 149 p. Illus. Index.

Introductory history of all aspects of early American woodcarving through the nineteenth century. Discusses "professional" carving (ship figureheads, shop signs, furniture decoration) as well as "amateur" work (decoys, weathervanes). One chapter devoted to carved religious images. A partial list, by state, of "Early American Woodcarvings in Art Museums and Historical Societies" (pp. 136-38). Excellent bibliography (pp. 139-43).

95 _____. THE INDEX OF AMERICAN DESIGN. New York: Macmillan, 1950. 247 p. Chiefly illus. Index.

Important visual source for all types of American folk art (c. 1700-1900) reproduced from renderings and photographs gathered by the Works Progress Administration between 1935 and 1941. The entire index of 17,000 items is located at the National Gallery in Washington, D.C. and comprises a valuable resource for scholars of American folk arts. Reproductions of carved items are included throughout (toys, figureheads, etc.). A general index includes subject entries for all the items reproduced. In 1972, more of the items from the index were reproduced in Hornung's two-volume TREASURY OF AMERICAN DESIGN (see 104). Bibliography (pp. 219-21).

96 Craven, Wayne. "Sculpture." AMERICAN ART JOURNAL 7 (May 1975): 34-42. Illus.

Briefly summarizes the sculptural arts and crafts practiced in the colonies (gravestone, furniture carving, etc.) prior to the 1770s. Also describes four European statues, commissioned for this country, which are notable as the earliest "formal" sculpture in this country. The photos are identified with lengthy, explanatory captions.

97 Earnest, Adele. THE ART OF THE DECOY: AMERICAN BIRD CARVINGS. New York: Clarkson N. Potter, 1965. 208 p. 170 Illus.

First study to treat decoys as an indigenous American art form. Presents the history and types of decoys as well as the techniques used to make them. Decoys are identified by carver (if known), breed of bird, and present location. Chapter on

the "Men Who Carved" discusses individual craftsmen. "Text References" (p. 199) provides bibliographic guidance.

98 Fitzgerald, Ken. WEATHERVANES AND WHIRLIGIGS. New York: Clarkson N. Potter, 1967. Distributed by Crown Publishers, New York. 186 p. Illus.

After a brief history of the European weathervane, Fitzgerald traces the developing form of the vane in the colonies and the new republic. One chapter is devoted to the whirligig, a toy with movable parts which whirl or spin in the wind. Line drawings illustrate the objects clearly.

99* Forbes, Harriett. GRAVESTONES OF EARLY NEW ENGLAND, AND THE MEN WHO MADE THEM, 1653-1800. Boston: Houghton Mifflin Co., 1927. Reprint. New York: DaCapo Press, 1967. 141 p. Illus. Index.

First serious study of gravestone carving, its craftsmen, and its symbolism. Appendix lists stonecutters working in New England prior to 1800. Supplemented by Forbes's article "Early Portrait Sculpture in New England," OLDTIME NEW ENGLAND 19 (April 1929): 159-73.

100* Fried, Frederick. ARTISTS IN WOOD; AMERICAN CARVERS OF CIGAR-STORE INDIANS, SHOW FIGURES, AND CIRCUS WAGONS. New York: Clarkson N. Potter, 1970. 311 p. Illus.

Thoroughly illustrated and documented study of an over-looked aspect of nineteenth-century American and Canadian folk sculpture. Biographical material is provided for major artisans. Appendices consist of the following: "Show Figure Carvers," "Auctions of Show Figures and Their Prices," and "Collections of Show Figures." Bibliography (pp. 279-87).

101 Gillon, Edmund Vincent, Jr. EARLY NEW ENGLAND GRAVESTONE RUBBINGS. Dover Pictorial Archive. New York: Dover Publications, 1966. 195 plates. Paperback.

Abundant visual resource with only meager notes on the plates.

102* _____. VICTORIAN CEMETERY ART. New York: Dover Publications, 1972. 185 p. 260 photographs by the author. Paperback.

Brief introduction emphasizes the possible importance of Victorian sepulchral monuments to American aesthetics of the mid-nineteenth century. The photos are arranged thematically and indexed by cemetery location. No artists are identified, no styles discussed.

103 Hemphill, Herbert W., Jr., and Weissman, Julia. TWENTIETH-CENTURY AMERICAN FOLK ART AND ARTISTS. New York: E.P. Dutton & Co., 1974. 237 p. Illus.

Inspired by a 1970 exhibition of the same title held at the
Museum of American Folk Art in New York. Hemphill includes
a wide range of three-dimensional objects such as Santos,
scarecrows, "fantasy gardens," and "storefront art" in this
visual survey. Brief introduction attempts a definition of
twentieth-century folk art. Captions provide information about
several unknown "primitive" artists. Indexed by artist. Bib-
liography (pp. 232-33).

104 Hornung, Clarence P. TREASURY OF AMERICAN DESIGN. 2 vols.
New York: Harry N. Abrams, 1972. 875 p. 2,900 illus, 800 in color.

Rich visual resource of American folk art (c. 1700-1900)
selected from the renderings and photographs in the Index of
American Design (located at the National Gallery in Washing-
ton, D.C.). More than five times as many illustrations as in
the 1950 Christensen compilation, INDEX OF AMERICAN DE-
SIGN (see 95).

105 Klamkin, Marian, and Klamkin, Charles. WOODCARVINGS; NORTH
AMERICAN FOLK SCULPTURES. New York: Hawthorne Press, 1974.
vii, 213 p. Illus. Index.

Popular introduction to the varieties and forms of such carved
objects as ship figureheads, circus figures, trade signs,
weathervanes, toys, and bird decoys. Bibliography (pp. 205-
6).

106* Lipman, Jean. AMERICAN FOLK ART IN WOOD, METAL AND STONE.
New York: Pantheon Books, 1948. Reprint. New York: Dover Publi-
cations, 1972. 193 p. 183 illus.

Pioneer study of three-dimensional images in American folk
art: weathervanes, cigar-store figures, circus figures, toys,
decoys and portraits (wood and stone). Text provides a thor-
ough analysis emphasizing the social and cultural factors which
encouraged such works. Extensive bibliography (pp. 189-93).

107* Lipman, Jean, and Winchester, Alice. THE FLOWERING OF AMERICAN
FOLK ART, 1776-1876. New York: Viking Press in cooperation with
the Whitney Museum of American Art, 1974. 288 p. 410 illus.

An extensively documented catalog accompanying a major
exhibition organized by the Whitney Museum. Each item is
illustrated. The chapter devoted to "Sculpture in Wood,
Metal, Stone and Bone" (pp. 119-89) introduces its subject
historically and culturally. Portraits, figureheads, weather-
vanes, whirligigs, cigar-store figures, decoys, and toys are
presented. Appendices include a short biographical index of
artists and a brief booklist (pp. 284-87).

108* Ludwig, Allan I. GRAVEN IMAGES; NEW ENGLAND STONECARVING AND ITS SYMBOLS, 1650-1815. Middletown, Conn.: Wesleyan University Press, 1966. 513 p. Illus. Index.

> Comprehensive and scholarly treatment of stonecarving--its religious roots, iconography, and major styles. The numerous illustrations, photographs, and maps are excellent. Full, annotated bibliography (pp. 455-59).

109 Mackey, William F., Jr. AMERICAN BIRD DECOYS. New York: E.P. Dutton & Co., 1965. 256 p. Illus. Index.

> "Aims to focus attention upon the rich heritage of collectible decoys that have been made and used in America during the past century or more, to describe their inimitable characteristics and to tell the colorful stories of the men who made them." All the examples are from the author's collection.

110 Newark Museum. AMERICAN FOLK SCULPTURE; THE WORK OF EIGHTEENTH AND NINETEENTH CENTURY CRAFTSMEN. Organized by Holger Cahill. Newark, N.J.: 1931. 108 p. Illus. Paperback.

> Catalog to one of the first major exhibitions of American woodcarving and metal work (a few items of pottery, plaster, and stone also included). Chiefly drawn from the Abby A. Rockefeller Collection (see 88). The reading list (pp. 103-8) is diverse and useful for material on the minor arts represented in the exhibition.

111* New York. Museum of Modern Art. AMERICAN FOLK ART; THE ART OF THE COMMON MAN IN AMERICA, 1750-1900. Exhibition directed by Holger Cahill. New York: 1932. Reprint. New York: Arno Press, 1971. 52 p. 172 plates.

> Catalog for an influential early exhibition acknowledging American folk art as worthy of serious scholarly study. Views folk art as an "authentic expression of American experience." Many of the 175 items exhibited were from the Abby A. Rockefeller Collection (see 88). Excellent bibliography (pp. 47-52) which has become a standard resource.

112 O'Keefe, Patric. "The Magic Santos of New Mexico." ART AND ARTISTS 3 (December 1968): 32-36. Illus.

> The development of these figures as religious objects is traced and a brief description of types is provided. Specific works from the Taylor Museum (Colorado Springs, Colo.) are illustrated and described.

113 Pinckney, Pauline A. AMERICAN FIGUREHEADS AND THEIR CARVERS. New York: W.W. Norton, 1940. 223 p. Illus. Index.

Comprehensive treatment of the subject with an extensive discussion of contributions by the Skillins and William Rush. Useful appendices include: "List of Figureheads," "Contemporary Descriptions of Figureheads," "List of Carvers," and "Bibliography" (pp. 204-10).

114 Smithsonian Institution. AMERICAN FOLK ART: THE ART AND SPIRIT OF A PEOPLE. Text by Peter C. Walsh. Washington, D.C.: 1965. 105 p. Illus.

Selected from the Eleanor and Mabel van Alstyne Collection, this exhibition of over 150 items is arranged to reflect early attitudes about death, Indians, enterprise, sport, women, the family, etc. Includes many different media.

115* Tashjian, Dickran, and Tashjian, Ann. MEMORIALS FOR CHILDREN OF CHANGE; THE ART OF EARLY NEW ENGLAND STONECARVING. Middletown, Conn.: Wesleyan University Press, 1974. 324 p. 162 illus. Index.

Argues that gravestone carving was not considered a religious art and hence could develop rapidly, free of Puritan strictures. Discusses the artistic style of the stones as well as the typography and sentiments expressed on the stones. Excellent chapter on funeral rites. Selected bibliography (pp. 297-99).

116 Taylor Museum of the Colorado Fine Arts Center. SANTOS: THE RELIGIOUS FOLK ART OF NEW MEXICO. Text and photographs by Mitchell A. Wilder and Edgar Breitenbach. Colorado Springs, Colo.: 1943. 49 p. 64 plates.

A large selection of Santos in the Taylor Museum is presented. Introductory essays survey the historical, religious, and artistic aspects of this folk art. Each large black-white illustration is accompanied by a lengthy description of the image, its symbolic importance, and its relationship to other Santos.

117 Walker Art Center (Minneapolis, Minn.). NAIVES AND VISIONARIES. Introduced and organized by Martin Friedman. New York: E.P. Dutton & Co. for the Walker Art Center, 1974. [99]p. Illus. Paperback.

The visionary environments of nine artist-craftsmen are described and analyzed by separate critics and historians. Excellent photographs. Artists included: S.P. Dinsmoor, James Hampton, Jesse Howard, Grandma Prisbrey, Simon Rodia, Herman Rusch, Clarence Schmidt, Fred Smith, Louis C. Wippich. Bibliography (p. 95).

118 Wasserman, Emily. GRAVESTONE DESIGNS: RUBBINGS AND PHOTOGRAPHS FROM EARLY NEW YORK AND NEW JERSEY. Dover Pictorial

Archive. New York: Dover Publications, 1972. [49]p. 135 plates of rubbings and photographs.

> Excellent visual documentation of gravestones in the specified area. Brief historical and stylistic introduction to the stones, their carvers and their texts. Fuller iconographic discussion of specific traditional symbols. Bibliography (pp. xi–xii).

Chapter 7

FIRST SCHOOL OF AMERICAN SCULPTURE

The first school of American sculpture includes the early expatriates (Horatio Greenough, Thomas Crawford, and Hiram Powers) who emigrated to Italy during the first half of the nineteenth century and who patterned their work after the marble neoclassical styles of Canova and Thorwaldsen. Many other American sculptors (W.W. Story, Randolph Rogers, Harriet Hosmer) subsequently settled or paid lengthy visits to the American artists' settlements in Rome and Florence. The subjects favored by these expatriates ranged from ideal/classical themes to representations of heroic historical events. Small portrait busts, carved throughout this period, reflect the stiff formula of neoclassicism. Erastus Dow Palmer and Henry Kirke Brown, however, rejected the European training and sought instead an American sculpture based on native subjects. Their marble sculptures displayed at the important 1876 Centennial Exhibition (Philadelphia) marked the final phase of this "first school." Reference works which are especially relevant to this period are Dunlap (see 62), Groce and Wallace (see 31), Tuckerman (see 40), and Waters (see 42).

119 Brooks, Van Wyck. THE DREAM OF ARCADIA; AMERICAN WRITERS AND ARTISTS IN ITALY, 1760-1915. New York: E.P. Dutton & Co., 1958. 272 p.

> Descriptive presentation of the artistic milieu in Italy among the early American expatriates. Anecdotal information on such sculptors as Greenough, Powers, and Story.

120 Clark, William J., Jr. GREAT AMERICAN SCULPTURES. Philadelphia: Gebbie & Barrie, 1877. 144 p. 12 steel engravings.

> An articulate commentary on the state of American sculpture at the time of the Centennial Exposition of 1876. Clark discusses specific major works by leading sculptors (including Bartholomew, Hosmer, Palmer, Rogers, Story). One chapter devoted to female sculptors.

121* Crane, Sylvia E. WHITE SILENCE: GREENOUGH, POWERS, AND CRAWFORD; AMERICAN SCULPTORS IN NINETEENTH-CENTURY ITALY. Coral Gables, Fla.: University of Miami Press, 1972. 517 p. 58 illus. Index.

Presents a concise, objective biography of each sculptor and a lively, convincing portrayal of the artistic community in which the Americans lived while in Italy. The list of works for each artist is occasionally incomplete. The photographs lack clarity. An extensive bibliography (pp. 459-89) includes manuscript sources as well as secondary sources.

122* Gardner, Albert Ten Eyck. YANKEE STONECUTTERS; THE FIRST AMERICAN SCHOOL OF SCULPTURE, 1800-1850. New York: Columbia University Press for the Metropolitan Museum of Art, 1945. Reprint. Freeport, N.Y.: Books for Libraries, 1968. 84 p. 12 illus.

An engaging, informative introduction to nineteenth-century academic sculpture, its patrons and practitioners. Emphasis is placed on the neoclassical sculptors active from 1830-60 in Italy. Extensive "Biographical Dictionary of American Sculptors Born Between 1800-1830" (pp. 60-73, 115 entries). Lists of sculptors who preceded and followed are appended. The bibliography (pp. 76-80) is a standard reference source.

123* Gerdts, William H., Jr. AMERICAN NEO-CLASSIC SCULPTURE; THE MARBLE RESURRECTION. New York: Viking Press, 1973. 160 p. 179 illus.

Presents American neoclassic sculpture thematically and stresses its relationship to European taste of the period. Popular nineteenth-century themes which are briefly discussed include "The Greek Slave," "Death," "George Washington," United States Capitol," and "Animals." The bibliography (pp. 149-60) is exceptionally comprehensive, devoting an entire section to nineteenth-century travel books and diaries which relate visits to the studios of the American sculptors in Italy.

124 _____. "Marble and Nudity." ART IN AMERICA 59 (May/June 1971): 60-67. Illus.

Analyzes the American reaction to and acceptance of nude neoclassical statues. The use of color in early nineteenth-century statuary is also briefly discussed. Includes material found in Gerdts's books, AMERICAN NEO-CLASSIC SCULPTURE (see 123) and GREAT AMERICAN NUDE (see 66).

125 _____. "The Marble Savage." ART IN AMERICA 62 (July/August 1974): 64-70. Illus.

Expanding one of the themes in his AMERICAN NEO-CLASSIC SCULPTURE (see 123), Gerdts focuses on the styles and the significance of the Indian, the frontiersman, and the female captive in nineteenth-century sculpture.

126 Hawthorne, Nathaniel. MARBLE FAUN; OR, ROMANCE OF MONTE
BENI. 2 vols. Boston: Ticknor and Fields, 1860.

> In this novel, Hawthorne vividly depicts the "art-life" in
> Italy in 1858. He patterned his characters after those sculp-
> tors he knew in Rome: Akers, Story, and Vinnie Ream Hoxie.

127 _____. PASSAGES FROM THE FRENCH AND ITALIAN NOTEBOOKS.
Boston: Houghton Mifflin Co., 1871. Reprint. Unexpurgated manuscript
edition. New Haven, Conn.: Yale University Press, 1941.

> Provides a literate, firsthand account of the cultural scene in
> Italy during fifteen months from 1858 to 1859. Entries on the
> major artists with whom Hawthorne socialized (Crawford, Hos-
> mer, Story, Powers, Akers, etc.) are located by the index.

128 Jarves, James Jackson. THE ART IDEA. New York: Hurd and Hough-
ton, 1864. 381 p. Reissue. Cambridge, Mass.: Harvard University
Press, Belknap Press, 1960.

> A widely-read, influential statement of aesthetic theory and
> art history written by the leading art critic of the day.
> Jarves challenges the "sentimental prettiness and lack of tech-
> nical distinction" he finds in the work of the American neo-
> classical expatriates. A more mature statement of Jarves's
> theories can be found in ART THOUGHTS.

129 _____. ART THOUGHTS: THE EXPERIENCES AND OBSERVATIONS OF
AN AMERICAN AMATEUR IN EUROPE. New York: Hurd and Houghton,
1869. Reprint. xi, 379 p. New York: Garland Publishing, 1976.

> See annotation above for THE ART IDEA.

130 Kimball, [Sidney] Fiske. "Beginnings of Sculpture in Colonial America."
ART AND ARCHAEOLOGY 8 (May/June 1919): 185-89. 4 illus.

> Useful summary of the earliest classical casts and original
> sculpture imported into this country from Europe.

131 Lee, Hannah. FAMILIAR SKETCHES OF SCULPTURE AND SCULPTORS.
2 vols. Boston: Crosby, Nichols, 1854.

> Early history of world sculpture. Volume 2 (pp. 112-230)
> chronicles American sculpture. For early artists, Lee relies
> on Dunlap and tradition. Her own contemporaries are de-
> scribed by autobiographical letters; an acquaintance's memoir;
> a critic's review; or by Lee's own essay. Includes Ball, Hos-
> mer, Mills, and many others.

132 "Sculpture in America." By S.G.W. Benjamin. HARPERS MAGAZINE
58 (April 1879): 657-72. 16 illus.

A well-written, moderate nineteenth-century evaluation of the
development and promise of the sculptural arts in America.
Reflecting the opinions of the period, the author states that
"it is in imitations of the antique or allegory, and portraiture
and genre, that our sculpture has exerted its best efforts."

133* Thorpe, Margaret. THE LITERARY SCULPTORS. Durham, N.C.: Duke
University Press, 1965. x, 206 p. Illus.

Vivid reconstruction of the social and artistic milieu in the
American communities in Rome and Florence in the mid-nine-
teenth century. Brief characterizations of the women who
composed the "white marmorean flock." (Initially published
in the NEW ENGLAND QUARTERLY 32 [June 1959]: 149-
69.) Outlines the controversy concerning nude sculpture as
well as the search for truly American subject material. Chap-
ter devoted to the patronage system of nineteenth-century arts
in America. Selected bibliography (pp. 198-202).

134 Vassar College. Art Gallery. THE WHITE MARMOREAN FLOCK; NINE-
TEENTH CENTURY AMERICAN WOMEN NEOCLASSICAL SCULPTORS.
Poughkeepsie, N.Y.: 1972. [40]p. 37 illus. Paperback.

Catalog accompanying an exhibition of the marmorean (marble)
works of Foley, Hosmer, Lander, Lewis, Ream, Stebbins, and Whit-
ney. The introduction by William H. Gerdts, Jr. reviews the
accomplishments of the "flock"; their careers and their out-
standing works. Extensive three-page bibliography is very
similar to the bibliography in Gerdts's AMERICAN NEO-
CLASSIC SCULPTURE (see 123).

135 Vermeule, Cornelius III. "America's Neoclassic Sculptors; Fallen Angels
Resurrected." PROCEEDINGS OF THE MASSACHUSETTS HISTORICAL
SOCIETY 83 (1971): 28-33. Reprint. ANTIQUES 102 (November 1972):
868-75.

Introductory remarks on the influence and major works of
Greenough, Powers, Crawford, and Story.

Chapter 8

AMERICAN SCULPTURE IN THE LATE NINETEENTH AND EARLY TWENTIETH CENTURIES

After the Civil War the demand for commemorative public statuary greatly increased. Cast bronze, being more suitable to outdoor exposure, replaced marble as the popular medium. The accurate, realistic portraiture favored for these memorials was also facilitated by the use of bronze.

Paris became the stylistic and spiritual center for sculpture, and many American artists (Augustus Saint-Gaudens, Daniel Chester French, Frederick MacMonnies, G.G. Barnard) studied under French masters at the Ecole des Beaux-Arts. In the United States the National Sculpture Society was formed to provide an education for young sculptors and to promote, through exhibitions, the work of American sculptors (Paul Manship, Herbert Adams, Anna Hyatt Huntington, Karl Bitter). The society, located in New York City (see appendix of this bibliography), retained a strong artistic influence in the United States through the 1920s. Sculptors worked closely with architects throughout this period to produce, adorn, and embellish buildings. The 1893 Columbian Exposition was a major example of such fusion of talents. Reference works focusing especially on artists of this period are Fielding (see 30), INDEX OF TWENTIETH CENTURY ARTISTS (see 33), and Taft (see 83).

136 Adams, Adeline Valentine Pond. THE SPIRIT OF AMERICAN SCULPTURE. New York: Gilliss Press for the National Sculpture Society, 1923. 254 p. Illus.

> An informal history of American sculpture published for the opening of the National Sculpture Society's exhibition in 1923. Emphasis is on the sculptors who came to pre-eminence after the 1876 Columbian Exposition (Ward, Saint-Gaudens, French), and the early twentieth-century artists such as Manship, MacMonnies, and Adams. Dated in its outlook, but useful for the historical perspective it provides. Specifically discusses popular types of sculptures such as "The Statue and Bust," "Equestrian Statues," "Reliefs," and "Garden Sculpture."

137* Caffin, Charles Henry. AMERICAN MASTERS OF SCULPTURE. New York:

Doubleday, Page, 1903. Reprint. Freeport, N.Y.: Books for Libraries, 1968. 252 p. 32 illus. Index.

Brief appreciations of eleven American sculptors, most of whom looked to Paris for their inspiration. Includes Adams, Barnard, Bartlett, S.H. Borglum, V.D. Brenner, French, MacMonnies, C.H. Niehaus, Saint-Gaudens, Ward, and O.L. Warner.

138 Kohlman, Rena Tucker. "America's Women Sculptors." INTERNATIONAL STUDIO 76 (December 1922): 225-35. Illus.

Introduces the work of twenty American women sculptors of the early twentieth century. A small portfolio of their works is included.

139* McSpadden, Joseph Walker. FAMOUS SCULPTORS OF AMERICA. New York: Dodd, Mead & Co., 1924. Reprint. Freeport, N.Y.: Books for Libraries, 1968. 392 p. Illus.

Informal biographical sketches of Barnard, Bartlett, Borglum, Fraser, French, Hosmer, Huntington, MacNeil, MacMonnies, Rhind, Saint-Gaudens, Scudder, Vonnoh, Ward. Bibliography (pp. 369-77).

140 Partridge, William Ordway. "An American School of Sculpture." ARENA 7 (May 1893): 641-53.

By determining historically "what constitutes greatness in plastic art" and "what are the conditions which produce such greatness," Partridge enthusiastically predicts that one may "fully expect a great art era for America." Reflects the critics and artists of the late nineteenth century.

141* Proske, Beatrice Gilman. BROOKGREEN GARDENS SCULPTURE. New ed., rev. and enl. Brookgreen, S.C.: Brookgreen Gardens, 1968. 606 p. Illus. Index.

Twenty-two page introduction outlines the history of sculpture in America with particular emphasis on the late nineteenth and early twentieth century (the period which the Brookgreen Gardens has most actively collected). Informative biographical essays introduce the annotated catalog entries for each of the 176 sculptors represented at the Gardens. At least one work by each artist is illustrated. The extensive bibliography (pp. 513-44) includes material on individual artists (often quite minor) as well as general works.

142 Taft, Lorado. MODERN TENDENCIES IN SCULPTURE. Scammon Lectures for 1917. Chicago: University of Chicago Press for the Art Institute of Chicago, 1921. 178 p. Illus. Index.

After discussing Rodin and French and German sculpture, Taft

presents essays on Saint-Gaudens and on "Recent Tendencies in American Sculpture," i.e., Barnard, Bitter, French, etc. Taft's chatty, anecdotal essays reflect the biases and enthusiasms of his generation.

143 _____. "Women Sculptors of America." MENTOR 6 (1 April 1919): entire issue. Illus.

Brief introductions to numerous women sculptors. Taft's essay emphasizes Abastenia Eberle, Laura Gardin, Anna Hyatt Huntington, Evelyn Longman, Janet Scudder, Bessie Vonnah, and Nellie V. Walker.

Chapter 9

SURVEYS OF TWENTIETH-CENTURY AMERICAN SCULPTURE

Included in this chapter are surveys which attempt a history of more than one period of American twentieth-century art. Depending on the date of publication, the various authors characterize modern or twentieth-century art and describe the developments leading up to it. Material on the history of kinetic art and on constructivism is included here. Reference works of particular relevance to this chapter are: INDEX OF TWENTIETH CENTURY ARTISTS (see 33), and WHO'S WHO IN AMERICAN ART (see 43).

144* Andersen, Wayne [V.]. AMERICAN SCULPTURE IN PROCESS: 1930/1970. Boston: New York Graphic Society, 1975. ix, 278 p. Illus. Index.

In this pioneering survey, covering forty years of contemporary American sculpture, Andersen has identified and traced the contributions of over one hundred individual American sculptors. However, the chronological development of forms, aesthetics, and schools is emphasized rather than the careers of each artist. Specific chapters deal with sculpture in Chicago and in California. Also the role of sculpture in pop art, minimal art, earthworks, and process art is outlined. Most of the abundant (over 300) illustrations are in black and white. The large bibliography (pp. 261-72) contains a useful, although unannotated, list of exhibition catalogs and magazine articles dealing specifically with the concerns of the text. A listing of standard histories and studies of sculpture is also included.

145* Arnason, H. Harvard. A HISTORY OF MODERN ART; PAINTING, SCULPTURE, ARCHITECTURE. New York: Harry N. Abrams, [1968]. 663 p. Illus. Index.

International in scope, this well-illustrated introduction to modern art only briefly discusses American sculpture prior to 1945. However, more recent sculptural trends are summarized under such subheadings as "Abstract Sculpture," "Assemblages and Junk Sculpture," and "Primary Structures." Bibliography (pp. 631-43).

146* Ashton, Dore. MODERN AMERICAN SCULPTURE. New York: Harry N.
Abrams, [1967]. 54 p. 80 plates.

> Thoughtful discussion of contemporary sculpture as it has devel-
> oped in the United States from Archipenko, Lachaise, and
> Nadelman to Acton, Kipp, Paris, and Lye. The various
> styles and trends of recent sculpture are introduced and charac-
> terized; major artists of each movement are described. Beauti-
> ful, large illustrations, primarily in color, represent the work
> of over one hundred sculptors.

147 Baltimore Museum of Art. THE PARTIAL FIGURE IN MODERN SCULP-
TURE FROM RODIN TO 1969. Text by Albert E. Elsen. Baltimore:
1969. 114 p. 113 illus. Paperback.

> This book, published to accompany a large thematic exhibition
> in Baltimore, traces the origins, development, and significance
> of the partial human figure in modern sculpture. Elsen first
> discusses Rodin and his influence on an international group of
> artists, including Archipenko, Epstein, Lipchitz, and Lachaise.
> Work of the post-World War II era is represented mainly by
> American sculptors, from Hare and Roszak to Trova and Rivers.
> Bibliography (pp. 105-7) and notes.

148 Berckelaers, Ferdinand Louis [Seuphor, Michel]. THE SCULPTURE OF
THIS CENTURY; DICTIONARY OF MODERN SCULPTURE. Translated
from the French. New York: George Braziller, 1960. 372 p. Illus.
Index.

> The first part of this book is an informal overview of twentieth-
> century sculpture. The anecdotes and irreverent personal
> opinions emphasize the author's European/Parisian bias. One
> chapter, however, is devoted to American sculpture and
> another to Calder. The dictionary part of the book is an
> alphabetical listing of sculptors. Each paragraph-length entry
> provides biographical and bibliographical information. The
> general bibliography (pp. 353-55) lists major national surveys
> and exhibitions.

149* Burnham, Jack. BEYOND MODERN SCULPTURE; THE EFFECTS OF
SCIENCE AND TECHNOLOGY ON THE SCULPTURE OF THIS CENTURY.
New York: George Braziller, 1968. x, 402 p. Illus. Index.

> Analyzes the trends of contemporary international sculpture to
> illustrate its dependence on and interrelationship with the
> social, economic, and technical changes of this century.
> Burnham traces the disintegration of form, and the dissolution
> of faith in the traditional values of space, scale, and propor-
> tion. The aesthetic arguments are further developed in his
> STRUCTURE OF ART (see 211). Bibliographical footnotes
> (pp. 379-88).

150 Chipp, Herschel B., ed. THEORIES OF MODERN ART; A SOURCE
BOOK BY ARTISTS AND CRITICS. California Studies in the History of
Art, vol. 11. Berkeley and Los Angeles: University of California Press,
1968. 679 p. Illus. Index.

A valuable anthology of the "fundamental theoretical documents
of twentieth century art." Includes manifestos and artists'
statements from post-Impressionism to the contemporary scene.
Although largely European in outlook, the following American
sculptors are included: Baizerman, Ferber, Sydney Geist,
Oldenburg, Rickey, Roszak, D. Smith, Stankiewicz. "Selected
Bibliography of Artists' Writings and Theoretical Documents"
(pp. 627-51).

151 Davis, Douglas M. ART AND THE FUTURE: A HISTORY/PROPHECY OF
THE COLLABORATION BETWEEN SCIENCE, TECHNOLOGY AND ART.
London: Thames & Hudson, 1973. 208 p. Illus. Index.

Thorough review of the artistic projects which have been stimu-
lated by a collaboration between the sciences and the arts.
Numerous sculptors experimenting with such endeavors are dis-
cussed, from Duchamp to Sonfist. Extensive bibliography (pp. 195-
203) covers the diverse concerns of this text. Published in the
United States as ART INTO THE FUTURE (Praeger, 1973).

152* Giedion-Welcker, Carola. CONTEMPORARY SCULPTURE, AN EVOLU-
TION IN VOLUME AND SPACE. Documents of Modern Art, no. 12.
New York: George Wittenborn, 1955. 358 p. Illus. Index.

In this major work, Giedion-Welcker presents a careful analy-
sis of the nature of modern sculpture, its historic precedents,
its various forms, and its aesthetic rationale. The 1937 edi-
tion (MODERN PLASTIC ART) was substantially revised in 1955
to reflect new trends and styles. The largest section of the
book contains hundreds of photographs; the captions provide
essential, factual information and also attempt to characterize
an artist's work. Detailed biographies of the major sculptors
(pp. 257-83) are accompanied by portraits. The exemplary
bibliography by Bernard Karpel (pp. 285-324) is invaluable
for locating obscure source material on modern movements and
individual artists. Its coverage is unsurpassed.

153 Goldwater, Robert. WHAT IS MODERN SCULPTURE? New York:
Museum of Modern Art, 1969. Distributed by New York Graphic Society,
Greenwich, Conn. 148 p. 117 illus. Paperback.

Excellent introductory survey to the theories and the varieties
of modern sculpture. It focuses on the aesthetics of a few
individual works, each of which is illustrated on the adjacent
page. Minimal biographical and bibliographical information
(p. 147).

154 Goodrich, Lloyd, and Baur, John I.H. AMERICAN ART OF OUR CEN-
TURY. New York: Whitney Museum of American Art, 1961. 309 p.
Illus.

> Five chapters of this thirtieth anniversary publication deal
> specifically with sculpture in the Whitney Museum's collection.
> Goodrich outlines developments between 1910 and 1939. Baur
> discusses the traditional, expressionistic, and abstract sculptural
> forms which marked the 1940s and 1950s. A catalog of the
> collection (pp. 267-97) and an index by medium are provided.

155 Hunter, Sam. MODERN AMERICAN PAINTING AND SCULPTURE.
New York: Dell Publishing Co., 1959. 256 p. Illus. Index. Paper-
back.

> The standard introductory history of modern art until Hunter's
> AMERICAN ART (see 156) was published. The single chapter
> devoted to sculpture discusses Calder, Ferber, Hare, Lachaise,
> Lassaw, Lipton, Nadelman, Roszak, D. Smith, and Zorach.
> Biographical sketches for the principal artists. Glossary. Ex-
> tensive bibliography (pp. 221-49), prepared by Bernard Karpel,
> contains titles not in the later AMERICAN ART bibliography.

156* Hunter, Sam, and Jacobus, John. AMERICAN ART OF THE 20TH CEN-
TURY. Englewood Cliffs, N.J.: Prentice-Hall; New York: Harry N.
Abrams, 1973. (First published in 1972 by Abrams without Jacobus's chap-
ters on architecture.) 583 p. 988 illus. Index.

> The most thorough introductory survey of twentieth-century
> American painting, sculpture, and architecture. The first
> chapter to deal with sculpture presents Calder, Lassaw, Lip-
> ton, Nadelman, etc. The second one, "Recent Sculpture,
> Assemblage, Minimalism, and Earthworks," provides a detailed
> account of the development and rationale of the sculptural
> forms of the 1960s and 1970s. Excellent illustrations through-
> out the book support and extend the text. The extensive
> bibliographies (pp. 525-60), compiled by Bernard Karpel,
> Roberta P. Smith, and Nicole Sweedler Metzner, are an in-
> valuable reference tool, providing information on general
> movements as well as individual artists.

157 Kramer, Hilton. AGE OF THE AVANT-GARDE: AN ART CHRONICLE
OF 1956-1972. New York: Farrar, Straus & Giroux, 1973. 583 p.
Illus. Index.

> Collection of critical essays and reviews by an art critic for
> the NEW YORK TIMES. Kramer discusses Baizeman, Cornell,
> Frank, Hunt, King, Lachaise, Morris, Nevelson, Noguchi,
> Oldenburg, DeRivera, Segal, D. Smith, Storrs, DiSuvero, and
> Trova.

158 Nemser, Cindy. ART TALK: CONVERSATIONS WITH 12 WOMEN
 ARTISTS. New York: Charles Scribner's Sons, 1975. 381 p. Illus.

 The twelve women artists discuss their work and its critical
 reception by the art world. They also talk about their posi-
 tion as women and the impact of that position on their life
 and work. Sculptors included are Grossman, Hesse, Katzen,
 Marisol, and Nevelson. Selected bibliography (pp. 359-67).

159 Popper, Frank. ORIGINS AND DEVELOPMENT OF KINETIC ART.
 Translated from the French. Greenwich, Conn.: New York Graphic
 Society, 1968. 272 p. Illus. Index.

 Standard, scholarly history of kinetic art. Beginning with
 Impressionism, Popper is concerned with "movement in the
 work . . . and analysis of works in real movement." Inter-
 national in scope. Essential background material for a study
 of the topic. Bibliography (pp. 255-61).

160* Read, Herbert [Edward]. CONCISE HISTORY OF MODERN SCULPTURE.
 New York: Praeger Publishers, 1964. 310 p. Illus. Index.

 An introduction to modern sculpture which briefly summarizes
 the major movements and personalities. Strongly English and
 European in outlook. Abundantly illustrated for its small for-
 mat. Text references (pp. 279-82). Short bibliography
 (pp. 283-85).

161* Rickey, George. CONSTRUCTIVISM; ORIGINS AND EVOLUTION.
 New York: George Braziller, 1967. xi, 305 p. 160 illus. Index.

 A substantial history of the constructivist movement as it was
 defined by one of its major proponents, Vladimir Tatlin. In-
 cludes much of the art that preceded the "orthodox constructi-
 vist attitude" as well as the nonobjective art of the 1950s and
 1960s which evolved out of constructivism. In addition to
 abundant material on Gabo, the text discusses Archipenko,
 Calder, Duchamp, Kelly, Liberman, Lippold, Lye, Nevelson,
 Rickey, D. Smith, and Wilfred among others. Biographies.
 "Survey of Museum Holdings of Constructivist Art." Extensive
 824-item bibliography (pp. 247-300).

162 _____. "Morphology of Movement: A Study of Kinetic Art." ART
 JOURNAL 22 (Summer 1963): 220-31. Illus.

 Brief, concise text and ample illustrations introduce the many
 forms of kinetic art. Reprinted in a revised form in Gyorgy
 Kepes's NATURE AND ART OF MOTION (New York: George
 Braziller, 1965).

163* Ritchie, Andrew Carnduff. SCULPTURE OF THE TWENTIETH CENTURY.
New York: Museum of Modern Art, 1952. Reprint. New York: Arno
Press, 1972. 238 p. Illus.

> Catalog of an exhibition, international in scope, presenting
> the sculpture of the first half of the twentieth century. The
> introduction surveys the relationship between sculpture and
> painting. A statement by the artist often precedes the illus-
> tration of a work. Biographical notes. Bibliography by
> Bernard Karpel (pp. 233-37).

164* Rose, Barbara. AMERICAN ART SINCE 1900. Rev. and exp. ed.
New York: Praeger Publishers, 1975. 320 p. Illus. Index.

> Historical survey which is often used as an introductory text
> at the college level. The chapter dealing with sculpture has
> been substantially revised and expanded in the 1975 edition.
> Additional material can be found in the final chapter, "Into
> the 70's: Beyond the Object." Bibliography (pp. 289-92).

165* _____, ed. READINGS IN AMERICAN ART, 1900-1975. New York:
Praeger Publishers, 1975. 308 p. Index.

> An anthology of writings by American artists and critics which
> accompanies and documents the developments and changes dis-
> cussed and illustrated in Rose's AMERICAN ART SINCE 1900
> (see 164). The READINGS, significantly expanded and re-
> vised since Rose's READINGS IN AMERICAN ART SINCE
> 1900 (1968), include a great deal of material dealing with
> sculpture and its contemporary manifestations. The bibliog-
> raphy (pp. 277-300) is more extensive than that found in
> AMERICAN ART SINCE 1900. No illustrations.

166 Schnier, Jacques Preston. SCULPTURE IN MODERN AMERICA. Berke-
ley and Los Angeles: University of California,1948. ix, 224 p. Illus. Index.

> A survey of the major movements in sculpture of the first half
> of the twentieth century. Beginning with the work of Man-
> ship, Schnier discusses the renewed interest in carving, the
> increased awareness of materials, and the growing fascination
> with surrealism and expressionism. Not a strict chronological
> survey. Bibliography (pp. 65-67) includes a selection of
> titles dealing with European sculpture and with psychoanalysis.

Seuphor, Michel [pseud.]. See Berckelaers, Ferdinand Louis.

167 Seymour, Charles, Jr. TRADITION AND EXPERIMENT IN MODERN
SCULPTURE. Washington, D.C.: American University Press, 1949.
Reprint. New York: Arno Press, 1970. 86 p. Illus.

> Seymour attempts to articulate a "poetics of sculpture" by sur-

veying works from all cultures. Stressing the inherent ambiguity in such a literary definition he explores several specific traits which characterize sculpture.

168 Solomon R. Guggenheim Museum (New York). MODERN SCULPTURE FROM THE JOSEPH H. HIRSHHORN COLLECTION. Introduced by H.H. Arnason. New York: 1962. 246 p. Illus.

Illustrated catalog to accompany an exhibition of Hirshhorn's outstanding collection of modern sculpture. American sculpture is represented by some fine works of Lipchitz, Nadelman, and D. Smith among others. The exhibited works are documented and a biographical outline for each artist is included. "Selected Bibliography" (pp. 233-43) is primarily devoted to material on the individual sculptors. For the catalog of the entire Hirshhorn Collection (now a part of the Smithsonian Institution), see the appendix of this bibliography under District of Columbia.

169 Trier, Eduard. FORM AND SPACE; SCULPTURE OF THE TWENTIETH CENTURY. Rev. and enl. ed. Translated from the German FIGUR UND RAUM. London: Thames & Hudson, 1968. 339 p. 245 illus.

Although reflecting a European bias in the selection of illustrations and examples, Trier's discussion of sculptural form, meaning, and purpose is relevant for aesthetics of American sculpture. Not intended as a chronological history of sculpture. Illustrations are carefully coordinated with the text. Biographical index provides brief biographical and bibliographical notes about the sculptors represented.

170 Valentiner, Wilhelm Reinhold. ORIGINS OF MODERN SCULPTURE. New York: Wittenborn, Schultz, 1946. 195 p. Illus.

Thoughtful discussion of the historic patterns and precedents which shape modern sculpture. Chapters focus on the relationship of painter and sculptor, the theme of horse and rider, the "appeal to the sense of touch." The photographs echo the juxtapositions explored in the text. Not intended as a traditional history, but rather an attempt to articulate common characteristics of great sculpture and to express optimism regarding contemporary experimentation in sculpture. Index of artists.

171 Wilenski, Reginald H. THE MEANING OF MODERN SCULPTURE. New York: Stokes, 1935. 192 p. Illus. Index.

Argues for the recognition and appreciation of modern sculpture (1905-35) by clarifying sculpture's relationship to contemporary society and outlining its newer manifestations in a "Modern Sculptor's Creed." Comparisons are frequently made

between classical and modern sculpture in order to emphasize the strength of the new forms.

Chapter 10

DEVELOPMENT OF AMERICAN
PREEMINENCE IN SCULPTURE

The material in this chapter focuses on the half-century during which American sculpture became recognized as a unique and important facet of contemporary art. The influx of European talents (Jacques Lipchitz, Gaston Lachaise, Elie Nadelman, Alexander Archipenko), the encouragement provided by the Works Progress Administration, and the stimulus of the 1913 Armory show produced a unique climate of self-confident experimentation in the United States.

172 Agard, Walter R. THE NEW ARCHITECTURAL SCULPTURE. New York: Oxford University Press, 1935. 106 p. 42 illus. Index.

> International survey of contemporary sculpture used with archi-
> tecture or as free-standing memorials. One chapter deals ex-
> clusively with the United States; other American examples,
> however, can be located throughout the book by means of the
> artist and location indexes. Bibliography (p. 85).

173 AMERICAN SCULPTORS SERIES. 16 vols. National Sculpture Society, 1947-55.

> A series of small volumes documenting the work of leading
> sculptors. Primarily illustrations with brief biographical out-
> lines and occasionally a "Statement." Artists are: DeCreeft,
> DeLue, Fraser, French, Haseltine, Harris, Hoffman, Howard,
> Huntington, Jennewein, Lawrie, Manship, Saint-Gaudens,
> Waugh, Weinman, W. Williams.

174 Andersen, Wayne [V.]. "American Sculpture: The Situation in the Fifties." ARTFORUM 5 (June 1967): 60-67. Illus.

> Useful article for reviewing the diversity of styles and mate-
> rials found in sculpture of the 1940s and 1950s. Andersen
> explores the influence of surrealism and abstract expressionism
> on sculpture of the period.

175 ART SINCE MID-CENTURY; THE NEW INTERNATIONALISM. 2 vols. Greenwich, Conn.: New York Graphic Society, 1971. Illus. Index in each volume.

Volume 1: ABSTRACT ART SINCE 1945. Volume 2: FIGUR-
ATIVE ART SINCE 1945. A compilation of essays by critics
and historians which deals with the issues presented by the in-
ternational art scene. Lucy Lippard's article on the geometric
styles in America and Lawrence Alloway's essay on Johns and
Rauschenberg are most directly related to the sculptural con-
cerns of America. Each volume has a selection of brief art-
ist's statements.

176 Barr, Alfred Hamilton, Jr., ed. CUBISM AND ABSTRACT ART. New
York: Museum of Modern Art, 1936. 249 p. Illus.

Important exhibition catalog which surveys and analyzes the
development of cubism and abstract art in Europe. Includes
the early European work of Archipenko, Calder, Duchamp,
Lipchitz, Moholy-Nagy. Bibliography by Beaumont Newhall
(pp. 234-49).

177* Baur, John I.H. REVOLUTION AND TRADITION IN MODERN AMERI-
CAN ART. Library of Congress Series in American Civilization. Cam-
bridge, Mass.: Harvard University Press, 1951. x, 170 p. Illus. Index.

A standard text which attempts to trace major movements in
American painting and sculpture after the Armory show in
1913. Concluding chapters deal with the artist in society,
current trends, and what constitutes "American Art." Biblio-
graphical information in the "Notes" (pp. 159-60).

178 Brummé, C. Ludwig. CONTEMPORARY AMERICAN SCULPTURE. New
York: Crown Publishers, 1948. 156 p. 130 plates.

Important visual survey of the work of eighty-seven American
sculptors of the 1930s and 1940s. The brief text outlines the
modern characteristics which Brummé sought in his selection of
artists. Brief biographies. Pioneering bibliography (pp. 150-
56) includes material of an international scope and citations
of individual artists.

179 _____. "Contemporary Sculpture: A Renaissance." MAGAZINE OF
ART 42 (October 1949): 212-17. Illus.

Commends the sculpture which is a "free expression of social
and spiritual fervor, appealing for an apolitical humanism."
The abstract classicism of Noguchi, Dombek, Baizerman,
Lipchitz, and Roszak exemplify this humanist approach.

180 California. University at Santa Barbara. Art Galleries. 19 SCULPTORS
OF THE 40'S. Organized by Phyllis Plous. Santa Barbara: 1973.
107 p. Illus. Paperback.

Catalog of an exhibition which reviews the major sculptural

styles of the 1940s. Sixty-seven pages of photographs of the sculptures and drawings in the show. Brief biographical notes and lengthy bibliographies. Americans included are Baizerman, Calder, Cornell, DeRivera, Duchamp, Ferber, Lassaw, Lipchitz, Lippold, Noguchi, and D. Smith.

181 Casson, Stanley. SCULPTURE OF TO-DAY. New York: Studio Publications, 1939. 144 p. Illus.

Arranged thematically, this 112-page collection of photographs presents an international body of sculpture. Casson's essay, and the instructive captions, serve to educate the reader about the varieties of styles and materials found in sculpture of the 1930s. Americans included are Archipenko, Davidson, Lawrie, Manship, Orloff, and Zorach.

182 "Contemporary Sculptors." ART IN AMERICA 44 (Winter 1956/57): 9-40. Illus.

An issue composed of brief introductory articles on the work and aesthetics of leading American sculptors: Calder, Hare, Lippold, Lipton, Nash, Noguchi, Roszak, D. Smith, and Townley. The essays, prepared by noted scholars and critics, are amplified by illustrations of each sculptors's work.

183 Delaware Art Museum and the University of Delaware. AVANT-GARDE PAINTING AND SCULPTURE IN AMERICA, 1910-1925. Organized by William Innes Homer. Wilmington: Delaware Art Museum, 1975. 176 p. Illus. and portraits. Paperback.

This exhibition and scholarly catalog presents the work of fifty-six artists who were experimenting with "advanced" styles between 1910 and 1925. The essays, by graduate students and by Homer, indicate the extent to which American artists were immersed in European modernism, while pointing out the distinctly American traits found in their work. Each artist is documented with an essay, a portrait, an illustration of at least one work, and bibliographical references. The sculptors included are Michael Brenner, Flannagan, Lachaise, Laurent, Robus, Storrs, Alice Morgon Wright, and Zorach. Chronology of "Avant-Garde Art and Artists in America, 1900-1925" (pp. 162-65) and a "List of Exhibitions in New York, 1910-1925" included.

184* Geldzahler, Henry. NEW YORK PAINTING AND SCULPTURE: 1940-1970. New York: E.P. Dutton & Co. in association with the Metropolitan Museum of Art, 1969. 494 p. Illus.

Catalog for a monumental exhibition held to celebrate the Metropolitan's centennial. Geldzahler briefly summarizes the importance of the abstract styles of painting and sculpture

which are known as the New York school. The selections of contemporary criticism focus on issues related primarily to abstract painting. Numerous illustrations and biographical data for the forty-three artists. Selected bibliography provided for each artist (pp. 453-83).

185* Greenberg, Clement. ART AND CULTURE; CRITICAL ESSAYS. Boston: Beacon Press, 1961. 278 p. Index.

An important collection of Greenberg's writings which focuses on the art and literature of the twentieth century. Major essays on modern sculpture included are: "The New Sculpture" (from PARTISAN REVIEW, June 1949), "Modernist Sculpture, Its Pictorial Past," "David Smith," "Jacques Lipchitz," and "Collage."

186 _____. "Cross-breeding of Modern Sculpture." ART NEWS 51 (Summer 1952): 74-77 and following. Illus.

A widely discussed article which proposed that sculpture--long considered inferior to painting--was perhaps becoming vital enough to effect a reversal of status with painting. Greenberg traced, historically, the continual struggle of each medium to gain preeminence.

INDEX OF TWENTIETH CENTURY ARTISTS. 4 vols. October 1933-April 1937. Reprint. 1970.

See citation 33.

187 Kuh, Katharine. THE ARTIST'S VOICE: TALKS WITH SEVENTEEN ARTISTS. New York: Harper & Row, 1962. 248 p. Illus.

Perceptive interviews with such American sculptors as Calder, Duchamp, Lipchitz, Noguchi, and D. Smith. Short biographical outlines included.

Lucie-Smith, Edward. LATE MODERN: THE VISUAL ARTS SINCE 1945. 1969.

See citation 240.

188 Morris, George L.K. "Relations of Painting and Sculpture." PARTISAN REVIEW 10 (January/February 1943): 63-71. Illus.

Perceptive analysis of the traditional distinctions and increasing similarities of these two art forms, by one of the foremost apologists of abstract art.

New York. Museum of Modern Art.

In 1942, the Museum of Modern Art began a highly-respected

series of exhibitions, organized by Dorothy C. Miller, which featured contemporary American artists. The catalogs, all of which were published in New York by the Museum of Modern Art, are a unique and important reflection of American art between 1942 and 1963. Each artist is represented by several photographs and a "statement" by either the artist or a critic. Basic biographical material is included from 1956 on. The catalogs, with shortened bibliographic information, follow.

189 . AMERICAN REALISTS AND MAGIC REALISTS. New York: 1943. 67 p.

Entirely devoted to painting.

190 . AMERICANS, 1942. New York: 1942. 128 p.

Eighteen artists from nine states; none from New York City. Biographical data.

191* . AMERICANS, 1963. New York: 1963. 112 p.

Includes Bontecou, Chryssa, Higgins, Indiana, Kohn, Lekakis, Marisol, Oldenburg, Seley. Biographical data.

192* . 15 AMERICANS. New York: 1952. 47 p.

Includes Ferber, Kiesler, Lippold, Wilfred.

193* . FOURTEEN AMERICANS. New York: 1946. 80 p.

Includes Hare, Noguchi, Roszak.

194* . SIXTEEN AMERICANS. New York: 1959. Distributed by Doubleday, Garden City, N.Y. 96 p.

Includes Mallary, Nevelson, Rauschenberg, Schmidt, Stankiewicz. Biographical data.

195* . 12 AMERICANS. New York: 1956. Distributed by Simon & Schuster, New York. 96 p.

Includes Hague, Lassaw, Lipton, DeRivera. Biographical data.

196 New York World's Fair, 1939. AMERICAN ART TODAY. New York: National Art Society, 1939. 342 p. Largely illus.

Exhibition catalog which documents the work of artists from all over the United States. Short introductory essay by Holger Cahill captures the optimism which attended the organization of this exhibition. An index by medium is provided. Work by over 250 sculptors is illustrated, making this a useful

reference tool for obscure American sculptors of the 1930s. No biographical data.

197 O'Connor, Francis V., comp. ART FOR THE MILLIONS; ESSAYS FROM THE 1930'S BY ARTISTS AND ADMINISTRATORS OF THE WPA FEDERAL ART PROJECT. Greenwich, Conn.: New York Graphic Society. 1973. 319 p. Illus. Index.

An anthology of Works Progress Administration writings and visual material originally gathered in 1939 by Holger Cahill. The social position of the artist, the role of government in the arts, as well as specific commissions are discussed. Sculptors whose writings are included are Bufano, Cashwan, Gershoy, Gregory, Hord, Piccoli, and D. Smith. A "Who's Who Among the Authors and Artists" [mentioned in the book] and a selected bibliography (p. 309) are included.

198 _____, ed. NEW DEAL ART PROJECTS; AN ANTHOLOGY OF MEMOIRS. Washington, D.C.: Smithsonian Institution, 1972. ix, 339 p. Illus.

Includes "The New Deal Sculpture Projects" (pp. 133-52) by Robert Cronbach which describes the working conditions and projects of the Works Progress Administration sculptors. Largely reflects Cronbach's own experiences. Bibliography (pp. 330-31).

199 Pearson, Ralph M. THE MODERN RENAISSANCE IN AMERICAN ART, PRESENTING THE WORK AND PHILOSOPHY OF 54 DISTINGUISHED ARTISTS. New York: Harper & Row, 1954. 325 p. 187 illus.

Pearson enthusiastically searches for signs of a renaissance in the art work and writings of American artists connected with the modern movement. Sculptors included are Baizerman, Calder, DeCreeft, DerHarootian, Lux, Maldarelli, Robus, Scaravaglione, Umlauf, and Zorach.

200* Ritchie, Andrew Carnduff. ABSTRACT PAINTING AND SCULPTURE IN AMERICA. New York: Museum of Modern Art, 1951. Reprint. New York: Arno Press, 1970. 159 p. Illus.

This catalog, documenting a landmark exhibition, is a solid introduction to abstract art, its history, its social context, and the forms it took in America between 1913 and 1950. It is through painting that Ritchie defines abstract art, but his aesthetic analysis is relevant to sculpture as well. Twelve sculptors are included in the exhibition, each accompanied by a brief biography in the catalog. Pioneering bibliography by Bernard Karpel (pp. 156-59).

201 Rodman, Selden. CONVERSATIONS WITH ARTISTS. New York: Devin-Adair, 1957. 254 p. Photographs of the artists.

One chapter, "Sculptors of Space," includes interviews with Baskin, Calder, Lindsay Daen, Hare, James J. Kearns, Lipchitz, Rickey, and D. Smith.

202 Wheeler, Monroe. PAINTERS AND SCULPTORS OF MODERN AMERICA. New York: T.Y. Crowell, 1942. 152 p. Plates.

"A collection of confidences and opinions" of eighteen painters and ten sculptors, which were published in the MAGAZINE OF ART between 1939 and 1942. The statements of personal philosophy are accompanied by photographs of the artist's work. Sculptors include Ben-Shmuel, Richard Davis, Flannagan, Gross, Kreis, Ruby, Scaravaglione, Slobodkin, Warneke, and Zorach (who contributed a rather extensive life history).

203 Whitney Museum of American Art (New York). THE 1930'S; PAINTING AND SCULPTURE IN AMERICA. Organized by William C. Agee. New York: 1968. Distributed by Praeger, New York. [20]p. 85 illus. Paperback.

Agee's introduction to this exhibition catalog contends that the 1930s have been "grossly misunderstood, distorted and overgeneralized." Most of the eighty artists exhibited are painters. Sculptors included are Diller, Robus, and Storrs. Selected bibliography (three pages long).

Chapter 11

AMERICAN SCULPTURE SINCE 1960

After 1960 the definition of sculpture widened markedly--often including the three-dimensional forms of pop art (Claes Oldenburg) as well as the philosophical/linguistic analyses of conceptual art (Vito Acconci). However, the most important sculptural style of the sixties was minimal art, a reductive style which explored the properties of basic form (Sol LeWitt, Ronald Bladen, Donald Judd). Artists since 1960 have experimented with new materials such as light bulbs and neon tubes (Howard Jones, Dan Flavin, Chryssa, Stephen Antonakos); plastics (Craig Kaufmann, Tony Bell, Dewayne Valentine); and the earth itself (Robert Smithson). The content of recent sculpture ranges from the figurative (Duane Hanson, George Segal, Edward Kienholz, Marisol, Edward Trova) to the eccentric (H.C. Westerman, Joseph Cornell, Louise Bourgeois) to the aggressively nonobjective (Richard Serra, Robert Morris, Carl Andre, and other minimalists).

The material on happenings and on conceptual art has been grouped together in two separate sections at the end of this chapter.

204* Alloway, Lawrence. AMERICAN POP ART. New York: Collier Books, 1974. xii, 144 p. 104 illus. Index. Paperback.

> Catalog which accompanied the Whitney Museum of American Art's major pop art exhibition in 1974. Alloway's controversial essay strives to define the concerns and characteristics of the movement. The careers of Johns, Lichtenstein, Oldenburg, Rauschenberg, and Warhol are discussed in depth. Work by all seventeen exhibitors is illustrated. Lengthy bibliography (pp. 133-40) strives to be "critical rather than comprehensive" when including material about the individual artists.

205 "American Sculpture." ARTFORUM 5 (Summer 1967): entire issue. Illus.

> A special issue devoted exclusively to sculpture. Reviews the artists and the aesthetic issues presented in the 1967 exhibition at the Los Angeles County Museum of Art. Articles by fourteen major artists/critics, including Andersen, Michael Fried, LeWitt, and Robert Morris.

ART SINCE MID-CENTURY: THE NEW INTERNATIONALISM. 2 vols. 1971.

See citation 175.

206 ARTS YEARBOOK 8: CONTEMPORARY SCULPTURE. New York: Art Digest, 1965. 194 p. Illus. Paperback.

Photographs and essays survey the sculpture of the mid-1960s. Includes a panel discussion, "Where Do We Go From Here?" (Glaser, Kipp, Sugarman, Weinrib); sculptor Sidney Geist's "Color It Sculpture," and Donald Judd's "Specific Objects." Many profiles and interviews with leading artists.

207* Battcock, Gregory, ed. MINIMAL ART; A CRITICAL ANTHOLOGY. New York: E.P. Dutton & Co., 1968. 448 p. Illus. Index. Paperback.

Collection of twenty-eight of the best, most-cited, critical essays on minimal art. International in scope, the following important writings are included: David Bourdon, "The Razed Sites of Carl Andre"; Michael Fried, "Art and Objecthood"; Clement Greenberg, "Recentness of Sculpture"; Robert Morris, "Notes on Sculpture" (parts 1 and 2); Barbara Rose, "ABC Art"; Irving Sandler, "Gesture and Non-Gesture in Recent Sculpture"; and Willoughby Sharp, "Luminism and Kineticism."

208 _____, THE NEW ART; A CRITICAL ANTHOLOGY. New York: E.P. Dutton & Co., 1966. 254 p. Illus. Paperback.

A collection of critical essays on op and pop art and artists. Writings on Johns and the "cool" works of Robert Morris are especially relevant. Bibliographical footnotes.

209 Benthall, Jonathan. SCIENCE AND TECHNOLOGY IN ART TODAY. New York: Praeger Publishers, 1972. 180 p. Illus. Index.

A provocative, well-written attempt to analyze recent developments in the relationship between science/technology and the arts. Benthall is especially enthusiastic about the possibilities for photography, computer-generated art, and holography. He discusses critically the tenets behind kinetic sculpture. Few American artists included. Bibliography (pp. 170-73).

210 Bourdon, David. "E=mc^2 a go-go." ART NEWS 64 (January 1966): 22-25 and following. Illus.

An important critical article outlining the history and aesthetic similarities distinguishing the Park Place group of artists. DiSuvero, Forakis, Grosvenor, Magar, and Myers are the principal sculptors discussed.

211* Burnham, Jack. THE STRUCTURE OF ART. Rev. ed. New York: George Braziller, 1973. xii, 195 p. Illus. Index.

> Burnham explains the relevance of structural analysis in "bridging the gap between art analysis and the staggering variety of means by which art is expressed." These theoretical issues are intimately involved in the understanding of conceptual art. (Many of the theories are derived from linguistic analysis.) He uses structural analysis to discuss forty-three works of art (of all periods and styles). Bibliography (pp. 183-89).

212 Busch, Julia. A DECADE OF SCULPTURE: NEW MEDIA IN THE 1960'S. Philadelphia: Art Alliance Press, 1975. 54 p. 167 illus. Index.

> Not attempting a comprehensive survey, Busch "surveys the many directions in which sculptors of the 1960s have employed their art. Busch presents a modern definition of sculpture, noting that emphasis today may be on the conceptual or verbal, rather than visual. The photographs, comprising nearly two-thirds of the book, are commented upon by either the artist or the author; they illustrate the concerns of Busch's text. Selected bibliography (pp. 49-51).

213* Calas, Nicholas, and Calas, Elena. ICONS AND IMAGES OF THE SIXTIES. New York: E.P. Dutton & Co., 1971. 347 p. Illus. Index.

> A collection of critical essays analyzing aspects of the contemporary art scene, as well as many individuals. In addition to "The Phenomenological Approach," essays deal with Andre, Bladen, Chryssa, Cornell, DeMaria, Flavin, Grosvenor, Judd, Kienholz, LeWitt, Liberman, Mallary, Morris, Nevelson, Ossorio, D. Smith, T. Smith, Snelson, Vollmer, VonSchelgell.

214* California. University at Berkeley. Art Museum. DIRECTIONS IN KINETIC SCULPTURE. By Peter Selz. Berkeley and Los Angeles: 1966. 78 p. Illus. Paperback.

> An important catalog which documents the work of fourteen kinetic sculptors. Five Americans are included: Benton, Breer, Lye, Mattox, Rickey. George Rickey traces the history of kinetic sculpture. Extensive "Chronology of Kinetic Art, 1878-1965" (pp. 68-75) compiled by Brenda Richardson. Selected and annotated bibliography (pp. 77-78) as well as biographical and bibliographical data for each artist.

215 _____. FUNK. Organized by Peter Selz. Berkeley and Los Angeles: 1967. 60 p. Illus.

> An exhibition of fifty-eight works by twenty-six artists. Selz's "Notes on Funk" provide a concise, but interim, definition of

this West Coast sculptural style, its characteristics and its historical sources. Thirty-nine pieces are illustrated and biographies for all the artists are included.

216 California. University at Irvine. Art Gallery. ASSEMBLAGE IN CALIFORNIA; WORKS FROM THE LATE 50'S AND EARLY 60'S. Irvine: 1968. 59 p. 36 illus. Paperback.

Well-illustrated exhibition catalog documenting the work of Berman, Conner, Herms, Kienholz, Mason, and Talbert. Each artist is introduced by a noted critic and is often the subject of a brief biographical/bibliographical outline.

217 _____. FIVE LOS ANGELES SCULPTORS. Text by John Coplans. Irvine: 1966. 36 p. Illus. Paperback.

An exhibition of work by Bell, DeLap, David Gray, McCracken, and Price. Coplans stresses the individuality of each artist although all are working with the same basic, reduced elements. A biography, chronology, and selective bibliography provided for each artist. The catalog essay appeared in a "slightly altered form" in ARTFORUM 4 (February 1966).

218 "California Sculpture Today." ARTFORUM 2 (August 1963): entire issue.

Devoted to contemporary California sculpture. John Coplans discusses the developments of the previous decade. Joseph Pugliese details "Casting in the Bay Area." A "Portfolio of California Sculpture" (pp. 15-59) illustrates the work of over seventy artists. Brief biographical data and, occasionally, a statement by or about the artist is included.

219 Fried, Michael. "Art and Objecthood." ARTFORUM 5 (June 1967): 12-23. Illus.

An important, controversial statement by one of the leading critical theorists of minimal art. Fried identifies and characterizes the new interest in the object--which is seen as a "theater for the negation of art." The limits and possibilities of this theatricality are thoroughly discussed. Reprinted in Battcock's MINIMAL ART (see 207), pp. 116-47.

Geldzahler, Henry. NEW YORK PAINTING AND SCULPTURE: 1940-1970. 1969.

See citation 184.

220 Greenberg, Clement. "Recentness of Sculpture." ART INTERNATIONAL 11 (April 1967): 19-21. Illus.

Appearing originally in AMERICAN SCULPTURE OF THE SIX-

TIES (see 239), this essay questions the ability of minimal art to be the vanguard of the avant-garde. Reprinted in Battcock's MINIMAL ART (see 207), pp. 180-86.

221 The Hague. Gemeentemuseum. MINIMAL ART. Organized by Enno Develing. The Hague, Netherlands: 1968. 104 p. Illus. Paperback. Text in English and Dutch.

This was the first comprehensive showing of the work of Andre, Bladen, Flavin, Grosvenor, Judd, LeWitt, Morris, Tony Smith, Smithson, and Steiner. The show prompted a great deal of critical commentary and served as the touchstone for all future exhibitions of minimal art. Bibliographies and exhibition lists for each artist.

222 Harvard University. William Hayes Fogg Art Museum. RECENT FIGURE SCULPTURE. Cambridge, Mass.: 1972. 48 p. Illus. Paperback.

Reports on a recent trend by American sculptors to use the human figure as their model. Jeanne Wasserman's introduction characterizes this trend. The "Chronological Summary of the Criticism Received by Each Artist" provides an interesting gauge of the contemporary response to figurative art. Artists included are DeAndrea, Gallo, Grooms, Grossman, Hanson, Hitchcock, Jimenez, King, and Segal. References and selected bibliography (pp. 44-47).

223 Hudson, Andrew. "Scale as Content: Bladen, Newman, Smith at the Corcoran." ARTFORUM 6 (December 1967): 46-47. Illus.

Review of the three works constructed by Bladen, Barnett Newman, and Tony Smith for specific spaces at the Corcoran Gallery in Washington, D.C.

224 Hultén, Karl Gunnar Pontus. THE MACHINE, AS SEEN AT THE END OF THE MECHANICAL AGE. New York: Museum of Modern Art, 1968. Distributed by New York Graphic Society, Greenwich, Conn. 216 p. Illus.

Exhibition catalog demonstrating various attitudes held by artists concerning the machine. Hultén's comments on kinetic art are especially helpful. Among the Americans included are Calder, Duchamp, Kienholz, Oldenburg, and Stankiewicz. Bibliographical references throughout.

225 Jewish Museum (New York). PRIMARY STRUCTURES: YOUNGER AMERICAN AND BRITISH SCULPTORS. New York: 1966. [50]p. Illus. Paperback.

Catalog of the first exhibition to focus public attention on the new aesthetic sensibility which eventually became known as

minimal art. The work of thirty-one Americans and eleven
Britons are included in this historically important show. Intro-
duction by Kynaston L. McShine outlines the forms and the
issues involved in the new art. "Selective bibliography . . .
limited to an exhibition list for each artist and the major arti-
cles dealing with their common esthetic" (p. 46). An extend-
ed bibliography by Katherine Kline has been deposited in the
libraries of the Jewish Museum and the Museum of Modern
Art.

226 _____. RECENT AMERICAN SCULPTURE. Organized and introduced
by Hans Van Weeren-Griek. New York: 1964. 36 p. Illus. Paper-
back.

Catalog accompanying an important exhibition of the work of
Agostini, Bontecou, Chamberlain, DiSuvero, Segal, Stankiewicz
and Sugarman. The catalog provides biographical and biblio-
graphical documentation for each artist as well as an illustra-
tion of one work. Short analyses by noted critics introduce
each sculptor.

227 Judd, Donald. "Black, White, and Gray." ARTS MAGAZINE 38
(March 1964): 36-38. Illus.

Important review of the Black, White, and Gray exhibition
organized by Sam Wagstaff at the Wadsworth Atheneum (Hart-
ford, Conn.: 1964). Judd, a sympathetic artist/critic, gives
serious critical attention to the reductive and "impersonal"
attitudes common to all the works displayed (Flavin, Kelly,
Liberman, Morris, Rauschenberg, T. Smith, and Truitt).

228 Kozloff, Max. "American Sculpture in Transition." ARTS MAGAZINE 38
(May/June 1964): 19-25. Illus.

Kozloff focuses on the interdisciplinary direction being taken
by the artists exhibited at the Walker Art Center's Ten Ameri-
can Sculptors show in 1964. He closely examines the work of
Agostini, Mallary, Segal, Sugarman, and Weinrib to discover
a "muscular and physically or chromatically adventurous kind
of statement." Kozloff still senses, though, that the idioms
found in American sculpture are "eclectic reflections of what-
ever has already been put forth in painting."

229 _____. "Further Adventures of American Sculpture." ARTS MAGAZINE
39 (February 1965): 24-31. Illus.

Important essay which attempts to clarify new sculptural trends
by means of four classifying characteristics: (1) aesthetics of
sterility, (2) situation in wood, (3) boxes, and (4) environ-
mental-polychrome. The article reflects the tremendous revi-
val of interest in American sculpture of the mid-1960s.

230*	_____. RENDERINGS; CRITICAL ESSAYS ON A CENTURY OF MODERN ART. New York: Simon & Schuster, 1968. 352 p. Illus. Index.

Critical reviews, written between 1961 and 1968, which record the artistic developments of the 1960s. Specific articles on Kienholz, Oldenburg, D. Smith, and "Primary Structures."

231	Kramer, Hilton. "The Emperor's New Bikini." ART IN AMERICA 57 (January/February 1969): 48-55. Illus.

A combative, reactionary article which challenges the basis of minimal art and the "permissiveness" which has surrounded its success.

232	Krauss, Rosalind. "Sense and Sensibility: Reflections on Post '60's Sculpture." ARTFORUM 12 (November 1973): 43-53. Illus.

Delineates the motivations and aesthetics which are common to both the minimal and post-minimal artists of the 1970s. Going beyond a discussion of form, Krauss proposes that recent sculpture is "visualizations of a linguistic space that is fully nonpsychological."

233	Kultermann, Udo. NEW REALISM. Translated from the German. Greenwich, Conn.: New York Graphic Society, 1972. 44 p. 152 plates.

Summary review of the styles, subjects, and techniques contributing to the new realism trend. American sculptors discussed are DeAndrea, Graham, and Hanson. Artists' biographies and exhibitions list (pp. 39-42). General bibliography (pp. 43-44).

234	_____. THE NEW SCULPTURE: ENVIRONMENTS AND ASSEMBLAGES. Translated from the German. London: Thames & Hudson, 1968. 236 p. 387 illus.

A survey of contemporary American, European, and Japanese sculpture, which, by its text and organization, reflects contemporary concerns with self-image, the environment, "one's sense of space," and the untraditional use of materials. Very brief biographies. Bibliography (pp. 233-36) is based heavily on European sources.

235*	Lippard, Lucy [R.]. CHANGING; ESSAYS IN ART CRITICISM. New York: E.P. Dutton & Co., 1971. 320 p. Illus.

A collection of critical essays "about issues and problems in recent art, rather than formal descriptions and analyses." Written in 1966/67, the essays focus on minimal art "Rejective Art"; the "Dematerialization of Art"; and the genesis of "Eccentric Abstraction," i.e., the work of Bourgeois, Hesse, Westermann, among others.

236 _____. "New York Letter: Recent Sculpture as Escape." ART INTER-
NATIONAL 10 (February 1966): 48-58. Illus.

> In reviewing the New York shows, Lippard postulates that
> contemporary sculpture is providing "an escape to those who
> feel the limitations of painting are too great to be overcome."
> Citing the work of several minimalists, Lippard applauds the
> vitality and challenge evident in their work.

237* _____. POP ART. With contributions by Lawrence Alloway, Nancy
Marmer, and Nicholas Calas. New York: Praeger Publishers, 1966.
216 p. Illus. Index by artist.

> Standard survey of the pop art movement in Britain, the
> United States, and Europe. Marner discusses "Pop Art in
> California," Lippard covers "Pop Art in New York," and
> Calas analyzes "Pop Icons." Selected bibliography (pp. 206-
> 8).

238 _____. "Rejective Art." ART INTERNATIONAL 10 (October 1966):
33-36. Illus.

> An important essay which grapples with definitions, origins,
> and characteristics of the minimal aesthetic. Deals specifically
> with Andre, Judd, LeWitt, and Morris. Reprinted in Lippard's
> CHANGING (see 235), pp. 141-53.

239* Los Angeles County Museum of Art. AMERICAN SCULPTURE OF THE
SIXTIES. Organized by Maurice Tuchman. Los Angeles: 1967. 258 p.
including 174 p. of illus.

> Illustrated book-catalog documenting one of the most important
> sculpture exhibitions of the century. The 166 artists represent
> a variety of styles and orientations. Ten noted critics (Law-
> rence Alloway, Wayne V. Andersen, Dore Ashton, John Cop-
> lans, Clement Greenberg, Max Kozloff, Lucy Lippard, James
> Monte, Barbara Rose, and Irving Sandler) comment on aspects
> of the exhibition and on the sculpture of the sixties in gen-
> eral. Statements by the artists. General bibliography (pp.
> 236-39). Biographies and bibliographies for each artist (pp.
> 240-56).

240 Lucie-Smith, Edward. LATE MODERN; THE VISUAL ARTS SINCE 1945.
New York: Praeger Publishers, 1969. 288 p. Illus. Index.

> In the final three chapters of this post-World War II survey,
> the development of European and American sculpture is out-
> lined. Major artists are discussed and styles are introduced.
> Characterizing the "new sculpture" as one which "springs from
> wholly different premises" than sculpture created immediately
> after the war, Lucie-Smith attempts to clarify the influences
> leading to such a change and to describe its aesthetic ration-

ale. A chapter on "Environments" completes the material on sculptural forms. Bibliography (pp. 275-77).

241 Milwaukee Art Center. DIRECTIONS 1: OPTIONS 1968. Milwaukee: 1968. 85 p. 61 illus. Paperback.

Catalog for an exhibition, which traveled to the Museum of Contemporary Art, Chicago, requiring spectator participation in some form. The work of such artists as Andre, Katzen, and Smithson is discussed by Lawrence Alloway in his perceptive introduction (printed also in ART AND ARTISTS 4, October 1967). Artists' statements (pp. 75-77). Biographies of the sixty-six artists in the exhibition (pp. 78-83).

242 Morris, Robert. "Anti-form." ARTFORUM 6 (April 1968): 33-35. Illus.

A leading artist/critic discusses contemporary sculpture which takes its form and meaning from the properties of materials used (such as the earth) and the forces of the environment (such as the tides).

243 _____. "Notes on Sculpture." ARTFORUM 4 (February 1966): 42-44; 5 (October 1966): 20-23; "Notes and Nonsequiturs," 5 (June 1967): 24-29; "Beyond Objects," 7 (April 1969): 50-54. Each part illus.

Influential series of essays presenting the issues involved in contemporary sculpture (such as size, scale, location, process, etc.) Morris, one of the foremost sculptor/critics, delineates important characteristics of a new sculptural aesthetic. Parts 1 and 2 are reprinted in Battcock's MINIMAL ART (see 207).

244* Müller, Grégoire. THE NEW AVANT-GARDE; ISSUES FOR THE ART OF THE SEVENTIES. Photographs by Gianfranco Gorgoni. New York: Praeger Publishers, 1972. 177 p. Illus. Paperback.

Investigates the new directions being taken in art by focusing on the work and thoughts of an international group of artists which includes Andre, Beuys, DeMaria, Flavin, Heizer, LeWitt, Merz, Morris, Nauman, Serra, Smithson, and Sonnier. In a brief theoretical introduction, Müller contends that "art as a language" has been replaced by "art as a phenomenon." Excellent photographs document some of the phenomena.

245 Piene, Nan R. "Light Art." ART IN AMERICA 55 (May/June 1967): 24-47. Illus.

Survey of contemporary artists who use light as their dominant medium, including Antonakos, Billy Apple, Chryssa, Flavin, and Howard Jones. Piene's essay explores historical antecedents, current manifestations, and future possibilities of such work.

246 Rose, Barbara. "ABC Art." ART IN AMERICA 53 (October/November 1965): 57-69. Illus.

Important critical essay explaining how and why artists such as Andre, Bladen, Flavin, Judd, Kipp, and Morris are "glorifying the minimal" and rejecting the "emotionalism of abstract expressionism." Includes several statements by the artists. Reprinted in Battcock's MINIMAL ART (see 207) pp. 274-97.

247 _____. "Blow-Up: The Problem of Scale in Sculpture." ART IN AMERICA 56 (July/August 1968): 80-91. Illus.

Poses critical questions regarding the ability of small, intimate sculptures to be enlarged to monumental size. The second half of the article describes the unique, artist-oriented Lippincott, Inc.--a Connecticut factory specializing in the fabrication of sculpture.

248 Russell, John, and Gablik, Suzi. POP ART REDEFINED. London: Thames & Hudson, 1969. 240 p. Illus. Index.

"This book is intimately related to the exhibition of Pop art which we . . . organized for the Arts Council of Great Britain. . . . It aims to redefine the areas in which Pop made a unique contribution; and it sees Pop in terms of formal ideas." Critical statements by Lawrence Alloway, John McHale, and Robert Rosenblum precede the artists' statements. Artists included are Brecht, Dine, Kienholz, and Oldenburg, among others.

249* Seitz, William C. THE ART OF ASSEMBLAGE. New York: Museum of Modern Art, 1961. Distributed by Doubleday, Garden City, N.Y. 176 p. Illus. Index.

Important catalog to accompany a major exhibition of collage and "found-object" art. International in scope; the Americans included are Bontecou, Chamberlain, Cornell, Duchamp, Kienholz, Marisol, Nevelson, Rauschenberg, Samaras, Seley, D. Smith, Stankiewicz, and Westermann. Minimal biographical information. A "Working Bibliography" (pp. 166-73) by Bernard Karpel.

250* Selz, Peter H. NEW IMAGES OF MAN. New York: Museum of Modern Art, 1959. Distributed by Doubleday, Garden City, N.Y. 159 p. Illus.

This catalog is considered a turning point in the evaluation of the human form in painting and sculpture. The fragmented, dehumanized forms of Baskin, Campoli, Roszak, and Westermann represent the American aspects of this new image. A statement from each artist and a brief criticism of his work

accompany the illustrations. Selected bibliography by Ilse Falk (pp. 155-59).

251 Sharp, Willoughby. AIR ART. New York: Kineticism Press, 1968. 36 p. Illus. Paperback.

> Catalog of a traveling exhibition (first displayed at the YM/ YWHA in Philadelphia) which presents the possible "forms" of air art. The works of eleven artist/groups (including Levine, Morris, Warhol) are described and biographical/bibliographical data are provided for each.

252 _____. "Luminism and Kineticism." In MINIMAL ART, edited by Gregory Battcock (see 218), pp. 317-58. Illus.

> Containing excerpts from several sources, this essay explains the historical and theoretical basis of both media. Full footnotes are useful as a bibliography.

253 Smithson, Robert. "Entropy and the New Monuments." ARTFORUM 4 (June 1966): 26-31. Illus.

> Important essay which identifies, in the work of Judd, LeWitt, and Morris, an acceptance of the inevitability of entropy. Smithson sees their "minimal" works as an attempt to nullify the role of time, space, movement, etc., in order to explore other dimensions.

254 Spear, Athena [T.]. "Sculptured Light." ART INTERNATIONAL 11 (December 1967): 29-49. Illus.

> A scholarly, historical essay which surveys the range and importance of visual effects introduced into the art of the twentieth century--effects such as reflection, transparency, and refraction. Beginning with Rodin and continuing through the most recent luminous projections and programmed light, Spear deals mainly with European artists and movements. However, Antonakos, Arman, Chryssa, Flavin, Levine, Lye, Moholy-Nagy, Samaras, and Weinrib are included. Footnotes provide bibliographical guidance.

255 Walker Art Center (Minneapolis, Minn.). EIGHT SCULPTORS; THE AM-BIGUOUS IMAGE. Minneapolis: 1966. 40 p. Illus. Paperback.

> Catalog for an exhibition in which the "artists have an aesthetic of ambiguity and detachment in common." Martin Friedman comments critically on the work of Judd, Morris, Samaras, and Westermann. Jan Van der Marck carefully reviews the work of Christo, Oldenburg, Segal, and Trova. Biography and bibliography for each artist.

256 _____. FIGURES/ENVIRONMENTS: ALEX KATZ, RED GROOMS, JANN HAWORTH, DUANE HANSON, PAUL THEK, LYNTON WELLS, GEORGE SEGAL, ROBERT WHITMAN. Minneapolis, Minn.: 1970. 43 p. Illus. Paperback.

Catalog for an exhibition which traveled to Cincinnati and Dallas. Martin Friedman's introductory essay is on Grooms, Hanson, Segal, Wells, and Whitman. Essays on Haworth, Katz, and Thek are by Dean Swanson. Biographies and bibliographies for each artist (pp. 34-41).

257 _____. 14 SCULPTORS; THE INDUSTRIAL EDGE. Minneapolis, Minn.: 1969. 53 p. Illus. plus 14 loose plates in pocket. Paperback.

Important exhibition catalog, both for the work included (sculpture which uses "industrial materials--glass, metal, plastic") and for the theoretical/critical essays by Barbara Rose, Christopher Finch, and Martin Friedman. Friedman's intelligent discussion of each artist is reprinted in ART INTERNATIONAL 14 (February 1970). The fourteen sculptors in the exhibition are Alexander, Bell, Bladen, Grosvenor, Hudson, Judd, Kauffman, Kelly, Morris, Murray, Randell, Stone, Valentine, and Weinrib. Good general bibliography (pp. 46-48) in addition to a bibliography for each artist (pp. 49-53).

258 Washington Gallery of Modern Art. A NEW AESTHETIC. Text by Barbara Rose. Washington, D.C.: 1967. 63 p. Illus. Paperback.

Catalog for an exhibition of the works of Bell, Ron Davis, Flavin, Judd, Kauffman, and McCracken which attempts "to define the unique relationship these works bear to conventional painting and sculpture . . . which gives them their identity as the bearers of a new aesthetic attitude." Each artist is documented by a critical commentary, a personal statement, an exhibition list, a biographical outline, and a selected bibliography.

259 Whitney Museum of American Art (New York). HUMAN CONCERN/ PERSONAL TORMENT; THE GROTESQUE IN AMERICAN ART. Organized by Robert Doty. New York: Praeger Publishers for the Whitney Museum, 1969. [78]p. Chiefly illus.

A wide variety of styles and concerns are represented in this exhibition. Among the eighty-seven artists included are Arneson, Baskin, Berlant, Connor, Grossman, Hanson, Kienholz, Mallary, Paris, Samaras, D. Smith, Thek, and Trova. In his introductory essay, Doty attempts to explain the cultural and social needs which this vividly expressive art fulfills--especially in the twentieth century. Two-page selected bibliography.

260 _____. LIGHT: OBJECT AND IMAGE. Organized by Robert Doty. New York: 1968. 28 p. Illus. Paperback.

Catalog for a traveling exhibition. Artists included are Antonakos, Flavin, Jones, Landsman, McClanahan, and Mefferd. Exhibition list and bibliography for each artist.

HAPPENINGS

261 Henri, Adrian. TOTAL ART: ENVIRONMENTS, HAPPENINGS, AND PERFORMANCE. New York: Praeger Publishers, 1974. 216 p. Illus. Index.

A survey of artistic forms which attempt to integrate the viewer and the art object. Historical and thematic discussions clarify this recent movement. Brief but useful bibliographical notes and bibliography (p. 208).

262* Kaprow, Allan. ASSEMBLAGE, ENVIRONMENTS, & HAPPENINGS. New York: Harry N. Abrams, 1966. 341 p. Oversized. Illus.

The text (pp. 146-208) characterizes and clarifies the forms of this short-lived art movement. Written with the authority of an originator and a participant, Kaprow's essay is essential to an understanding of happenings. (Part of the essay is reproduced in ARTFORUM 4, March 1966.) Profuse black-white photographs illustrate the wide variety of experimentation in these art forms, as well as the enactment of several happenings. A selection of scenarios complement those published in Kirby's HAPPENINGS (see 265).

263 Kirby, Michael. ART OF TIME; ESSAYS ON THE AVANT-GARDE. New York: E.P. Dutton & Co., 1969. 255 p. Paperback.

Analyzes the interrelationships between theater, dance, and sculpture. Kirby stresses the necessity of interdisciplinary explorations in generating creative activity.

264 _____, ed. "Happenings." DRAMA REVIEW (Tulane University, New Orleans) 10 (Winter 1965). 247 p. Illus.

This issue on happenings contains significant articles by Cage, Higgins, Robert Morris, Oldenburg, LeMonte Young, the Fluxus group, and others.

265* _____. HAPPENINGS, AN ILLUSTRATED ANTHOLOGY. New York: E.P. Dutton & Co., 1965. 287 p. Illus.

An anthology of scripts, productions, and statements by Dine, Grooms, Kaprow, Oldenburg, and Whitman. The lengthy introduction attempts to trace the origins of happenings. A basic reference source. Bibliographical footnotes.

266* Kostelanetz, Richard. THE THEATER OF MIXED MEANS. New York:

Dial Press, 1968. 330 p. Illus. Index.

"An introduction to happenings, kinetic environments, and other mixed-means performances." Includes conversations with Kaprow, Oldenburg, Rauschenberg, and others, as well as a discussion of critical values relevant to the "Theater of Mixed Means." A very useful bibliography (pp. 291-301) lists statements, essays, and scripts by the artists.

Kultermann, Udo. THE NEW SCULPTURE: ENVIRONMENTS AND ASSEMBLAGES. 1968.

See citation 234.

CONCEPTUAL ART

267* Battcock, Gregory, ed. IDEA ART; A CRITICAL ANTHOLOGY. New York: E.P. Dutton & Co., 1973. xii, 203 p. Paperback.

Anthology of critical essays surveying conceptual art, earthworks, and body art by such authors as Dore Ashton, Jack Burnham, Joseph Kosuth, and Ursula Meyer. Examples of "art documentation" are provided by Lawrence Weiner, Daniel Buren, Mel Bochner, and Sol LeWitt. Strongly negative criticism by Robert Hughes is countered by Les Levine.

268 Bern. Kunsthalle. WHEN ATTITUDES BECOME FORM: LIVE IN YOUR HEAD. Bern, Switzerland: 1969. 180 p. Illus. Looseleaf notebook.

A landmark exhibition which focused on the international variety of "works, concepts, processes, situations and information" which express contemporary artistic positions. Introductory essays by Harald Szeeman (in German), Scott Burden (in English), Grégoire Müller (in French), and Tomaso Trini (in Italian). Alphabetically arranged fact sheets on each of the sixty-nine artists provide biographical/bibliographical information; lists of exhibitions; and, often, documentation on the work displayed/executed for the Bern show. Among the Americans included are Andre, Artschwager, Bochner, Bollinger, Ferrer, Hesse, Kienholz, LeWitt, Nauman, Tuttle, and Weiner. General bibliography (one-page). A slightly different catalog was issued for the same exhibition in London (at the Institute of Contemporary Arts in 1969). Szeeman's essay was translated, and an essay by Charles Harrison was added, for the British edition.

269 Burnham, Jack. "Alice's Head: Reflections on Conceptual Art." ARTFORM 8 (February 1970): 37-43. Illus.

Philosophical analysis of conceptual art; its basic motives and its historical development.

_____. THE STRUCTURE OF ART. 1973.

See citation 211.

270 Celant, Germano. ART POVERA. New York: Praeger Publishers, 1969.
 240 p. Illus.

 A compilation, international in scope, of photographs, written
 documents, and work by conceptual artists such as Barry, De-
 Maria, Heizer, Hesse, Huebler, Kaltenbach, Kosuth, Robert
 Morris, Nauman, Oppenheim, Serra, Smithson, Sonnier,
 Walther, and Weiner. Provides the beginnings of a defini-
 tion of conceptual art.

271 Cornell University. Andrew Dickson White Museum of Art. EARTH ART.
 Ithaca, N.Y.: 1970. [44]p. Illus. Paperback.

 Catalog documenting the informal symposium held at Cornell
 at the time of the pioneering earth art exhibition (February
 1969). "Notes toward an Understanding of Earth Art" by
 Willoughby Sharp outlines the history, characteristics, and
 aesthetics of this art form. William C. Lipke discusses the
 position of earth art in contemporary criticism. Six Americans
 are included: Jenny, Richard Long, David Medalla, Morris,
 Oppenheim, Smithson. Extensive six-page selected bibliog-
 raphy. Eleven pages of biographical data.

272 LeWitt, Sol. "Paragraphs on Conceptual Art." ARTFORUM 5 (June
 1967): 79-83. Illus.

 Important statement clarifying the basis and the concerns of
 conceptual art by one of its most articulate practitioners.

273* Lippard, Lucy [R.], ed. SIX YEARS: THE DEMATERIALIZATION OF
 THE ART OBJECT FROM 1966 TO 1972: A CROSS REFERENCE BOOK
 OF INFORMATION ON SOME ESTHETIC BOUNDRIES. New York:
 Praeger Publishers, [1973]. 272 p. Illus. Index. Paperback.

 A unique type of bibliography and list of events, arranged
 chronologically, which reflects a "gradual de-emphasis on
 sculptural concerns" and concentrates "increasingly on textual
 and photographic work." "The form of the book intentionally
 reflects chaos rather than imposing order" on the variety of
 phenomena known as process, conceptual, serial, demateriall-
 ized art. In addition to listing publications and events, Lip-
 pard often comments on the importance or meaning of a specif-
 ic object. The index is essential when trying to trace infor-
 mation about a particular artist.

274 Lippard, Lucy [R.], and Chandler, John. "The Dematerialization of Art."
 ART INTERNATIONAL 12 (February 1968): 31-36. Illus.

Clear and intelligent explanation of the trends toward non-
material, process, serial, and conceptual art. Reprinted in
Lippard's CHANGING (see 235), pp. 255-76.

275* Meyer, Ursula, comp. CONCEPTUAL ART. New York: E.P. Dutton
& Co., 1972. 247 p. Illus. Index. Paperback.

An anthology of writings or pieces by forty-one conceptual
artists. Meyer clarifies the intent of the more obscure state-
ments and outlines the concerns of the entire movement. Bib-
liography (pp. 223-27).

276 Morris, Robert. "Some Notes on the Phenomenology of Making: The
Search for the Motivated." ARTFORUM 8 (April 1970): 62-66. Illus.

Explains the aesthetic principles underlying process art, i.e.,
art which is defined as the action taken on an object.

277 New York. Museum of Modern Art. INFORMATION. Edited and intro-
duced by Kynaston L. McShine. New York: 1970. 207 p. Illus.

This book-catalog is an "international report on the activity of
younger artists" which helps to identify the dimensions of con-
ceptual art. Each of the ninety-six artists "created his own
contribution to this book; [hence] the book is essentially an
anthology and is considered a necessary adjunct to the exhibi-
tion." A partial listing of "films that reflect the concerns and
attitudes of the artists represented in the exhibition" (pp. 193-
99). "Recommended Reading" (pp. 200-205) compiled by Jane
Necol.

278 Whitney Museum of American Art (New York). ANTI-ILLUSION:
PROCEDURES/MATERIALS. New York: 1969. 61 p. Illus. Paperback.

A major exhibition of objects, environments, music, films, etc.,
by twenty-one artists. The show reflects contemporary interest
in process art. Essays by James Monte and Marcia Tucker
clarify the issues and discuss individual artists. Includes the
work of Asher, Bollinger, Ferrer, LeVa, Morris, Nauman,
Ryman, Tuttle. Biographical bibliography for each of the art-
ists (pp. 52-59). General bibliography (pp. 60-61).

Section III

INDIVIDUAL SCULPTORS

Section III

INDIVIDUAL SCULPTORS

This section provides basic bibliographic information on 219 American sculptors. The Key to Abbreviations includes books and catalogs which have extensive bibliographies relevant to more than one artist. Throughout the following section one will be directed to the titles in the key to find further bibliographic material.

ACCONCI, VITO 1940-

279 AVALANCHE, no. 6 (Fall 1972). 79 p. Index.

> The complete issue devoted to a survey of Acconci's performance pieces--documented by photographs and described by the artist. Excerpts from tapes with Liza Béar provide the only detached, evaluative commentary (pp. 70-77).

280 "Drifts and Conversations by Vito Acconci." AVALANCHE, no. 2 (Winter 1971), pp. 82-95. Illus.

> Brief commentaries prompted by photographs of various body performances. Followed by "A Discussion with Acconci, Fox, and Oppenheim" (pp. 96-99).

281 Nemser, Cindy. "An Interview with Vito Acconci." ARTS MAGAZINE 45 (March 1971): 20-23. Illus.

> Acconci explains his aesthetics in terms of specific works and events. Photographs from his 1970 film "Openings" and other pieces.

282 Pincus-Witten, Robert. "Vito Acconci and the Conceptual Performance." ARTFORUM 10 (April 1972): 47-49. Illus.

> Analyzes the origins and meanings of the conceptual performance, concluding that it is conducted "in a virtually autistic vacuum" and "remains as elitist and infra-referential as Duchamp."

ACTON, ARLO 1933-

283 Leider, Philip. "Three San Francisco Sculptors." ARTFORUM 3 (September 1964): 36-37. Illus. of 4 works.

> Works by three sculptors (Acton, Robert Hudson, and Melvin Moss) are illustrated. A list of exhibitions for each artist included.

Further bibliography: Tuchman (see 239).

ADAMS, HERBERT 1858-1945

284 "Herbert Adams." PAN-AMERICAN UNION BULLETIN 45 (July 1917): 93-104. 10 illus.

> Describes the artistic achievements of Adams's career; includes brief biographical information.

285 Peixotto, Ernest. "The Sculpture of Herbert Adams." AMERICAN MAGAZINE OF ART 12 (May 1921): 151-59. Illus.

> An appreciative description of several of Adams's major works. Biographical details.

Further bibliography: Brookgreen (see 141).

AGOSTINI, PETER 1913-

286 Goldstein, Carl. "Peter Agostini's Heads." ART INTERNATIONAL 18 (January 1974): 24-25. Illus.

> Reviewing a gallery exhibition, Goldstein characterizes and praises the qualities he finds in these works done between 1971 and 1973.

287 Kozloff, Max. "New York Letter: Agostini." ART INTERNATIONAL 6 (September 1962): 33-35. Illus.

> Kozloff analyzes the appeal of Agostini's work--discussing the impact of the material (white plaster) and the artist's use of subject matter.

Further bibliography: Hirshhorn (see 168); Recent Am. (see 226); Tuchman (see 239).

AKERS, BENJAMIN PAUL 1825-61

288 Cary, Richard. "The Misted Prism: Paul Akers and Elizabeth Akers

Allen." COLBY LIBRARY QUARTERLY, series 7 (March 1966): 193-226. Illus.

> An account, based on Mrs. Allen's papers, of her short marraige to Akers. Reveals Mrs. Allen's preoccupation with money.

289 Miller, William B. "A New Review of the Career of Paul Akers, 1825-1861." COLBY LIBRARY QUARTERLY, series 7 (March 1966): 227-55. Illus.

> Using the Akers papers, which are housed at Colby College (Waterville, Maine), Miller reconstructs a revised version of Akers's life and career. Documentary material throughout. "Catalogue of Works by Paul Akers" (pp. 253-55). Bibliographical footnotes.

290 Tuckerman, Henry Theodore. "Two of Our Sculptors: Benjamin Paul Akers and Edward Sheffield Bartholomew." HOURS AT HOME 2 (April 1866): 525-32.

> In the extremely florid prose of the late nineteenth century, Tuckerman describes the life and work of both of these noted expatriot sculptors. Akers's personality and physical appearance are described and a few paragraphs from his writings on art are excerpted.

Further bibliography: Craven (see 60); Gerdts-Neoclassic (see 123).

ALEXANDER, PETER 1939-

291 California. University at Los Angeles. Art Galleries. TRANSPARENCY, REFLECTION, LIGHT, SPACE: FOUR ARTISTS. Los Angeles: 1971. 140 p. Illus.

> An exhibition arranged by Peter Alexander, Larry Bell, Robert Irwin, Craig Kauffman. Alexander is interviewed by Frederick S. Wight about his work and aesthetics (pp. 9-39). A brief biographical outline, list of exhibitions, and bibliography accompany the interview.

292 Plagens, Peter. "The Sculpture of Peter Alexander." ARTFORUM 9 (October 1970): 48-51. Illus.

> Five works by this Los Angeles sculptor are illustrated and discussed. Plagens is especially interested in Alexander's use of color and transparency.

ANDERSON, JEREMY 1921-

293 San Francisco Museum of Art. JEREMY ANDERSON. San Francisco:

1966. 48 p. Illus. Paperback.

Catalog of an exhibition which traveled to Pasadena Art Museum in 1967. Introductory essay by Gerald Nordland outlines Anderson's life and work, analyzing the sources for the many symbolic, surrealistic, and primitive elements in his work. Biographical chronology. Excellent photographs of the sculpture and drawings. Selected bibliography.

Further bibliography: Tuchman (see 239).

ANDRE, CARL 1935-

294 "Carl Andre." AVALANCHE, no. 1 (Fall 1970), pp. 18-27. Illus.

An interview, conducted in December of 1968, in which Andre "clarifies the nature of his relationship to earth-oriented sculpture."

295 The Hague. Gemeentemuseum. CARL ANDRE EXHIBITION. The Hague, Netherlands: 1969. 64 p. Illus. Paperback. Text in English and Dutch.

Major one-man exhibition including works from 1959 to 1969. Andre comments on his work, its place in the world, his materials, etc. Letter from Hollis Frampton, a friend, relates Andre's early experimentations (before 1964). List of exhibitions. Bibliography (pp. 60-62).

296 Solomon R. Guggenheim Museum (New York). CARL ANDRE. Exhibition and catalog by Diane Waldman. New York: 1970. 83 p. Illus. Paperback.

Important catalog in which Waldman critically evaluates the artist's development in relationship to the minimal and conceptual trends of the 1960s. Bibliography reflects the broad scope of the essay (pp. 77-81).

297 Tuchman, Phyllis. "An Interview with Carl Andre." ARTFORUM 8 (June 1970): 55-61. 12 illus.

Interview focuses on Andre's determination of a work's location, arrangement, color, scale, etc.

Further bibliography: Tuchman (see 239); Whitney, 200 YEARS (see 86).

ANDREA, JOHN DE. See DE ANDREA, JOHN

ANTONAKOS, STEPHEN 1926-

298 Houston. Contemporary Arts Museum. ANTONAKOS' "PILLOWS."
Houston, Tex.: 1971. 28 p. 17 illus. Paperback.

> Naomi Spector's introductory essay discusses the importance of
> this brief period (1962–63) and its relationship to the rest of
> Antonakos's work. Biography.

299 New York. State University at Albany. STEPHEN ANTONAKOS: SIX
CORNER NEONS. Albany, N.Y.: 1973. 10 p. Illus. Paperback.

> Catalog accompanying an exhibition which traveled to five
> New York State University campuses in 1973-74. Includes an
> essay by Naomi Spector characterizing and describing this one
> aspect of Antonakos's work. Lists exhibitions, teaching posi-
> tions.

Further bibliography: Tuchman (see 239); Whitney-Light, Object, Image (see
260).

ARCHIPENKO, ALEXANDER 1887-1964

300 Archipenko, Alexander, et al. ARCHIPENKO: FIFTY CREATIVE YEARS,
1908-1958. New York: TEKHNE, 1960. 109 p. 292 illus. Index.

> Primarily Archipenko's reflections on his own work and tech-
> niques. The excellent illustrations, grouped by type or sub-
> ject, parallel the sculptor's remarks. The appendix contains
> many other useful pieces of documentation: a chronology as
> well as excerpts from the critical writings of fifty art histori-
> ans and critics. Bibliography (pp. 98-102).

301* California. University at Los Angeles. Dickson Art Center. ALEXAN-
DER ARCHIPENKO: MEMORIAL EXHIBITION. Los Angeles: UCLA Art
Galleries, 1967. 80 p. 83 illus. Paperback.

> A monographic catalog which includes a foreword by Katharine
> Kuh, a comment on the Archipenko Collection by Frances
> Archipenko, a substantial essay on the artist's life and work
> by Frederick S. Wight, and a brief essay on the drawings and
> prints by Donald H. Karshan. Includes several works never
> shown prior to this retrospective exhibition. Comprehensive
> chronology. Lengthy selective bibliography (pp. 74-80).

302 Hildebrandt, Hans. ALEXANDRE ARCHIPENKO, SON OEUVRE. Berlin:
Ukranske Slowo, 1923. 65 p. Illus. Text in English and Ukranian.

> A careful, sympathetic study of Archipenko's early work, writ-
> ten when the sculptor was thirty-six years old.

303 Karshan, Donald H. ARCHIPENKO: THE SCULPTURE AND GRAPHIC ART. Including "Print Catalogue Raisonné." Tübingen: Ernest Wasmuth, 1974. 163 p. Illus. Index.

A useful catalog and study of Archipenko's works on paper which are often studies for sculpture. The first chapter on the early sculpture "attempts to establish a basis for the dating of several important works and reappraise [Archipenko's] historic position." In English. Biography. Chronology. Selected bibliography (p. 160).

304 _____, ed. ARCHIPENKO: INTERNATIONAL VISIONARY. Washington, D.C.: Smithsonian Institution Press for the National Collection of Fine Arts, 1969. 116 p.

Catalog for the retrospective exhibition which traveled abroad with the International Art Program. Text, in English, is compiled from other sources: critiques by Guillaume Apollinaire (1912, 1914) and Guy Habasque (1961); Archipenko's own "Concave and Void," "Sculpto-Painting," and "Polychrome Manifesto" (1956). Plates include memorabilia and sketches, as well as photos of the sculpture.

Further bibliography: Giedion-Welcker (see 152); Index-20th Cent. (see 33), vol. 3, pp. 249-52 and supplement; Whitney, 200 YEARS (see 86).

ARMAN (Armand Fernandez) 1928-

305 LaJolla Museum of Contemporary Art. ARMAN: SELECTED WORKS, 1958-1974. LaJolla, Calif.: 1974. [46]p. Illus. Paperback.

Essay by Jan Van der Marck, "Logician of Form/Magician of Gesture," briefly analyzes the impetus, meaning, and symbolism in Arman's work as it has developed since the late 1950s. List of exhibitions. One-page selected bibliography.

306 Martin, Henry. ARMAN: OR, FOUR AND TWENTY BLACKBIRDS BAKED IN A PIE; OR, WHY SETTLE FOR LESS WHEN YOU CAN SETTLE FOR MORE. New York: Harry N. Abrams, 1973. 200 p. 178 illus.

This first English language monograph explores Arman's fascination with "accumulation and destruction: and the metaphysical implications of an aesthetic." Excellent plates. Biographical outline. Selected bibliography (p. 199).

307 Swenson, G.R. "Arman and Esthetic Change." QUADRUM 17 (1964): 87-96. Illus.

Swenson's perceptive and lucid article closely analyzes Arman's

importance to the "new intellectual climate of the fine arts." Followed with a short appraisal by P. Restany (pp. 97-98).

308 Van der Marck, Jan. "Arman: The Parisian Avant-Garde in New York." ART IN AMERICA 61 (November/December 1973): 88-95. Illus.

Follows Arman's artistic development and his relationship to the new realists in Europe and the United States. Van der Marck sees Arman's work as "graphic in origin" and "striving for pictorial before sculptural effects." A perceptive analysis.

ARNESON, ROBERT 1930-

309 Chicago. Museum of Contemporary Art. ROBERT ARNESON. Chicago: 1974. [32]p. Illus. Paperback.

Catalog accompanying the first retrospective exhibition of Arneson's ceramic work. Essay by Stephen Prokopoff traces Arneson's development since the early 1960s. Suzanne Foley then comments on Arneson's imagery and his use of clay. Only representative works from each of the major series in the exhibition are illustrated. Exhibition traveled to the San Francisco Museum of Art.

310 Zack, D[avid]. "Ceramics of Robert Arneson." CRAFT HORIZONS 30 (January/February 1970): 36-41. Illus.

Describes the phases through which Arneson's art has passed, focusing on his erotic imagery. (The readers, outraged, responded in the May/June issue of the magazine.)

ASAWA, RUTH 1926-

311 San Francisco Museum of Art. RUTH ASAWA: A RETROSPECTIVE VIEW. San Francisco: 1973. 28 p. Illus. Paperback.

Gerald Nordland's essay outlines the events influencing Asawa's life and art. Stresses her personal commitment to education. One-page selected bibliography.

BAIZERMAN, SAUL 1889-1957

312 Boston. Institute of Contemporary Art. SAUL BAIZERMAN RETROSPEC-TIVE. Introduction by Thomas M. Messer. Boston: 1958. 24 p. Illus. Paperback.

This exhibition catalog includes a chronology, an exhibition list, "Known Location of Work," and a selected bibliography.

313 Goodnough, Robert. "Baizerman Makes a Sculpture--'Exuberance'." ART NEWS 51 (March 1952): 40-43. Illus.

> The unusual technique of hammering copper to produce a two-sided relief is described by Baizerman. Brief introduction to his artistic goals and concerns.

314 Walker Art Center (Minneapolis, Minn.). SAUL BAIZERMAN. Minneapolis: 1953. 23 p. 11 illus.

> The introductory essay by Julius Held reviews Baizerman's career and describes the hammering technique which Baizerman used in the 1950s.

Further bibliography: Hirshhorn (see 168); UCSB (see 180); Whitney, 200 YEARS (see 86).

BALL, THOMAS 1819-1911

315 Ball, Thomas. MY THREE SCORE YEARS AND TEN: AN AUTOBIOGRAPHY. Boston: Roberts Brothers, 1891. Reprint of 1892 ed. N.Y.: Garland Publishing, 1976. 379 p. Illus.

> A charming autobiography by one of Boston's better known expatriate sculptors. Ball reveals much about his work and those who commissioned it.

316 Craven, Wayne. "The Early Sculptures of Thomas Ball." NORTH CAROLINA MUSEUM OF ART BULLETIN (Raleigh, N.C.) 5 (Fall 1964/Winter 1965): 3-12. Illus.

> Ball gained his reputation for naturalistic portraiture by virtue of the vitality and animation of his early small statuettes and busts. Craven feels this quality is lacking in Ball's later, monumental works.

317 Partridge, William [Ordway]. "Thomas Ball." NEW ENGLAND MAGAZINE, n.s. 12 (May 1895): 291-304. 12 illus.

> Reviews with praise the sculptural work of Ball. Lengthy discussion of the history of equestrian statuary precedes Partridge's commentary on Ball's equestrian "Washington." Includes biographical details.

BARNARD, GEORGE GREY 1863-1938

318 Dickson, Harold E. "George Grey Barnard's Controversial 'Lincoln'." ART JOURNAL 27 (Fall 1967): 8-15 and following. Illus.

> Based on Barnard family scrapbooks and correspondence, Dickson relates the history of this monumental (often unpopular)

Lincoln statue in Cincinnati, Ohio.

319 _____. "Log of a Masterpiece: Barnard's 'Struggle of the Two Natures of Man'." ART JOURNAL 20 (Spring 1961): 139–43. Illus.

> Traces the evolution of this major piece of sculpture. Provides information on Barnard's working habits and artistic outlook.

320 _____. "The Other Orphan." AMERICAN ART JOURNAL 1 (Fall 1969): 108–18. Illus.

> Relates the hapless history of Barnard's controversial sculpture "Pan." Based on documentary material lent by the Barnard family.

321 Pennsylvania. State University. Library (University Park). GEORGE GREY BARNARD, CENTENARY EXHIBITION, 1863–1963. Text by Harold E. Dickson. University Park, Pa.: 1964. 39 p. Illus.

> An excellent photographic record of Barnard's major works, his studio, and his family, with descriptive captions to amplify the brief introduction. Also includes a facsimile reproduction of the catalog for the 1908 Barnard exhibition held at the Boston Museum of Fine Arts.

Further bibliography: Index–20th Cent. (see 33), vol. 3, pp. 253–56 and supplement; Craven (see 60); Brookgreen (see 141); Whitney, 200 YEARS (see 86).

BARTHOLOMEW, EDWARD SHEFFIELD 1822–58

322 Tuckerman, Henry [Theodore]. "Two of Our Sculptors: Benjamin Paul Akers and Edward Sheffield Bartholomew." HOURS AT HOME 2 (April 1866): 525–32.

> In the extremely florid prose of the mid–nineteenth century, Tuckerman describes the life and work of both of these noted expatriot sculptors who died at an early age. Tuckerman focuses on Bartholomew's personality and the difficulties of his career rather than on an evaluation of his work.

323 Wendell, William G. "Edward Sheffield Bartholomew, Sculptor." WADSWORTH ATHENEUM BULLETIN (Hartford, Conn.), series 5 (Winter 1962): 1–18. Illus.

> Biographical sketch of this acclaimed sculptor from Hartford, Connecticut, who died in Italy at the age of thirty-six. Bibliography.

Further bibliography: Gerdts–Neoclassic (see 123); Whitney, 200 YEARS (see 86).

BARTLETT, PAUL WAYLAND 1865-1925

324 Wheeler, Charles V. "Bartlett, 1865-1925." AMERICAN MAGAZINE
OF ART 16 (November 1925): 573-85. 13 illus.

> Reviews Bartlett's career and relates the importance of his
> work to this history of sculpture.

Further bibliography: Brookgreen (see 141); Craven (see 60); Broder (see 58);
Whitney, 200 YEARS (see 86).

BASKIN, LEONARD 1922-

325 Ayrton, Michael. "The Sculpture of Leonard Baskin." MOTIF (London),
Winter 1962/63, pp. 52-59. 11 illus.

> Comments upon the influences--personal and artistic--which
> have shaped Baskin's sculpture. The psychological imminence
> of death is identified as an all-powerful force in Baskin's
> work.

326* Baskin, Leonard. BASKIN: SCULPTURE, DRAWINGS AND PRINTS.
New York: George Braziller, 1970. 170 p. Illus.

> A visual anthology of Baskin's work (fifty-eight illustrations of
> sculpture) preceded by the artist's thoughts on his own work,
> his ideology, and the influences of others upon his work.
> Selective bibliography (pp. 167-70).

327 FIGURES OF A DEAD MAN. Preface by Archibald MacLeish. Photo-
graphs by Hyman Edelstein. Amherst: University of Massachusetts Press,
1968. Chiefly illus.

> Photographic presentation of Baskin's series of "Dead Men"
> begun in the 1950s and continued through the 1960s.

328 O'Doherty, Brian. "Leonard Baskin." ART IN AMERICA 50 (Summer
1962): 66-72. Illus.

> Perceptive essay which captures Baskin's incisive, relentless,
> obsessive view of life and art.

Further bibliography: Hirshhorn (see 168); Craven (see 60).

BEASLEY, BRUCE 1939-

329 M.H. DeYoung Memorial Museum and the California Palace of the Le-
gion of Honor (San Francisco). BRUCE BEASLEY: AN EXHIBITION OF
ACRYLIC SCULPTURE. San Francisco: 1972. [47]p. Illus. Paperback.

Introduction by William H. Elsner discusses Beasley's life and the development of his work. The twenty-eight pieces in the exhibition (all illustrated) were completed during or since 1969--when Beasley began doing acrylic sculptures. Exhibition list. Bibliographical notes.

BELL, LARRY 1939-

330 Danieli, Fidel A. "Bell's Progress." ARTFORUM 5 (June 1967): 68-71. Illus.

Definitive essay which describes Bell's art and its development through 1967.

331 Pasadena Art Museum. LARRY BELL. Text by Barbara Haskell. Pasadena, Calif.: 1972. 42 p. 36 illus. Paperback.

Distinctively designed catalog which captures some of the elusive perceptual effects which are Bell's primary concern. Haskell intelligently discusses Bell's work and its significance and relationship to other contemporary work. Bibliography compiled by Fran Frosquez (p. 36).

332 Tate Gallery (London). LARRY BELL, ROBERT IRWIN, DOUG WHEELER. London: 1970. 31 p. Illus. Paperback.

Introductory remarks by Michael Compton focus briefly on the work of each of the artists included in this exhibition. Bibliography (pp. 19-20).

Further bibliography: Tuchman (see 239); 14 Sculptors (see 257); Whitney, 200 YEARS (see 86).

BELLAMY, JOHN HALEY 1836-1914

333 Hill, Nola. "Bellamy's Greatest Eagle." ANTIQUES 51 (April 1947): 259.

Discusses his carved figurehead for the U.S.S. Lancaster which is now in the Mariner's Museum in Newport News, Virginia.

334 Safford, Victor. "John Haley Bellamy, the Woodcarver of Kittery Point." ANTIQUES 27 (March 1935): 102-6. Illus.

A sympathetic biographical account of the carver of ships' figureheads and the widely popular "Bellamy eagles." A short editorial essay on "Bellamy's style and Its Imitators" follows (pp. 106-7).

BENGLIS, LYNDA 1941-

335 Kertess, Klaus. "Foam Structures." ART AND ARTISTS 7 (May 1972): 32-37. Illus.

 Explores the artistic and technical experimentation involved in Benglis' poured polyurethane pieces of the early 1970s.

336 Pincus-Witten, Robert. "Lynda Benglis: The Frozen Gesture." ART-FORUM 13 (November 1974): 54-59. Illus.

 Traces the rapid changes in Beglis' work--from her late 1969 latex and foam pieces to her 1974 "exploration of the media." Pincus-Witten searches for a common theme throughout.

BERTOIA, HARRY 1915-

337 Nelson, June Kompass. HARRY BERTOIA, SCULPTOR. Detroit: Wayne State University Press, 1970. 137 p. 85 illus. Index.

 Chapters deal with Bertoia's life, his experimental techniques, his large scale architectural commissions, and the critical response to his work. Chronology. Bibliography.

BITTER, KARL 1867-1915

338 Dennis, James M. KARL BITTER: ARCHITECTURAL SCULPTOR, 1867-1915. Madison: University of Wisconsin Press, 1967. 316 p. Illus. Index.

 Dennis carefully studies the stylistic development of Bitter's sculpture during his brief career in the United States (1889-1915). Major works and specific public commissions (Cleveland, St. Louis, New York City, etc.) are fully discussed. The introduction relates the biographical facts of Bitter's career. Bibliographical notes (pp. 267-94).

339 Schevill, Ferdinand. KARL BITTER, A BIOGRAPHY. Chicago: University of Chicago Press under the auspices of the National Sculpture Society, 1917. 81 p. 41 plates.

 An admiring personal portrait supplemented with photographs of Bitter's major commissions. A listing of works and a chronology are included.

Further bibliography: Brookgreen (see 141); Craven (see 60).

BLADEN, RONALD 1918-

340 Baker, Kenneth. "Ronald Bladen." ARTFORUM 10 (April 1972): 79-80. Illus.

> Attempts to characterize Bladen's work and to identify factors which distinguish it from the work of Tony Smith and Robert Morris.

341 Berkson, Bill. "Ronald Bladen: Sculpture and Where We Stand." ART AND LITERATURE, no. 12 (Spring 1967), pp. 139-50. Illus.

> An interview with Bladen conducted in 1966.

342 Robins, Corinne. "The Artist Speaks: Ronald Bladen." ART IN AMERICA 57 (September/October 1969): 76-81. Illus.

> In addition to illustrating Bladen's entire sculptural output (eleven pieces since 1963), this interview/article explores the artist's life, his aesthetics, and the development of specific pieces.

343 Vancouver Art Gallery. RONALD BLADEN/ROBERT MURRAY. Vancouver, B.C., Canada: 1970. 50 p. 35 illus. Spiral-bound paperback.

> Introduction by Doris Schadbolt with statements by the artists and selected critics. The eight works are informally photographed while under construction and after completion. Short biographies. Extensive bibliographies.

Further bibliographies: Tuchman (see 239); Whitney, 200 YEARS (see 86).

BOCHNER, MEL 1940-

344 Bochner, Mel. "Excerpts from Speculation (1967-1970)." ARTFORUM 8 (May 1970): 70-73. Illus.

> Reflections on the terminology appropriate to conceptual art excerpted from the artist's unpublished notebooks.

345 Pincus-Witten, Robert. "Mel Bochner: Constant as Variable." ARTFORUM 11 (December 1972): 28-34. 13 illus.

> An important article tracing Bochner's artistic development and his relationship to the post-minimal aesthetic. Bibliography.

BOLOTOWSKY, ILYA 1907-

346 Solomon R. Guggenheim Museum (New York). ILYA BOLOTOWSKY. New York: 1974. 133 p. Illus. Paperback.

Shown also at the National Collection of Fine Arts, this one-man exhibition explores the neoplastic forms and ideals followed by Bolotowsky. Seven of his three-dimensional columns (done between 1962 and 1974) are illustrated. Lists of exhibitions and reviews. Selected bibliography (pp. 132-33).

BONTECOU, LEE 1931-

347 Chicago. Museum of Contemporary Art. LEE BONTECOU. Chicago: 1972. 26 p. Illus. Paperback.

Essay by Carter Ratcliff discusses Bontecou's fabrications and her relationship to contemporary aesthetics. Twenty-three works are illustrated.

348 Judd, Donald. "Lee Bontecou." ARTS MAGAZINE 39 (April 1965): 16-21. Illus.

Analyzes the evolution of Bonecou's art: its scale, its structure, and its image. Five works, a page of drawings, and a portrait of the artist are reproduced.

Further bibliography: Recent Am. (see 226).

BORGLUM, JOHN GUTZON 1867-1941

349 Borglum, Gutzon. "Art That Is Real and American." WORLD'S WORK 28 (June 1914): 200-217. Illus.

An impassioned plea for the recognition and appreciation of American art. Borglum extolls "the sincerity, the individuality and the reverence" which characterize art created by Americans out of the American experience. His own works illustrate his thesis. A short biography (pp. 198-200) by George Marvin precedes the essay.

350 Casey, Robert Joseph, and Borglum, Mary. GIVE THE MAN ROOM; THE STORY OF GUTZON BORGLUM. Indianapolis: Bobbs-Merrill, 1952. 326 p. Illus. Index.

A lively, popularly-written biography of Gutzon Borglum, the carver of Mount Rushmore, and brother of Solon H. Borglum (see entry below). Commentary by Borglum and his acquaintances is not footnoted.

Further bibliography: Brookgreen (see 141); Craven (see 60); Broder (see 58); Whitney, 200 YEARS (see 86).

BORGLUM, SOLON HANNIBAL 1868-1922

351 Davies, Alfred Mervyn. SOLON H. BORGLUM: "A MAN WHO
 STANDS ALONE." Chester, Conn.: Pequot Press, 1974. 306 p. Illus.

> A sympathetic biography by Borglum's son-in-law, describing
> the sculptor's life, his relationship to his brother Gutzon, and
> the importance which Solon played in the national conscious-
> ness at the turn of the century. The sculptural work is sum-
> marized but not critically analyzed or documented. Thorough
> bibliography (pp. 257-65).

Further bibliography: Brookgreen (see 141); Craven (see 60); Broder (see 58);
Whitney, 200 YEARS (see 86).

BOURGEOIS, LOUISE 1911-

352 Lippard, Lucy R. "Louise Bourgeois: From the Inside Out." ARTFORUM
 13 (March 1975): 26-33. 15 illus.

> Lippard sees Bourgeois's sculpture as an unusually evocative
> expression of personal strengths and weaknesses. The changes
> in Bourgeois's subject and material are reviewed and the power
> of her imagery is analyzed.

352a Marandel, J.P. "Louise Bourgeois." ART INTERNATIONAL 15 (December
 1971): 46-47 and following. 6 illus. Text in French.

> Marandel describes Bourgeois's work, exploring briefly her devel-
> opment of biomorphic forms. Especially useful for the illustrations.

353 Robbins, Daniel. "Sculpture by Louise Bourgeois." ART INTERNATIONAL
 8 (October 1964): 29-31. 5 illus.

> Reviews Bourgeois's life and artistic development, focusing on
> the relationship of her drawings to her sculpture, her sculp-
> tural techniques, and her ability to remain free of the fashions
> of contemporary art.

354 Rubin, William S. "Some Reflections Prompted by the Recent Work of
 Louise Bourgeois." ART INTERNATIONAL 13 (April 1969): 17-20. Illus.

> Proposes that Bourgeois's work has remained fresh and vital by
> remaining essentially figurative and by avoiding the rush to
> abstract expressionism.

Further bibliography: Giedion-Welcker (see 152); Whitney, 200 YEARS (see
86).

BRECHT, GEORGE 1925-

355 Page, Robin, and Liss, Carla. "Interview with George Brecht." ART AND ARTISTS 7 (October 1972): 28-33. Illus.

> Brecht discusses his involvement with Fluxus (an international avant-garde group which developed in the 1960s) and the Yam Festival. He describes objects he created while associated with Fluxus.

356 Van der Marck, Jan. "George Brecht: An Art of Multiple Implications." ART IN AMERICA 62 (July/August 1974): 48-57. Illus.

> On the occasion of Brecht's reappearance on the New York art scene (1973), this article traces the Fluxus movement and its influence. The bibliographical notes are useful in tracing the history of Fluxus.

BROWERE, JOHN HENRY ISSAC 1790-1834

357 Hart, Charles. BROWERE'S LIFE MASKS OF GREAT AMERICANS. New York: Doubleday & McClure, 1899. 137 p. Illus.

> A short essay on the fame and character of each of the twenty-one personalities represented by a life mask. Some documentation is included to verify Browere's work. Nineteen of the masks were included in the 1940 Marlborough exhibition.

358 LIFE MASKS OF NOTED AMERICANS OF 1825, BY JOHN H.I. BROWERE. New York: Knoedler under the sponsorship of the New York State Historical Association in Cooperstown, New York, 1940.

> Foreword by Dixon Ryan Fox states that this exhibition of twenty life masks taken by Browere is only a part of a much larger body of work by Browere. See appendix under New York, Cooperstown.

BROWN, HENRY KIRKE 1814-86

359 Craven, Wayne. "Henry Kirke Brown: His Search for an American Art in the 1840's." AMERICAN ART JOURNAL 4 (November 1972): 44-58. Illus.

> In a sequel to the 1969 article below, Craven traces the diffi-culties and successes which met Brown upon his return to the United States in 1946. (The lack of bronze casting facilities was one of the major frustrations.) Documents his sculpture done among the Indians and his De Witt Clinton statue. Based on Brown's letters which are deposited at the Library of Congress.

360 _____. "Henry Kirke Brown in Italy, 1842-1846." AMERICAN ART JOURNAL 1 (Spring 1969): 65-77. Illus.

During his four-year internship in Italy, Brown developed an artistic philosophy which eventually rejected European neo-classical traditions for an art based on American forms and spirit. This account, based on family letters, carefully documents Brown's accomplishments while in Italy.

Further bibliography: Gerdts-Neoclassic (see 123); Whitney, 200 YEARS (see 86).

CAESAR, DORIS 1892-

361 Baur, John I.H. "Doris Caesar." In FOUR AMERICAN EXPRESSION-ISTS, pp. 21-36. New York: Whitney Museum of American Art, 1959. Illus. of 13 works.

Baur's essay, published to accompany the Four Expressionists exhibition, perceptively evaluates Caesar's artistic development and her "mature style."

362 Bush, Martin H. DORIS CAESAR. [Syracuse, N.Y.?: Distributed by Syracuse University Press, 1970.] 159 p. Illus.

An appreciative presentation of Caesar's artistic development. The text is composed of talks with the artist and of excerpts from critical analyses of her work. Introduction by Marya Zaturenska. The illustrations are the essence of this book. Exhibition list. Chronology. Selected bibliography (pp. 151-56).

CALDER, ALEXANDER 1898-1976

363* Arnason, H.H[oward]. CALDER. Princeton, N.J.: Van Nostrand Co., 1966. Photographs by Pedro E. Guerrero. 192 p. 126 illus. Index.

Critical biography concentrating on Calder's sculptures, mobiles, and stabiles. Each phase of the work is illustrated by numerous excellent photographs. Full chronology of the work is accompanied by illustrations (pp. 150-83). Selected bibliography emphasizes material published after 1951 (pp. 184-85).

364 Chicago. Museum of Contemporary Art. ALEXANDER CALDER: A RETROSPECTIVE EXHIBITION, WORK FROM 1925-1974. Chicago: 1974. [32]p. Illus. Paperback.

Exhibition catalog containing an important critical essay by Albert E. Elsen, "Calder on Balance." The notes to this scholarly article provide bibliographic guidance.

365* Mulas, Ugo. CALDER. Introduction by H.H. Arnason. New York: Viking Press, 1971. 216 p. Chiefly illus. Index.

"A photographic interpretation of Alexander Calder and his

sculpture, accompanied by a text that includes a chronology of the artist's career, interspersed with quotations from Calder himself and from artists and critics." Selected bibliography (pp. 207-14).

366* New York. Museum of Modern Art. ALEXANDER CALDER. By James Johnson Sweeney. Rev. ed. New York: 1951. 80 p. Illus. Reprint with 4 other catalogs. FIVE AMERICAN SCULPTORS. New York: Arno Press, 1969.

Important critical catalog (first published in 1943) to accompany a major Calder retrospective. Sweeney's lengthy essay outlines, chronologically, the development of Calder's art. Each phase of his work is concisely characterized and discussed. Biographical notes. Exhibition list. Critical bibliography by Bernard Karpel (pp. 77-80). The 1943 edition has been reprinted, with four other catalogs, in a volume entitled FIVE AMERICAN SCULPTORS (Arno Press, New York).

367 Sartre, Jean Paul. "Existentialist on Mobilist." ART NEWS 46 (December 1947): 22-23 and following. 2 illus.

A brief, but poetically evocative, characterization and interpretation of Calder's mobiles. Translated from the catalog of the 1946 Calder exhibition at the Louis Carré Gallery in Paris.

368 Solomon R. Guggenheim Museum (New York). ALEXANDER CALDER: A RETROSPECTIVE EXHIBITION. New York: Solomon R. Guggenheim Foundation, 1964. 91 p. Chiefly illus. Paperback.

Primarily a visual record of Calder's life and work with a brief introduction and foreword by Thomas M. Messer. Includes all of Calder's "Circus." Selective bibliography (pp. 85-87) updates the 1951 Museum of Modern Art bibliography in Sweeney's ALEXANDER CALDER (see 366).

Further bibliography: Giedion-Welcker (see 152); Hirshhorn (see 168); Tuchman (see 239); Whitney, 200 YEARS (see 86).

CALDER, ALEXANDER STIRLING 1870-1945

369 Poore, Henry Rankin. "Stirling Calder, Sculptor." INTERNATIONAL STUDIO 67 (April 1919): xxxvii-li. Illus.

Characterizes Calder's work and his attitudes about art and life. His major works are illustrated and described. A. Stirling Calder was the father of Alexander Calder (see previous entries).

Further bibliography: Index-20th Cent. (see 33), vol. 2, pp. 123-27 and supple-

ment; Brookgreen (see 141); Craven (see 60); Broder (see 58); Whitney, 200 YEARS (see 86).

CALLERY, MARY 1903-77

370 MARY CALLERY, SCULPTURE. New York: Distributed by George Wittenborn, 1961. xi, 151 p. 172 illus. Text in English and French.

> Basically a photographic documentation of Callery's work. The introduction by Philip R. Adams discusses her development. An essay by Christian Zervos examines the imagery in her work. Bibliography by Bernard Karpel (pp. 149-51).

Further bibliography: Giedion-Welcker (see 152).

CERACCHI, GIUSEPPE 1751-1802

371 Desportes, Ulysses. "Giuseppe Ceracchi in America and His Busts of George Washington." ART QUARTERLY 26 (Summer 1963): 140-79. Illus.

> A complete review of the circumstances surrounding the unsatisfactory reception given in America to Ceracchi's statues of Washington.

372 _____. "'Great Men of America' in Roman Guise, Sculptured by Giuseppe Ceracchi." ANTIQUES 96 (July 1969): 72-75. Illus.

> In an effort to become known in the United States, Ceracchi completed twenty-seven terra-cotta busts of the "Great Men of America." The six of these which have been located and authenticated are illustrated and discussed in terms of Ceracchi's style.

373 Gardner, Albert Ten Eyck. "Fragment of a Lost Monument." METROPOLITAN MUSEUM OF ART BULLETIN n.s. 6 (March 1948): 189-98. Illus.

> Relates the conception, execution, and hapless dispersal of various of Ceracchi's portraits of George Washington. Reveals a great deal about the artist's eccentric life.

CHAMBERLAIN, JOHN ANGUS 1927-

374 Solomon R. Guggenheim Museum (New York). JOHN CHAMBERLAIN: A RETROSPECTIVE EXHIBITION. Organized by Diane Waldman. New York: 1971. 104 p. 83 illus. Paperback.

This important exhibition includes work done since 1957. In

the introductory essay, Waldman identifies Chamberlain's uniqueness among other abstract expressionist sculptors and notes his innate feeling for form. Excerpts from a 1971 conversation between Elizabeth C. Baker, Donald Judd, Waldman, and Chamberlain are included.

375 Tuchman, Phyllis. "An Interview with John Chamberlain." ARTFORUM 10 (February 1972): 38-43. Illus.

A wide-ranging interview which reveals much about Chamberlain's personality, his aesthetics, and life history. Barbara Rose comments on the interview in her follow-up critique "On Chamberlain's Interview" (pp. 44-45).

Further bibliography: Recent Am. (see 226); Tuchman (see 239); Hunter (see 156); Whitney, 200 YEARS (see 86).

CHASE-RIBOUD, BARBARA DEWAYNE 1939-

376 California. University at Berkeley. Art Museum. CHASE-RIBOUD. Berkeley and Los Angeles: 1973. 30 p. 18 illus.

First publication on this American living in Paris. Catalog essays by F.W. Heckmanns, Francoise Nora-Cachin, and Géneviere Monnier evaluate Chase-Riboud's work and its significance to contemporary art. Biographical outline. Exhibition list. Bibliography.

CHRISTO (Christo Javacheff) 1935-

377 Alloway, Lawrence. CHRISTO. New York: Harry N. Abrams, 1970 (c. 1969). xi, 12 p. plus 71 illus.

Analyzes Christo's art since 1959. The wrapped object and its ability to facilitate monumentally-scaled art are discussed. Numerous illustrations enhance the usefulness of this inexpensive volume. Biographical outline. Bibliography (pp. 5-8).

378 Bourdon, David. CHRISTO. New York: Harry N. Abrams, 1971. 321 p. Chiefly illus.

Primarily composed of excellent photographs, this book documents Christo's work. Bourdon's text (pp. 1-56) traces Christo's artistic development. Biographical outline. Selected bibliography (p. 321).

379 CHRISTO: VALLEY CURTAIN (RIFLE, COLORADO, 1970-1972). Photographs by Harry Shunk. New York: Harry N. Abrams, 1973. 351 p. Illus. Oversized.

A lavish photographic documentation of Christo's "Valley Curtain" project, which also includes letters of contract, engineering calculations, etc. No explanatory or interpretive text.

380 Pennsylvania. University. Institute of Contemporary Art (Philadelphia). CHRISTO: MONUMENTS AND PROJECTS. Philadelphia: 1968. 15 p. 10 illus. Paperback.

Essay by Stephen Prokopoff outlines Christo's development and training. Reprinted in ART AND ARTISTS 4 (April 1969). Chronology and extensive bibliography add to the value of this exhibition catalog.

381 Van der Marck, Jan. "The Valley Curtain." ART IN AMERICA 60 (May/June 1972): 54-67. Illus.

The technological documentation of this historic project is juxtaposed with a perceptive essay on the personal importance and psychological symbolism of the project.

CHRYSSA (Varda Chryssa) 1933-

382 Calas, Nicolas. "Chryssa and Time's Magic Square." ART INTERNATIONAL 6 (February 1962): 35-37. Illus.

Brief but articulate analysis of the iconography in Chryssa's early neon works.

383 Hunter, Sam. "Chryssa." ART NEWS 72 (January 1973): 63-66. Illus.

Summary review of Chryssa's art, aesthetics, techniques, and personality.

384 Pace Gallery (New York). CHRYSSA: SELECTED WORKS, 1955-1967. New York: 1968. 48 p. Illus. Paperback.

The brief introduction by Diane Waldman discusses Chryssa's artistic development--technically, aesthetically, and iconographically. (See also Waldman's article in ART INTERNATIONAL 12, April 1968.) Thirty-two works from this major exhibition are illustrated. Biographical outline. List of exhibitions. Bibliography (pp. 47-48).

Further bibliography: Tuchman (see 239).

CLEVENGER, SHOBAL VAIL 1812-43

385 Brumbaugh, Thomas B. "Letters of an American Sculptor, Shobal Clevenger." ART QUARTERLY 24 (Winter 1961): 370-77. Illus.

Brumbaugh reproduces four Clevenger letters recently uncovered, which are perhaps the only extant personal fragments from the sculptor's short life. Fully introduced and documented by Brumbaugh.

386 _____. "Shobal Clevenger: An Ohio Stonecutter in Search of Fame." ART QUARTERLY 29 (Spring 1966): 29–45. Illus.

Biography of a vigorous Ohio sculptor who, despite constant poverty, gained recognition for his authentic, naturalistic portrait busts. He worked both in this country and in Italy. His life reflects the difficulties experienced by many early American artists.

Further bibliography: Craven (see 60); Gerdts-Neoclassic (see 123).

CLEWS, HENRY, JR. 1876-1936

387 Proske, Beatrice [Gilman]. HENRY CLEWS, JR. Brookgreen, S.C.: Brookgreen Gardens, 1953. 34 p. 17 illus. Paperback.

Perceptive and thorough analysis of Clews's artistic development--from portrait and relief sculptures to imaginative, animalistic caricatures. Brief bibliography (p. 34).

388 Remington, Preston. "Sculpture by Henry Clews, Jr." METROPOLITAN MUSEUM OF ART BULLETIN (New York) 34 (May 1939): 107-9. Illus.

On the occasion of a Clews retrospective, Remington briefly describes his portraiture and his fantastical sculptures.

Further bibliography: Brookgreen (see 141).

COFFEE, WILLIAM JOHN c.1774-1846

389 Groce, George C. "William John Coffee, Long-Lost Sculptor." AMERICAN COLLECTOR 15 (May 1946): 14-15.

Outline of Coffee's life and work based on the scant documentation available.

390 Rutledge, Anna Wells. "William John Coffee as a Portrait Sculptor." GAZETTE DES BEAUX ARTS, series 6, vol. 28 (November 1945): 297-312. Illus.

From documentary sources, Rutledge reconstructs Coffee's life and career--especially his friendship with Thomas Jefferson. No critical evaluation of the work.

COGDELL, JOHN STEVENS 1778-1847

391 Rutledge, Anna Wells. "Cogdell and Mills, Charleston Sculptors."
ANTIQUES 41 (March 1942): 192-93, 205-7. Illus.

> Predecessor of Clark Mills as a modeler of portrait busts in
> Charleston. Cogdell's naturalistic style seems to have captured
> effectively the personalities of the sitters. Checklist of seven-
> teen sculptures and sixteen portrait paintings by Cogdell.

Further bibliography: Craven (see 60).

CONNOR, BRUCE 1933-

392 Leider, Philip. "Bruce Connor: A New Sensibility." ARTFORUM 1,
no. 6 (1962): 30-31. 6 illus.

> Praises and describes Connor's ability to communicate a "com-
> pletely new way of seeing the world."

393 Pennsylvania. University. Institute of Contemporary Art (Philadelphia).
BRUCE CONNOR. By Joan Siegfried. Philadelphia: 1967. 24 p.
10 illus.

> Small catalog accompanying a retrospective exhibition of Con-
> nor's works (sculpture, assemblage, collage, drawing, film)
> produced between 1958 and 1967. Siegfried's essay explores
> recurring images in Connor's work prior to his involvement with
> film in 1964.

Further bibliography: Tuchman (see 239).

CORNELL, JOSEPH 1903-72

394 Ashton, Dore. A JOSEPH CORNELL ALBUM. New York: Viking Press,
1974. 254 p. Illus.

> Includes "special contributions by John Ashbery [and others]
> and assorted ephemera, readings, decorations and reproductions
> of the works by Joseph Cornell." Ashton's scholarly, yet sym-
> pathetic, text (pp. 1-11) is based on her experience with
> Cornell's work and thought. The rest of the album is composed
> of poems for and memoirs of Cornell. Also, some of Cornell's
> own writing is included. Excellent illustrations.

395 Cortesi, Alexandra. "Joseph Cornell." ARTFORUM 4 (April 1966):
27-31. Illus.

> Describes the evocative power of Cornell's boxes, their physi-
> cal components and their symbolic content.

396 [Coplans, John]. "Notes on the Nature of Joseph Cornell." ARTFORUM
1 (February 1963): 27-29. Illus.

> Outline of Cornell's artistic development and the categories
> of work which distinguish each phase.

397 O'Doherty, Brian. "Joseph Cornell: Outsider on the Left." In AMERI-
CAN MASTERS: THE VOICE AND THE MYTH, pp. 254-83. New York:
Random House, Ridge Press, 1974. Illus.

> O'Doherty analyzes Cornell's place in the contemporary Ameri-
> can art scene and discusses Cornell's associations with surreal-
> ism. The abundant photographs, by Hans Namuth, focus on
> Cornell's work and his studio. Selected bibliography (pp. 285-
> 86).

398 Pasadena Art Museum. AN EXHIBITION OF WORKS BY JOSEPH COR-
NELL. Pasadena, Calif.: 1967. 76 p. Illus. of 37 works. Unusually
small paperback.

> The introductory essay by Fairfield Porter describes the con-
> tents of Cornell's boxes and explores their meanings. (A
> slightly different version of Porter's article is in ART AND
> LITERATURE, no. 8 [Spring 1966].) The catalog and description
> of the seventy-four works in the exhibition are the work of
> Barbara Berman and Gretchen Glicksman.

399 Rosenberg, Harold. "Object Poems." In ARTWORKS AND PACKAGES,
pp. 75-87. New York: Horizon Press, 1969. Illus.

> Rosenberg perceptively characterizes the imagery in and the
> effect of Cornell's evocative boxes.

400* Solomon R. Guggenheim Museum (New York). JOSEPH CORNELL. Text
by Diane Waldman. New York: 1967. 55 p. Illus. Paperback.

> A major study of Cornell's life, art, and imagery which ac-
> companied his first one-man museum show in New York.
> Waldman's lucid essay provides an important discussion of
> Cornell's relationship to the surrealists and to other contempo-
> rary artists. Thirty works are illustrated. List of exhibitions.
> Bibliography (pp. 52-53).

CRAWFORD, THOMAS 1813-57

401 Crane, Sylvia E. WHITE SILENCE: GREENOUGH, POWERS, AND
CRAWFORD: AMERICAN SCULPTORS IN NINETEENTH CENTURY ITALY.
Coral Gables, Fla.: University of Miami Press, 1972.

> Historically accurate biography (pp. 273-408) which focuses on
> Crawford's relationship to Rome and Italian culture. A "List

of Works" is provided. Appendix includes bibliographical material. (Complete information in citation 121.)

402* Gale, Robert. THOMAS CRAWFORD, AMERICAN SCULPTOR. Pittsburgh: University of Pittsburgh Press, 1964. x, 241 p. Illus. Index.

> Extensively documented biography of this early "literary" sculptor who contributed several figures to the U.S. Capitol and grounds. The "Catalogue" includes a listing of known and located works as well as "works now presumed unfinished and/or lost." The bibliographical footnotes are thorough.

Further bibliography: Craven (see 60); Gerdts-Neoclassic (see 123); Whitney, 200 YEARS (see 86).

CREEFT, JOSE DE. See DE CREEFT, JOSE

DALLIN, CYRUS EDWIN 1861-1944

403 Ewers, John C. "Cyrus E. Dallin, Sculptor of the Indians." MONTANA; THE MAGAZINE OF WESTERN HISTORY 18 (January 1968): 34-43. Illus. of 5 works.

> Relates Dallin's life and his unique position as a sculptor of Indians. Bibliographical note (p. 38).

404 Long, E. Waldo. "Dallin, Sculptor of Indians." WORLD'S WORK 54 (September 1927): 563-68. Illus.

> Facts and anecdotes of Dallin's life are presented, as well as commentary from the sculptor himself regarding his impressions of and respect for the American Indian.

Further bibliography: Brookgreen (see 141); Craven (see 60); Broder (see 58); Whitney, 200 YEARS (see 86).

DAVIDSON, JO 1883-1952

405 Davidson, Jo. BETWEEN SITTINGS: AN INFORMAL AUTOBIOGRAPHY OF JO DAVIDSON. New York: Dial Press, 1951. vii, 369 p. Illus.

> Primarily relates Davidson's experiences with the noteworthy people who posed for him.

406 DuBois, René. ["Jo Davidson."] INTERNATIONAL STUDIO 76 (November 1922): 177-81. 4 illus.

> In the text of this review (which begins on page 180), DuBois characterizes Davidson's portrait work, praising especially the Gertrude Stein seated portrait.

Individual Sculptors

Further bibliography: Index 20th Cent. (see 33), vol. 2, pp. 157–59 and supplement; Brookgreen (see 141); Broder (see 58); Whitney, 200 YEARS (see 86).

DE ANDREA, JOHN 1941-

407 Chicago. Museum of Contemporary Art. JOHN DE ANDREA/DUANE HANSON: THE REAL AND IDEAL IN FIGURATIVE SCULPTURE. Chicago: 1974. [16]p. 20 illus. Paperback.

Dennis Adrian's essay explores the role of imitation in the work of these two verist sculptors.

408 Masheck, Joseph. "Verist Sculpture: Hanson and DeAndrea" ART IN AMERICA 60 (November/December 1972): 90–97. Illus.

Identifies the artistic referents in DeAndrea's nude figure sculpture. A brief interview with the artist follows (pp. 98–99).

Further bibliography: Recent Figure (see 222).

DE CREEFT, JOSE 1884-

409 DeCreeft, José. THE SCULPTURE OF JOSE DE CREEFT. Introduction by Jules Campos. New York: Kennedy Graphics DaCapo Press, 1972. 227 p. 283 illus. Index of the illus.

A rich visual anthology of DeCreeft's sculptural work which includes work done throughout his career. A brief introduction by Campos is followed by DeCreeft's own "Statement on Sculpture" (originally published in 7 ARTS, no. 2, 1954). Biographical chronology. List of exhibitions. Selected bibliography which does not include material after 1963 (pp. 220–21).

410 Devree, Charlotte. JOSE DE CREEFT. New York: American Federation of Arts, 1960. 32 p. 19 plates.

This catalog, which accompanied a DeCreeft retrospective, discusses the development of the sculptor's career and the significance of the direct-carving technique to his images. Chronology. List of exhibitions. Selected bibliography (pp. 22–30).

411 Welty, Eudora. "José DeCreeft." MAGAZINE OF ART 37 (February 1944): 42–47. 7 illus.

Biographical outline embellished with a vivid characterization of DeCreeft's personality and work.

Further bibliography: Hirshhorn (see 168); Whitney, 200 YEARS (see 86).

DE KOONING, WILLEM 1904-

412 Walker Art Center (Minneapolis, Minn.). DE KOONING: DRAWINGS/ SCULPTURES/PASTELS. Organized by Philip Larson and Peter Schjeldahl. New York: E.P. Dutton & Co., 1974. [40]p. Illus.

> Catalog of the first exhibition of de Kooning's experiments with sculpture (done between 1969 and 1974). Schjeldahl's essay discusses the nature and effect of de Kooning's sculpture. (A slightly revised version of Schjeldahl's essay is in ART IN AMERICA, March/April 1974.)

Further bibliography on de Kooning as a painter: Keaveney, AMERICAN PAINTING.

DE LAP, TONY 1927-

413 California. University at Irvine. Art Gallery. TONY DE LAP: THE LAST FIVE YEARS: 1963-1968. Irvine: 1968. 50 p. Illus. Paperback.

> Catalog essay by Alan Solomon traces DeLap's development and the "distinctiveness of San Francisco object-art with its surrealistic overtones." Discusses DeLap's techniques and the recurring characteristics of his work. Biographical data. List of exhibitions. Selected bibliography (pp. 48-49).

414 Coplans, John. "DeLap; Space and Illusion." ARTFORUM 2 (February 1964): 19-21. Illus.

> Brief analysis and description of DeLap's work in 1964.

Further bibliography: Tuchman (see 239).

DE MARIA, WALTER 1935-

415 Bourdon, David. "Walter DeMaria: The Singular Experience." ART INTERNATIONAL 12 (December 1968): 39-43 and following. Illus.

> Carefully describes and analyzes several specific objects from DeMaria's work, discussing their relationships to other art movements and their implications for future explorations.

Further bibliography: Tuchman (see 239); Hunter (see 156); Whitney, 200 YEARS (see 86).

DE RIVERA, JOSE RUIZ 1904-

416 Ashton, Dore. "Sculpture of José DeRivera." ARTS MAGAZINE 30

(April 1956): 38–41. Illus.

Incorporating commentary by the artist, Ashton provides an articulate exploration of DeRivera's aesthetic and artistic principles. Discusses his use of materials and subject matter.

417 Gordon, John. JOSE DE RIVERA. New York: American Federation of Arts, 1961. 52 p. Illus. of 25 works.

Small monographic booklet to accompany a circulating exhibition of DeRivera's work. Includes a statement by the artist, a chronology, and a bibliography (pp. 27–29).

418 LaJolla Museum of Contemporary Art. JOSÉ DE RIVERA RETROSPECTIVE EXHIBITION, 1930-1971. LaJolla, Calif.: 1972. 48 p. Chiefly illus.

Catalog for an exhibition which traveled to the Whitney Museum. Introductory essay by Thomas S. Tibbs. Fifty of the 191 works in the exhibition are illustrated.

Further bibliography: Hirshhorn (see 168); Tuchman (see 239); Whitney, 200 YEARS (see 86).

DEXTER, HENRY 1806-76

419 Albee, John. HENRY DEXTER, SCULPTOR . . . A MEMORIAL. Cambridge, Mass.: Privately printed, 1898.

A regrettably old study of one of the earliest native American sculptors. Albee, a friend and admirer, has generously quoted from Dexter's own writings. Catalog of 199 of Dexter's works (pp. 111-17).

DINE, JIM 1935-

420 Gordon, John. JIM DINE. New York: Praeger Publishers for the Whitney Museum of American Art, 1970. [96]p. Illus.

Catalog of Dine's first retrospective exhibition. Although Dine is known principally as a painter, this catalog records his work in a wide variety of media (including sculpture and assemblage). Exhibition list. Extensive four-page bibliography by Libby Seaberg.

Further bibliography on Dine as a painter: Keaveney, AMERICAN PAINTING.

DI SUVERO, MARK 1933-

421 Baker, Elizabeth [C.]. "Mark DiSuvero's Burgundian Season." ART IN

AMERICA 62 (May/June 1974): 59-63. Illus.

Reviews the six pieces DiSuvero made during his year-long stay in France.

422　Geist, Sidney. "New Sculptor: Mark DiSuvero." ARTS MAGAZINE 35 (December 1960): 40-43. Illus.

Enthusiastic review of DiSuvero's first exhibition in New York. Perceptively evaluates his materials and style.

423　Kozloff, Max. "Mark DiSuvero: Leviathan." ARTFORUM 5 (June 1967): 41-46. Illus.

Thorough discussion of the artist's work since 1960.

424　Ratcliff, Carter. "Mark DiSuvero." ARTFORUM 11 (November 1972): 34-42. 18 illus.

Written on the occasion of the 1972 DiSuvero exhibition in Eindhoven, Holland, this lengthy essay traces the artist's development from the early 1960s.

424a　Whitney Museum of American Art (New York). MARK DI SUVERO. Exhibition catalog by James K. Monte. New York: 1975. 92 p. Illus. Paperback.

Catalog for DiSuvero's first one-man museum exhibition in the United States. Monte briefly reviews DiSuvero's life and career before evaluating the work stylistically. Twelve sculptures in the exhibition were installed temporarily at outdoor sites throughout New York's five boroughs. Excellent black-white photographs. List of exhibitions. Bibliography (pp. 90-92).

Further bibliography: Tuchman (see 239); Hunter (see 156); Whitney, 200 YEARS (see 86).

DUCHAMP, MARCEL 1887-1968

425　Cabanne, Pierre. DIALOGUES WITH MARCEL DUCHAMP. Translated from the French by Ron Padgett. Documents of Twentieth Century Art. New York: Viking Press, 1971. 136 p. Illus.

Contains interviews, done in 1966, which constitute a revealing portrait of Duchamp and a useful introduction to his work. Introduced by Robert Motherwell with a preface by Salvador Dali and an "Appreciation" by Jasper Johns. Extensive chronology. Selected bibliography by Bernard Karpel (pp. 121-32).

426* D'Harnoncourt, Anne, and McShine, Kynaston [L.], eds. MARCEL DUCHAMP. New York: Museum of Modern Art and the Philadelphia Museum of Art, 1973. Distributed by New York Graphic Society, Greenwich, Conn. 348 p. Illus.

> Outstanding monograph which accompanied the 1973 Duchamp retrospective. Essays contributed by Duchamp scholars and friends: Richard Hamilton ("The 'Large Glass'"), Arturo Schwarz, Robert Lebel ("Duchamp and André Breton"), Octavio Paz, Lucy Lippard, and several others. Bibliography by Bernard Karpel (pp. 327-35).

427 Duchamp, Marcel. SALT SELLER: THE WRITINGS OF MARCEL DUCHAMP. Edited by Michel Sanouillet and Elmer Peterson. New York: Oxford University Press, 1973. xii, 196 p. Illus.

> A completely translated collection of the signed and published writings of Duchamp. Includes a translation of the 1958 MARCHAND DU SEL as well as later writings from L'INFINITIF (1966). A large portion of the writings relate to Duchamp's major work, "The Large Glass."

428 Lebel, Robert. MARCEL DUCHAMP. Translated from the French by George Heard Hamilton. New York: Grove Press, 1959. 191 p. Illus.

> Lebel's thorough biographical study is supplemented by the following well-known essays: "Creative Act" by Duchamp, "Lighthouse of the Bride" by Breton, "Souvenir of Marcel Duchamp" by H.P. Roché. Illustrations of the major works and a catalog raisonné are standard resources. The bibliography is exhaustive on writings about Duchamp (pp. 177-88).

429 Pasadena Art Museum. MARCEL DUCHAMP, A RETROSPECTIVE EXHIBITION: BY OR OF MARCEL DUCHAMP OR RROSE [sic.] SELAVY. Text by Walter Hopps. Pasadena, Calif.: 1963. [58]p. Illus.

> The first comprehensive retrospective exhibition which includes over one hundred paintings, sculptures, drawings, letters, and "things." Catalog text consists of reproductions of parts of Lebel's book (above), corrected in hand by Duchamp. The thirty-five pieces illustrated are among the less well-known of Duchamp's works.

430 Schwarz, Arturo. THE COMPLETE WORKS OF MARCEL DUCHAMP. New York: Harry N. Abrams, 1969. 630 p. 765 illus. Oversized. Index.

> This authoritative monograph discusses Duchamp's work as it led up to and emanated from "The Large Glass." Works not particularly crucial in that progression, however, are discussed fully in the illustrated "Critical Catalogue Raisonné" (pp. 372-580). The entries in this catalog are more numerous and more

fully descriptive than in Lebel's catalog. Index to the locations of Duchamp's works. Exhaustive bibliography of Duchamp's own writings (pp. 583-606). A more general "Bibliography of Works Quoted" (pp. 607-17).

431 Tate Gallery (London). THE ALMOST COMPLETE WORKS OF MARCEL DUCHAMP. London: Arts Council of Great Britain, 1966. 110 p. Illus.

Retrospective catalog of 244 items with an introduction and essay by Richard Hamilton. The information in the catalog only occasionally deviates from Lebel's more extensive catalog raisonné (1959). Annotated bibliography, compiled by Arturo Schwarz, "of items written and/or spoken by the artist, not items written about or on the artist" (pp. 92-109).

432 Tomkins, Calvin. THE BRIDE AND THE BACHELORS: FIVE MASTERS OF THE AVANT-GARDE. New York: Viking Press, 1968. 306 p. Illus.

A witty, intelligent look at the five masters (Cage, Duchamp, Cunningham, Rauschenberg, Tinguely) who capitalized on the antiserious in their revolutionary work. The Duchamp chapter (pp. 9-68) appeared in a modified format in the NEW YORKER, February 6, 1965.

433* _____. THE WORLD OF MARCEL DUCHAMP. Time-Life Library of Art. New York: 1966. 192 p. Illus. Index.

Excellent introductory text describing the influence of Duchamp on contemporary art. Tompkins is especially thorough when discussing Dada and surrealism. The illustrations include works by many artists besides Duchamp. Bibliography (p. 185). Chronology (p. 184).

Further bibliography: Giedion-Welcker (see 152).

EAKINS, THOMAS COWPERTHWAIT 1844-1916

434 Corcoran Gallery of Art (Washington, D.C.). THE SCULPTURE OF THOMAS EAKINS. By Moussa M. Domit. Washington, D.C.: 1969. viii, 66 p. Illus. Paperback.

Catalog to accompany the first exhibition of Eakin's sculpture. Primarily a painter, Eakins executed ten complete sculptures and about seventeen studies. Biography and selected bibliography (pp. 64-65).

435 Hendricks, Gordon. THE LIFE AND WORK OF THOMAS EAKINS. New York: Grossman, 1974. 397 p. Illus. Index.

Major study, profusely illustrated, which discusses Eakins as

a painter, photographer, and an occasional sculptor. Chronology. Checklist of works in public and nonpublic collections. General bibliography (pp. 305-14).

Further bibliography: Whitney, 200 YEARS (see 86); (on Eakins as a painter) Keaveney, AMERICAN PAINTING.

EDMONDSON, WILLIAM 1883-1951

436 Fuller, Edmund L. VISIONS IN STONE: THE SCULPTURE OF WILLIAM EDMONDSON. Pittsburgh: University of Pittsburgh Press, 1973. 123 p. 108 illus.

Brief biographical sketch of Edmondson, a black, untutored Tennessee sculptor who carved simple, direct limestone forms. Excellent photographs.

EDWARDS, MELVIN 1937-

437 Wadsworth Atheneum. GILLIAM/EDWARDS/WILLIAMS: EXTENTIONS. Hartford, Conn.: 1974. 39 p. Illus. Paperback.

Catalog of a group show which illustrates five of Edward's sculptural works and provides a useful exhibition list and bibliography (p. 30). Introductory essay by Jackie Serwer. Short statement by the artist.

ERNST, MAX 1891-1976

438 "Hommage to Max Ernst." Edited by Gualtieri di San Lazzaro. A special issue of XXe SIECLE REVIEW. New York: XXe SIECLE, 1971. 132 p. Illus. Text in English and French.

The article by René de Solier, "Max Ernst's Sculptures" (pp. 127-31), studies the sculptural work from 1959 to 1961. The psychological and symbolic implications of the work are explored. This special issue is not part of the regular XXe SIECLE series.

439 Jewish Museum (New York). MAX ERNST: SCULPTURE AND RECENT PAINTING. Edited by Sam Hunter. New York: 1966. 68 p. Illus.

Exhibition catalog which describes the "recent painting and entire Surrealist sculptural oeuvre" of Ernst. Lucy R. Lippard's essay "The Sculpture" (pp. 37-56) provides a useful discussion of the anthropological and mythical sources of Ernst's sculpture. (Much of the material in Lippard's essay is contained in an article in ART INTERNATIONAL II [February 1967].) Bibliography (pp. 65-68).

440* Russell, John. MAX ERNST: LIFE AND WORK. New York: Harry N. Abrams, 1967. 359 p. Illus. Index.

> Introductory book to Ernst's life and work. Chapter 13 is entitled "Max Ernst as Sculptor" (pp. 203-8). Biographical notes. Bibliography (pp. 336-41).

441 Schneede, Uwe M. MAX ERNST. Translated by R.W. Last. New York: Praeger Publishers, 1973. 216 p. Illus. Index of names.

> Basically an expanded chronology, extensively illustrated, which traces the development of Ernst's art. Schneede attempts to discuss each phase of Ernst's work against its political and artistic background. Selected bibliography (pp. 204-5).

442 Solomon R. Guggenheim Museum (New York). MAX ERNST: A RETROSPECTIVE. Text by Diane Waldman. New York: 1975. 271 p. Illus. Paperback.

> The most comprehensive retrospective of Ernst's work ever attempted--over 300 items (all of which are illustrated). Several works of sculpture support Waldman's contention that Ernst upholds the true spirit of Dada and surrealism. Chronology. Selected bibliography and exhibitions list compiled by Sabine Rewald (pp. 257-69).

ESCOBAR, MARISOL. See MARISOL

FERBER, HERBERT 1906-

443 Ferber, Herbert. "On Sculpture." ART IN AMERICA 42 (December 1954): 262-65 and following. Illus.

> Ferber defines the characteristics of modern sculpture as distinct from the older forms; he discusses its "meaning" and its materials. The statement is illustrated with photographs of Ferber's work.

444* Goossen, Eugene C. "Herbert Ferber." In THREE AMERICAN SCULPTORS, by E.C. Goossen et al., pp. 7-26 and following. New York: Grove Press, 1959. 13 illus.

> Goossen discusses individual works and how they reflect Ferber's aesthetic. Biographical note.

445 Tuchman, Phyllis. "An Interview with Herbert Ferber." ARTFORUM 9 (April 1971): 52-57. Illus. of 11 works.

> Tuchman probes Ferber's attitudes about sculpture during the past thirty years, his vision of its recent developments, and the goals of his art.

446 Walker Art Center (Minneapolis, Minn.). THE SCULPTURE OF HERBERT FERBER. Minneapolis: 1962. 64 p. Illus. Paperback.

> Ferber's artistic development is thoroughly explored by Wayne V. Andersen in the catalog essay. (Andersen's comments on Ferber's "Environmental Sculpture" are reproduced in ART IN- TERNATIONAL 6 [September 1962].) More than forty-five photographs accompany the essay. A basic catalog raisonné, a full chronology, and a useful bibliography (pp. 62-64) complete the catalog.

Further bibliography: Giedion-Welcker (see 152); Craven (see 60); UCSB (see 180); Whitney, 200 YEARS (see 86).

FERNANDEZ, ARMAND. See ARMAN

FERRER, RAFAEL 1933-

447 Cincinnati. Contemporary Arts Center. DESEO: AN ADVENTURE: RAFAEL FERRER. Cincinnati: 1973. 56 p. Illus.

> "Deseo is another episode in the artist's unfolding exploration of the unknown . . .," a sort of mythical situation set up by Ferrer and explained/interpreted by Carter Ratcliff. "Autobiog- raphy" by Ferrer (pp. 48-55). List of exhibitions. Bibliog- raphy (p. 56).

448 Pennsylvania. University. Institute of Contemporary Art (Philadelphia). RAFAEL FERRER: ENCLOSURES. Philadelphia: 1971. 20 p. Illus. Paperback.

> Exhibition catalog which contains a perceptive interview, con- ducted by Stephen S. Prokopoff, clarifying Ferrer's sources and his goals. Eleven of his environmental pieces (dating from 1968 to 1971) are illustrated. List of exhibitions is included.

449 Prokopoff, Stephen. "Rafael Ferrer: An Interview." ART AND ARTISTS 7 (April 1972): 36-43. 6 illus.

> Discusses the materials Ferrer chooses to use as well as his sense of time and of change.

FLANNAGAN, JOHN BERNARD 1895-1942

450 Arnason, H.H[oward]. "John Flannagan, Reappraised." ART IN AMERI- CA 48 (Spring 1960): 64-69. Illus. of 7 works.

> Attempts to determine Flannagan's place in American sculpture and his relationship to the rest of the art world of the 1920s and 1930s.

451 Flannagan, John. "The Image in the Rock." MAGAZINE OF ART 35 (March 1942): 90-95. Illus. of 12 works.

> Flannagan's personal credo, outlining his artistic and aesthetic beliefs.

452 Forsyth, Robert J. "The Early Flannagan and Carved Furniture." ART JOURNAL 27 (Fall 1967): 34-39. Illus.

> A study of the forms and the images which Flannagan used in his early experimental furniture carvings. Forsyth explores the variety of visual sources which interested the sculptor during the 1923-25 period.

453* New York. Museum of Modern Art. THE SCULPTURE OF JOHN B. FLANNAGAN. Edited by Dorothy C. Miller. New York: 1942. 40 p. Illus. Reprint (with 4 other catalogs). FIVE AMERICAN SCULPTORS. New York: Arno Press, 1969.

> This heavily illustrated exhibition catalog describes and praises Flannagan's work. Flannagan's drawings are related to his completed sculptures. Brief statement by Flannagan. Chronology.

454 Valentiner, W[ilhelm]. R[einhold]. THE LETTERS OF JOHN B. FLANNAGAN. New York: Curt Valentin, 1942. 103 p. Illus.

> In an introductory essay Valentiner praises Flannagan's quiet, self-contained sculptural style. Flannagan's letters (dated 1929 to 1941) are an articulate record of his aesthetics, his working habits, and his personal life. Many of the letters are addressed to Carl Zigrosser, the distinguished art connoisseur and critic.

455 Weyhe Gallery (New York). JOHN B. FLANNAGAN: SCULPTURE AND DRAWINGS, 1924-1938. St. Paul, Minn.: Museum of Art, 1973. 32 p. Illus. Paperback.

> Catalog for a retrospective exhibition in New York and St. Paul of forty-five sculptures and fifteen drawings by Flannagan. The biographical introduction is by Robert J. Forsyth, and Flannagan's important "Image in the Rock" essay (see 451) is reprinted.

Further bibliography: Index-20th Cent. (see 33), vol. 3, p. 299 and supplement; Whitney, 200 YEARS (see 86).

FLAVIN, DAN 1933-

456 Cologne. Kunsthalle and Wallraf-Richartz-Museum. DAN FLAVIN:

THREE INSTALLATIONS IN FLORESCENT LIGHT. Cologne, Germany: 1973. 116 p. Illus. Paperback. Text in German and English.

> Outstanding description of Flavin's work done between 1962 and 1973. An extensive selection of his writings (pp. 82-116). Lengthy captions accompany the photographs. Bibliography (pp. 76-78).

457 Flavin, Dan. "some remarks . . . excerpts from a spleenish journal" ARTFORUM 5 (December 1966): 27-29. Illus.

> Rather irreverant remarks about the art world and his reactions to it; also a witty commentary on daily events.

458 _____. "some other comments . . . more pages from a spleenish journal." ARTFORUM 6 (December 1967): 20-25. Illus.

> More of the above.

459 Ottawa. National Gallery of Canada. FLORESCENT LIGHT, ETC., FROM DAN FLAVIN. Organized by Brydon Smith. Ottawa: 1969. 272 p. 110 illus. Text in French and English.

> A major retrospective exhibition of 114 works which traveled to the Vancouver Art Gallery and the Jewish Museum (New York). Essays include: "Less is Less (for Dan Flavin)" from ART AND ARTISTS 1 (December 1966), by Mel Bochner; an article by Donald Judd on Flavin's use of fluorescent tubing; and an autobiographical sketch by Flavin himself, ". . . in daylight and cool white" from ARTFORUM 4 (December 1965). List of exhibitions. "Selected Catalogues and Reviews" supplements the extensive bibliography (pp. 257-69).

460 Saint Louis Art Museum. [DAN FLAVIN]. 2 vols. DRAWINGS AND DIAGRAMS, 1963-1973 (94 p.) and CORNERS, BARRIERS, AND CORRIDORS IN FLUORESCENT LIGHT (56 p.). Organized by Emily S. Rauh. St. Louis, Mo.: 1973. Illus. Paperback.

> Brief commentary introduces this exhibition of Flavin's drawings and related fluorescent pieces. Although the introduction is brief, entries in both volumes of the catalog are well documented and annotated; several are illustrated. Each pamphlet has its own bibliography compiled by Donald C. Peirce. Volume 1 has a drawings bibliography (pp. 91-94) which covers the 1961-73 period. The bibliography in volume 2 only supplements the resources listed in the catalog for the Ottawa show (see entry above).

Further bibliography: Tuchman (see 239); Hunter (see 156); Whitney, 200 YEARS (see 86).

FOLEY, MARGARET d. 1887

461 Chatterton, Elsie B. "A Vermont Sculptor." NEWS AND NOTES (Vermont Historical Society) 7 (October 1955): 9-14. Illus.

> Sketchy biographical information on this nineteenth-century sculptor who spent part of her professional career in Rome.

Further bibliography: Gerdts-Neoclassic (see 123).

FORAKIS, PETER 1927-

462 Alloway, Lawrence. "Peter Forakis Since 1960: Notes On His Retrospective at Windham College, Vermont." ARTFORUM 6 (January 1968): 25-29. Illus.

> Briefly traces Forakis's development from "painting and Junk Culture to sculpture." Eleven works illustrated.

Further bibliography: Tuchman (see 239).

FRASER, JAMES EARLE 1876-1953

463 Kennedy Galleries (New York). JAMES EARLE FRASER: AMERICAN SCULPTOR; A RETROSPECTIVE EXHIBITION OF BRONZES FROM WORKS OF 1913 TO 1953. By Martin Bush. New York: 1969. 64 p. 30 illus.

> Biographical information and sculptural accomplishments are presented together in a single essay. No footnotes or bibliography.

464 Krakel, Dean Fenton. "END OF THE TRAIL": THE ODYSSEY OF A STATUE. Norman: University of Oklahoma Press, 1973. 196 p. Illus. Paperback. Index.

> Through his efforts to save Fraser's famous "End of the Trail," Krakel accumulated a great deal of information about the statue, its artist, his wife Laura Gardin, and their life together as sculptors. Krakel's primary interest is not art history, but he provides a vast amount of documentation. Listings and illustrations of the major works by Fraser and his wife are included.

465 Semple, Elizabeth Anna. "James Earle Fraser, Sculptor." CENTURY MAGAZINE n.s. 57 (April 1910): 929-32. 5 illus.

> Briefly outlines Fraser's life and artistic training. Describes his work done in relief.

Further bibliography: Brookgreen (see 141); Craven (see 60); Broder (see 58); Whitney, 200 YEARS (see 86).

FRAZEE, JOHN 1790-1852

466 Frazee, John. "The Autobiography of John Frazee." AMERICAN COL-
LECTOR 15 (September 1946): 15 and following; (October 1946): 10 and
following; and (November 1946): 12 and following.

> Excerpts from manuscripts in the New Jersey Historical Society
> and the New York Public Library which form an autobiography
> of this well-known New York gravestone carver. Frazee often
> is claimed to be the "First American Sculptor in Marble."
> Writings are anecdotal and interesting; parts 1 and 2 deal with
> Frazee's childhood and struggle to become a sculptor. Part 3
> discusses the realistic portrait busts done in his maturity.

Further bibliography: Craven (see 60); Gerdts-Neoclassic (see 123); Whitney,
200 YEARS (see 86).

FRENCH, DANIEL CHESTER 1850-1931

467 Adams, Adeline [Valentine Pond]. DANIEL CHESTER FRENCH: SCULP-
TOR. Boston: Houghton Mifflin Co., 1932. 90 p. 32 illus.

> Personal stories and anecdotes make up a large part of the
> biographical material in this book. A well-known critic of
> the day, Adams discusses the progress and quality of French's
> sculpture, never challenging his esteemed reputation. Excel-
> lent illustrations.

468* Cresson, Margaret French. THE LIFE OF DANIEL CHESTER FRENCH:
JOURNEY INTO FAME. Cambridge, Mass.: Harvard University Press,
1947. 331 p. Illus.

> An entertaining biography by French's daughter, also a sculp-
> tor, which includes favorite family stories as well as material
> regarding French's sculptural commissions. A complete listing
> of French's work (pp. 305-13) amplifies the numerous photo-
> graphs scattered throughout the book.

469 French, Mary A. MEMORIES OF A SCULPTOR'S WIFE. Boston: Hough-
ton Mifflin Co., 1928. 294 p. Illus. Index.

> Anecdotal autobiography which provides a vivid description of
> the social and cultural world in which the Frenches partici-
> pated. Discussion of French's sculpture is secondary.

470 Richman, Michael. "The Early Public Sculpture of Daniel Chester French."
AMERICAN ART JOURNAL 4 (November 1972): 96-115. Illus.

Detailed article discussing the artistic development found in French's public work executed between 1873 ("Minute Man") and 1892 (the Milmore memorial).

471 Taft, Lorado. "Daniel Chester French, Sculptor." BRUSH AND PENCIL 5 (January 1900): 145-63. 17 illus.

Review of French's life, career, and major works by one of his contemporaries, the sculptor/critic Taft. Catalogs French's works, the circumstances of their creation, their reception, etc.

Further bibliography: Index-20th Cent. (see 33), vol. 2, pp. 113-21 and supplement; Brookgreen (see 141); Whitney, 200 YEARS (see 86).

GABO, NAUM 1890-

472* GABO: CONSTRUCTIONS, SCULPTURE, PAINTINGS, DRAWINGS, EN-GRAVINGS. Cambridge, Mass.: Harvard University Press, 1957. 193 p. 132 plates.

Introduced by Herbert Read and Leslie Martin, this volume documents, both visually and verbally, Gabo's career. Included are a facsimile and a translation of the "Realist Manifesto, 1920"; Gabo's "The Constructive Idea in Art" (from CIRCLE, 1937); "Toward a Unity of the Constructive Arts" (from PLUS, 1938); "Sculpture: Carving and Construction in Space" (from CIRCLE, 1937); "On Constructive Realism" (from THREE LECTURES ON MODERN ART, 1949); and "Art and Science" (from NEW LANDSCAPE, 1956, ed. by G. Kepes). Also reprints an exchange of letters between Gabo and Herbert Read, and a 1956 interview. Biographical notes. Extensive bibliography by Bernard Karpel (pp. 187-93).

473 New York. Museum of Modern Art. NAUM GABO, ANTOINE PEVS-NER. Text by Ruth Olson and Abraham Chanin. New York: 1948. 83 p. Illus. Paperback.

Herbert Read, in the introduction to this exhibition catalog. Traces each artist's development. Bibliography by H.B. Müller (pp. 48-49).

474 Rickey, George. CONSTRUCTIVISM: ORIGINS AND EVOLUTION. New York: George Braziller, 1967. 305 p. Illus.

In this major study of constructivism, Gabo is discussed at length because he was the "clearest, deepest and most revolutionary thinker of the movement." Includes an extensive bibliography (pp. 247-300).

Further bibliography: Giedion-Welcker (see 152).

Individual Sculptors

GALLO, FRANK 1933-

475 Danenberg Contemporaries Gallery (New York). FRANK GALLO: SMALL SCULPTURES, ORIGINAL GRAPHICS. New York: 1972. 16 p. 20 illus. Paperback.

> A brief introduction to Gallo's epoxy-resin sculptures accompanies this portfolio of photographs. The essay is reprinted from the 1970 exhibition catalog, DE LAP, GALLO, HESSE (an exhibition presented by the Owens-Corning Fiberglass Center, New York City).

476 Graham Gallery (New York). FRANK GALLO. New York: 1965.

> Gallery announcement which contains illustrations of eight of Gallo's sculptures.

477 Holden, Donald, and Gallo, Frank. "Frank Gallo Makes His Own Rules: An Interview with Donald Holden." AMERICAN ARTIST 36 (March 1972): 52-60. 8 illus.

> Gallo discusses the influence of his life and his education on his work. The technical procedures which Gallo uses are explained and their effect described.

Further bibliography: Recent Figure (see 222).

GINNEVER, CHUCK 1931-

478 Alloway, Lawrence. "Chuck Ginnever." ARTFORUM 6 (September 1967): 36-39. Illus.

> Introduces the characteristics of Ginnever's sculpture and discusses his artistic development.

479 Baker, Kenneth. "Chuck Ginnever." ARTFORUM 10 (January 1972): 46-48. Illus.

> Reviews two works at the Paula Cooper Gallery (New York) and discusses the implications of these examples of Ginnever's new work.

GOTO, JOSEPH 1920-

480 Kuh, Katharine. "Joseph Goto." ART IN AMERICA 42 (Winter 1954): 33-35 and following. 5 illus.

> Brief description of Goto's welded sculptures and his aesthetic outlook.

481 Rhode Island School of Design (Providence). JOSEPH GOTO.
 Providence: 1971. 43 p. Illus. Paperback.

> Introduction, by William Jordy, outlines Goto's life and ex-
> plores his artistic development by referring to specific works,
> many of which are illustrated.

GRAFLY, CHARLES 1862-1929

482 Dallin, Vittoria C. "Charles Grafly's Work." NEW ENGLAND MAGA-
 ZINE 25 (October 1901): 228-35. 7 illus.

> Describes the appearance of Grafly's major works and wonders
> at their symbolism.

483 Pennsylvania Academy of Fine Arts. MEMORIAL EXHIBITION OF WORK
 BY CHARLES GRAFLY. Philadelphia: [1930]. 15 p. Illus.

> Short biographical outline and a listing of Grafly's major
> works precede the twenty-four pages of photographs.

484 Taft, Lorado. "Charles Grafly, Sculptor." BRUSH AND PENCIL 3
 (March 1899): 343-53. Illus.

> Taft, a fellow sculptor, chats enthusiastically about Grafly's
> talent, personality, and work. The events and achievements
> of Grafly's life are also presented.

Further bibliography: Brookgreen (see 141); Whitney, 200 YEARS (see 86).

GRAHAM, ROBERT 1938-

485 Dallas Museum of Fine Arts. ROBERT GRAHAM. Dallas, Tex.: 1972.
 16 p. Illus. of 12 works.

> Catalog for Graham's first one-man museum show. Introductory
> essay by Robert Murdock discusses Graham's use of space and
> scale. Biographical outline. List of exhibitions. Bibliography
> (p. 16).

486 Winer, Helene. "Robert Graham's Boxes." STUDIO INTERNATIONAL
 179 (May 1970): 216-17.

> Describes the physical characteristics and positioning of Gra-
> ham's nudes within his plexiglass boxes. The scale and orga-
> nization is discussed.

GRAVES, NANCY STEVENSON 1940-

487 Pennsylvania. University. Institute of Contemporary Art (Philadelphia). NANCY GRAVES: SCULPTURE AND DRAWING, 1970-1972. Philadelphia: 1972. 20 p. Illus. Paperback.

 Exhibition catalog with essays by Yvonne Rainer, dancer, and Martin W. Cassidy, a natural historian. Nine pieces of sculpture are illustrated. Biography. List of exhibitions. Short bibliography.

488 Richardson, Brenda. "Nancy Graves: A New Way of Seeing." ARTS MAGAZINE 46 (April 1972): 57-61. 10 illus.

 Seeks to clarify the extent of Graves's interest in ethnography by reviewing her career, especially her paintings and drawings.

489 Tuchman, Phyllis. NANCY GRAVES: SCULPTURE/DRAWINGS/FILMS, 1969-1971. Aachen, Germany: Neue Galerie im Alten Kurkaus, 1971. [156]p. Illus. Paperback.

 Primarily a photographic documentation of Graves's work, 1967-71, which deals largely with camels and animal bones. Excerpts from Graves's taped commentary on the origin and development of a single work, "Variability of Similar Forms."

490 Wasserman, Emily. "A Conversation with Nancy Graves." ARTFORUM 9 (October 1970): 42-47. Illus.

 Introduced by Wasserman, this interview explores Graves's use of animal imagery and anthropological referents.

Further bibliography: Whitney, 200 YEARS (see 86).

GREENLY, COLIN 1928-

491 Andrew Dickson White Museum of Art. Cornell University. COLIN GREENLY: INTANGIBLE SCULPTURE. Ithaca, N.Y.: 1972. 20 p. Paperback.

 Composed primarily of Greenly's recent intangible sculpture, i.e., photographs of the landscape with abstract energy signs superimposed. Introduction by Thomas W. Leavitt. Biographical information. List of exhibitions.

492 Corcoran Gallery of Art (Washington, D.C.). COLIN GREENLY. Washington, D.C.: 1968. 16 p. Illus.

 Eight works from Greenly's 1964-67 period are illustrated. The basis for his "Supercircle" is discussed by James Harithas, as are the more recent glass and aluminum sculptures.

GREENOUGH, HORATIO 1805-52

493 Crane, Sylvia E. WHITE SILENCE: GREENOUGH, POWERS, AND CRAWFORD; AMERICAN SCULPTORS IN NINETEENTH CENTURY ITALY. Coral Gables, Fla.: University of Miami Press, 1972. Illus.

> Well-documented biography of Greenough (pp. 35–166) and his relationship to other American artists in Italy. Appendix includes manuscript sources as well as a complete bibliography of secondary sources. List of works is included. (See citation 121).

494 Greenough, Frances Boott, ed. LETTERS OF HORATIO GREENOUGH TO HIS BROTHER, HENRY GREENOUGH. Boston: Ticknor & Co., 1887. Reprint. New York: DaCapo Press, 1970. 250 p.

> Contains seventy of Greenough's letters, a biographical sketch, and a few other family letters. Covering the 1825-84 Italian period, this collection records Greenough's social and political observations as well as his aesthetic deliberations. Complementary to Tuckerman's MEMORIAL (see 497).

495 Greenough, Horatio [Horace Bender]. TRAVELS, OBSERVATIONS, AND EXPERIENCE OF A YANKEE STONECUTTER. 1852. Facsimile reprint. Gainesville, Fla.: Scholars' Facsimiles and Reprints, 1958. 238 p.

> A collection of Greenough's own essays written under his pseudonym dealing with aesthetics, artistic taste in various cultures, and architectural functionalism. Brief, factual introduction to the facsimile edition by Nathalia Wright.

496 Proske, Beatrice Gilman. "Horatio Greenough's 'Bacchus'." AMERICAN ART JOURNAL 6 (May 1974): 35-38. Illus.

> Proske considers probable sources of inspiration for Greenough's 1819 "Bacchus," based on available documentary resources.

497 Tuckerman, Henry [Theodore]. A MEMORIAL TO HORATIO GREENOUGH. New York: G.P. Putnam's Sons, 1853. 245 p.

> A eulogy by Tuckerman, a personal friend, and tributes by Allston, Dana, and others. Includes essays by Greenough himself on aspects of American art and the aesthetics of beauty.

498* Wright, Nathalia. HORATIO GREENOUGH, THE FIRST AMERICAN SCULPTOR. Philadelphia: University of Pennsylvania Press, 1963. 382 p. Illus. Index.

> Extensively documented biography of Greenough which draws on family papers as well as public documents. Discusses

Greenough's artistic output, his architectural theories, and his "Yankee philosophy." Two-thirds of the known, extant Greenough sculptures are represented by photographs. Bibliographic references are included in the "Notes" (pp. 307-58).

499 _____, ed. LETTERS OF HORATIO GREENOUGH, AMERICAN SCULPTOR. Madison: University of Wisconsin Press, 1972. 485 p. Index.

Includes complete texts of all 241 located Greenough letters, with the exception of the three published in his TRAVELS and the letters found in Frances B. Greenough's 1887 collection. From 1825 to 1852 Greenough corresponded with literary figures of the day (Allston, Bryant, Cooper, Emerson) as well as his patrons and government employers. The collection is carefully edited and includes a list of known, but unrecovered, letters.

Further bibliography: Gerdts-Neoclassic (see 123); Whitney, 200 YEARS (see 86).

GREENOUGH, RICHARD 1819-1904

500 Brumbaugh, Thomas B. "The Art of Richard Greenough." OLD-TIME NEW ENGLAND 53 (January-March 1963): 60-78. Illus.

A thorough investigation of the art and life of this rather undistinguished sculptor, the younger brother of Horatio. Brumbaugh compares the work of the brothers and feels that Richard's sculpture owes an identifiable debt to Horatio. Bibliographic footnotes.

Further bibliography: Craven (see 60); Gerdts-Neoclassic (see 123).

GRIPPE, PETER 1912-

501 Grippe, Peter. "Enter Mephistopheles, with Images." ART NEWS 59 (October 1960): 45-47 and following. Illus.

"Grippe gives an account of the changing concepts which lead him to produce his very tactile Mephistopheles series." Grippe acknowledges the importance of his City theme (from the mid-1930s) to the development of his work.

GROOMS, RED 1937-

502 Berrigan, Ted. "Red Power." ART NEWS 65 (December 1966): 44-46. 9 illus.

Characterizes the friendliness and incisiveness of Grooms's environments.

503 Glueck, Grace. "Red Grooms, the Ruckus Kid." ART NEWS 72 (December 1973): 23-27. Illus.

> A lively review of Grooms's work exhibited at Rutgers University and later at the New York Cultural Center. Glueck outlines the wide variety of critical opinion which has greeted both Grooms's happenings and his environments of painted cutout figures.

Further bibliography: Recent Figure (see 222).

GROSS, CHAIM 1904-

504* Getlein, Frank. CHAIM GROSS. New York: Harry N. Abrams, 1974. 235 p. 251 illus.

> A major, profusely-illustrated, biography which emphasizes the political and artistic milieu in which Gross developed. A biographical outline (pp. 61-70) concisely relates the specifics of his life. Changes in technique and style are sympathetically discussed and beautifully illustrated. Gross himself compiled the selected bibliography (pp. 233-35).

505 Goodrich, Lloyd. "Chaim Gross." In FOUR AMERICAN EXPRESSIONISTS, pp. 53-68. New York: Whitney Museum of American Art, 1959. Illus.

> Goodrich describes the challenges of Gross's life and the success of his sculptural works.

506 Gross, Chaim. THE TECHNIQUE OF WOOD SCULPTURE. New York: Vista House, 1957. 136 p. 50 illus.

> Primarily an introduction and guide to the technique, tools, and materials of wood carving. Includes a brief personal autobiographical statement, "Becoming a Sculptor of Wood" (pp. 41-45).

507 Lombardo, Josef V. CHAIM GROSS, SCULPTOR. New York: Dalton House, 1949. vii, 247 p. 142 illus.

> Provides a careful, insightful analysis of the influences (artistic and biographical) which had shaped Gross's work by the time he was forty years old. Lombardo describes Gross's style and attempts a "careful critical study" of some principal works. "Catalogue Raisonné, 1926-1949" (pp. 227-35). Bibliography not restricted to material on Gross (pp. 237-42).

508 National Collection of Fine Arts. Smithsonian Institution. CHAIM GROSS: SCULPTURE AND DRAWINGS. Washington, D.C.: Smithsonian

Institution Press, 1974. 47 p. Illus. Paperback.

Catalog for an important exhibition of seventy-two sculptures
and drawings done between 1926 and 1970. A biographical
introduction by Janet A. Flint gives the highlights of Gross's
life. Selected bibliography (pp. 43-45).

Further bibliography: Whitney, 200 YEARS (see 86).

GROSSMAN, NANCY 1940-

509 Nemser, Cindy. "Nancy Grossman." In her ART TALK: CONVERSA-
TIONS WITH 12 WOMEN ARTISTS, pp. 326-55. New York: Charles
Scribner's Sons, 1975. Illus.

Free-flowing conversation which touches on Grossman's image
of herself as an artist, a sculptor, and a woman. Personal
and artistic development are openly discussed. Bibliography
(pp. 366-67).

510 Robins, Corinne. "Man is Anonymous: The Art of Nancy Grossman."
ART SPECTRUM 1 (February 1975): 33-37. 8 illus.

Describes, illustrates, and proposes explanations of Grossman's
bound-leather male figures. The artist's psychological impetus
is discussed by Robins and by Grossman herself.

Further bibliography: Recent Figure (see 222).

GROSVENOR, ROBERT 1937-

511 Bourdon, David. "Cantilevered Rainbow." ART NEWS 66 (Summer 1967):
28-31 and following. Illus.

Describes and critically evaluates Grosvenor's monumental,
soaring, colored constructions. Biographical information in-
cluded in the essay.

Further bibliography: Tuchman (see 239); 14 Sculptors (see 257); Whitney,
200 YEARS (see 86).

HAGUE, RAOUL 1905-

512 Hess, Thomas B. "Introducing the Sculpture of Raoul Hague." ART
NEWS 53 (January 1955): 19-21 and following. Illus.

Outlines Hague's career and describes his sculptural sensitivi-
ties. Several works are illustrated.

513 Steinberg, Leo. "Torsos and Raoul Hague." In his OTHER CRITERIA: CONFRONTATIONS WITH TWENTIETH-CENTURY ART, pp. 272-76. New York: Oxford University Press, 1972. Illus.

> Essay describing the grace, in feeling and form, of Hague's wooden torsos. (Originally appeared in ARTS MAGAZINE 30 [July 1956], pp. 25-27.)

514 Washington Gallery of Modern Art. RAOUL HAGUE. Washington, D.C.: 1964. 24 p. Illus. of 18 works. Paperback.

> Introduced by Dorothy Miller, this retrospective exhibition contained thirty works (from 1932 to 1964). The essay by Gerald Nordland deals with Hague's life and work. Chronology. Bibliography (p. 22).

HANSON, DUANE 1925-

515 Chicago. Museum of Contemporary Art. JOHN DE ANDREA/DUANE HANSON: THE REAL AND IDEAL IN FIGURATIVE SCULPTURE. Chicago: 1974. [16]p. 30 illus. Paperback.

> Dennis Adrian's essay explores the role of "imitation" in the work of these two verist sculptors.

516 Masheck, Joseph. "Verist Sculpture: Hanson and DeAndrea." ART IN AMERICA 60 (November/December 1972): 90-92. Illus.

> Discusses the artistic and sociological associations implicit in Hanson's realistic figures. A brief interview with Hanson follows (p. 99).

517 Württembergischer Kunstverein (Stuttgart, Germany). DUANE HANSON: [FIRST RETROSPECTIVE OF THE AMERICAN SCULPTOR]. Stuttgart, Germany: 1974. 108 p. Illus. Paperback. Text in German and English.

> Exhibition catalog which contains a catalogue raisonné of Hanson's work between 1967 and 1974. The preface and essay are by Tilman Osterwold. Hanson briefly explains the technical aspects of his work. List of exhibitions. Bibliography.

Further bibliography: Recent Figure (see 222).

HARE, DAVID 1917-

518* Goldwater, Robert. "David Hare." In THREE AMERICAN SCULPTORS, by E.C. Goossen et al., pp. 27-36. New York: Grove Press, 1959. 13 illus.

> Discusses Hare's sculptural form as it has developed since the 1940s. (Originally appeared in ART IN AMERICA, Winter 1956/57.)

519 Goodnough, Robert. "David Hare Makes a Sculpture--'Figure in a Window'." ART NEWS 55 (March 1956): 46-49. Illus.

> As this particular sculpture takes shape, Hare provides commentary and evidence of his working methods, his choices of arrangement, etc.

520 Hare, David. "The Spaces of the Mind." MAGAZINE OF ART 43 (February 1950): 48-53. Illus.

> An important essay by Hare on the character of artistic creation--his own and others.

Further bibliography: Giedion-Welcker (see 152); Hirshhorn (see 168); Whitney, 200 YEARS (see 86).

HART, JOEL TANNER 1810-77

521 Coleman, J. Winston, Jr. "Joel T. Hart, Kentucky Sculptor." ANTIQUES 52 (November 1947): 367. Illus.

> A short biography of this self-made artist who became known for his busts of Andrew Jackson and Henry Clay.

Further bibliography: Craven (see 60); Gerdts-Neoclassic (see 123).

HATCHETT, DUAYNE 1925-

522 Albright-Knox Art Gallery (Buffalo, New York). DUAYNE HATCHETT: RECENT PAINTINGS AND SCULPTURE. Buffalo, N.Y.: 1974. 36 p. Illus.

> Introduction by Douglas G. Schultz traces the shift of Hatchett's aesthetic perception during the previous five years. Seven sculptures illustrated. List of exhibitions. Bibliography (p. 33).

Further bibliography: Tuchman (see 239).

HEBALD, MILTON ELTING 1917-

523 Getlein, Frank. MILTON HEBALD. New York: Viking Press, 1971. 156 p. Illus.

> Presents Hebald's work with many black-white illustrations; also contains a detailed biography.

HEIZER, MICHAEL 1944-

524 "Discussions with Heizer, Oppenheim, Smithson." AVALANCHE, no. 1 (Fall 1970): 48-71. 32 illus.

> Based on discussions held in the winter of 1968/69, this trans-cript reflects each artist's view of his own work and its rele-vance to the rest of contemporary art.

525 [Heizer, Michael.] "The Art of Michael Heizer." ARTFORUM 8 (Decem-ber 1969): 32-39. Illus.

> Photographs of Heizer's earthworks with captions by the artist.

526 Müller, Gregoiré. "Michael Heizer." ARTS MAGAZINE 44 (December 1969/January 1970): 42-45. Illus of 8 works.

> An analysis of the philosophy behind Heizer's "Land Projects," which cites specific projects of 1968 and 1969.

Further bibliography: Whitney, 200 YEARS (see 86).

HERMS, GEORGE 1935-

527 Coplans, John. "Three Los Angeles Artists: Larry Bell, George Herms, Llyn Foulkes." ARTFORUM 1 (April 1963): 29-31. 5 illus.

> Coplans characterizes Herms's work and summarizes the progress of his career.

528 Factor, Don. "George Herms' Zodiac Boxes." ARTFORUM 5 (October 1966): pp. 48-49. Illus. of 5 works.

> Describes and discusses Herms's twelve boxes, each assembled during a different phase of the astrological year.

Further bibliography: UC Irvine (see 217).

HESSE, EVA 1936-70

529 Lippard, Lucy R. "Eva Hesse: The Circle." ART IN AMERICA 59 (May/June 1971): pp. 68-73. Illus.

> Compact chronological review of Hesse's artistic growth and a lucid analysis of her relationship to other artists of the "anti-form" movement, 1965-70.

530 Nemser, Cindy. "Eva Hesse." In her ART TALK: CONVERSATIONS WITH 12 WOMEN ARTISTS, pp. 200-229. New York: Charles

Scribner's Sons, 1975. Illus.

Three interviews, conducted shortly before Hesse's death, pro-
vide insights into the artist's personality and her artistic and
personal struggles. Bibliography (p. 364). Some of this mate-
rial appeared in Nemser's articles in ARTFORUM (May 1970)
and in FEMINIST ART JOURNAL (Winter 1973).

531 Pincus-Witten, Robert. "Eva Hesse: Post-Minimalism Into Sublime."
ARTFORUM 10 (November 1971): 32-44. 17 illus.

Excellent summary of Hesse's personal and artistic development
and her important role in the evolution of post-minimalism.
Pincus-Witten analyzes the imagery, symbolism, and forms of
each phase of Hesse's art, primarily considering work done
after 1965. He judiciously uses information and quotations
from Hesse's notes and journals. Bibliographic footnotes.

532* Solomon R. Guggenheim Museum (New York). EVA HESSE: A MEMORIAL
EXHIBITION. New York: The Solomon R. Guggenheim Foundation, 1972.
108 p. Illus. Paperback.

Robert Pincus-Witten's essay, "Eva Hesse: More Light on the
Transition from Post-Minimalism to the Sublime," elaborates on
his earlier thoughts in ARTFORUM (November 1971) by incor-
porating new material from Hesse's diaries, notebooks, and
papers. Linda Shearer writes on "Eva Hesse: Last Works."
A majority of the eighty-one pieces in the exhibition are il-
lustrated. List of exhibitions and reviews. One-page compre-
hensive bibliography.

Further bibliography: Whitney, 200 YEARS (see 86).

HIGGINS, EDWARD 1930-

533 Adrian, Dennis. "Edward Higgins' New Sculpture." ARTFORUM 5
(January 1967): 38-39. Illus.

Prompted by a gallery exhibition. Five works illustrated.

Further bibliography: Tuchman (see 239).

HOFFMAN, MALVINA 1887-1966

534 Alexandre, Arsène. MALVINA HOFFMAN. Paris: J.E. Pouterman,
1930. 46 p. 56 plates.

A tribute to Hoffman's art and a description of several of her
works. "Chronological List of the Principal Works of Malvina
Hoffman" includes eighty-six pieces.

535 Hoffman, Malvina. HEADS AND TALES. New York: Charles Scribner's Sons, 1936. 416 p. Illus.

> A lively account of the sculptor's around-the-world expedition to locate models (of various races) for the one hundred statues she created for the "Hall of Man" in Chicago's Field Museum. Of sociological, anthropological, biographical, as well as artistic interest.

536 _____. SCULPTURE: INSIDE AND OUT. New York: W.W. Norton, 1939. 330 p. Illus.

> Part 1 contains Hoffman's personal interpretation of the history of world sculpture. She concludes with anecdotes and insights about her contemporaries and their work. In part 2 Hoffman discusses the technical aspects of sculpture, often using her own work as examples.

537 _____. YESTERDAY IS TOMORROW: A PERSONAL HISTORY. New York: Crown Publishers, 1965. 378 p. Illus.

> Entertaining reminiscences of Hoffman's life, the people she knew, and the sculptures she worked on. "List of Sculptured Works" (pp. 374-78).

Further bibliography: Brookgreen (see 141).

HOSMER, HARRIET GOODHUE 1830-1908

538 Carr, Cornelia, ed. HARRIET HOSMER, LETTERS AND MEMORIES. New York: Moffett, Yard, 1912. 399 p. Illus. Index.

> The only published edition of Hosmer's papers, which are now located in the Schlesinger Library at Radcliffe. Arranged chronologically, they relate the struggles and successes of the "first American woman sculptor"--the leader of the "White Marmorean Flock." The appendices include contemporary responses to three of Hosmer's works as well as an essay by the artist, "The Process of Sculpture."

539 Thorpe, Margaret. "White Marmorean Flock." NEW ENGLAND QUARTERLY 32 (June 1959): 147-69. Illus.

> Describes the social and artistic life of the women sculptors who gathered in Rome in the mid-nineteenth century. Hosmer, a major figure in the group, is fully discussed by Thorpe. (This article eventually became a chapter in her book THE LITERARY SCULPTORS [see 133].)

540 Van Rensselaer, Susan. "Harriet Hosmer." ANTIQUES 84 (October 1963):

424-28. Illus.

Biographical summary stressing Hosmer's independence and determination.

Further bibliography: Brookgreen (see 141); Craven (see 60); Gerdts-Neoclassic (see 123); Whitney, 200 YEARS (see 86).

HOXIE, VINNIE REAM. See REAM, VINNIE

HUDSON, ROBERT 1938-

541 Danieli, Fidel A. "Robert Hudson: Space and Camouflage." ARTFORUM 6 (November 1967): 32-35. Illus.

Eight works, done between 1964 and 1967, illustrate Hudson's aesthetic and sculptural style.

542 San Francisco Museum of Art. ROBERT HUDSON/RICHARD SHAW: WORK IN PORCELAIN. San Francisco: 1973. 36 p. 29 illus. Paperback.

Brief introduction by Suzanne Foley traces the development of these two Bay area ceramic artists. Biography. Exhibition list. Selected bibliography (p. 34).

Further bibliography: Tuchman (see 239).

HUEBLER, DOUGLAS 1924-

543 Gilbert-Rolfe, Jeremy. "Douglas Huebler's Recent Work." ARTFORUM 12 (February 1974): 59-60. Illus.

Aesthetic explanation and justification of Huebler's duration pieces.

544 Lippard, Lucy R. "Douglas Huebler: Everything About Everything." ART NEWS 71 (December 1972): 29-31. Illus.

Sympathetically explores and analyzes the works created by Huebler at the time of his exhibition of conceptual art at the Boston Museum of Fine Arts.

HUGHES, ROBERT BALL 1806-68

545 Chamberlain, Georgia Stamm. "The Ball Hughes Statue of Alexander Hamilton." In her STUDIES ON AMERICAN PAINTERS AND SCULPTORS OF THE NINETEENTH CENTURY, pp. 6-10. Annandale, Va.: Turnpike Press, 1965.

Brief history of the carving and premature destruction of this statue, New York City's first public statue.

546 _____. "Portrait Busts of Robert Ball Hughes." ART QUARTERLY 20 (Winter 1957): 383-86. Illus. of 4 busts.

Essay which lists the known portrait busts done by Hughes.

HUNT, RICHARD HOWARD 1935-

547* New York. Museum of Modern Art. THE SCULPTURE OF RICHARD HUNT. New York: 1971. 24 p. 15 illus. Paperback.

Catalog of an exhibition presenting Hunt's work during the 1955-70 period. Comments by William S. Lieberman trace Hunt's artistic development. Catalog includes statements by the artist, an extensive chronology (pp. 7-11), a list of exhibitions, and a lengthy bibliography by Judy Goldmay (pp. 21-24).

HUNTINGTON, ANNA VAUGHN HYATT 1876-1973

548 Price, Frederick N. "Anna Hyatt Huntington." INTERNATIONAL STUDIO 79 (August 1924): 319-23. 7 illus.

Anecdotal retelling of Huntington's life and an appreciation of her sculptural achievements.

549 Schaub-Koch, Emile. L'OEUVRE D'ANNA HYATT HUNTINGTON. Paris: Editions Messein, [1949]. 396 p. 144 plates. Text in French.

Extensive monograph on Huntington and her work by a prolific Huntington scholar. Primarily a visual resource, the volume has no bibliography or list of plates.

550 Smith, Bertha H. "Two Women Who Collaborated in Sculpture." CRAFTSMAN 8 (June-September 1905): 623-33.

Referring to Huntington and Abastenia St. Leger, this article outlines their lives and their collaborative sculptural efforts, in particular, "Men and Bulls" and "Boy and Goat Playing." Portraits of each and illustrations of four works.

Further bibliography: Brookgreen (see 141); Craven (see 60); Whitney, 200 YEARS (see 86).

IRWIN, ROBERT 1928-

551 California. University at Los Angeles. Art Galleries. TRANSPARENCY,

REFLECTION, LIGHT, SPACE: FOUR ARTISTS. Los Angeles: 1971. 140 p. Illus.

> An exhibition arranged by Peter Alexander, Larry Bell, Robert Irwin, and Craig Kauffman of their own work. Irwin is interviewed by Frederick S. Wight about his work and aesthetics (pp. 67-105). A brief biographical outline, list of exhibitions, and bibliography accompany the interview.

552 Irwin, Robert. "The State of the Real: Robert Irwin Discusses the Activities of an Extended Consciousness." Compiled by Jan Butterfield. ARTS MAGAZINE 46 (Summer 1972): 47-49. Illus.

> Irwin explains his explorations with volumes and proposes "states of consciousness and the shape of our perception" as justifiable forms of art. Bibliographical note.

553 Tate Gallery (London). LARRY BELL, ROBERT IRWIN, DOUG WHEELER. London: 1970. 31 p. Paperback.

> Brief summary by Michael Compton of Irwin's artistic development from painting to "floating" aluminum disks to experimentation with sound. Short chronology. Portrait of the artist. Full bibliography.

Further bibliography: Whitney, 200 YEARS (see 86).

IVES, CHAUNCEY BRADLEY 1810-94

554 Gerdts, William H. "Chauncey Bradley Ives, American Sculptor." ANTIQUES 94 (November 1968): 714-18. Illus.

> Brief biography of this expatriate neoclassical sculptor. Gerdts outlines Ives's major achievements and successes (ideal works and images of children) as well as discussing his limitations.

Further bibliography: Craven (see 60); Gerdts-Neoclassic (see 123); Whitney, 200 YEARS (see 86).

JAVACHEFF, CHRISTO. See CHRISTO

JOHNS, JASPER 1930-

555 Jewish Museum (New York). JASPER JOHNS. Organized by Alan Solomon. New York: 1964. 63 p. Illus. Paperback.

> This is the catalog for the first major Johns exhibition. A formal essay by Solomon discusses Johns's aesthetic development. John Cage then presents the artist's ideas and ideals in a free-

form, impressionistic essay. Bibliography (pp. 61-63).

556 Kozloff, Max. JASPER JOHNS. New York: Harry N. Abrams, 1968. 195 p. 142 illus.

Lavish reproductions of Johns's paintings and three-dimensional collages provide an excellent introduction to the scope of Johns's work. Kozloff's essay attempts to relate Johns's art to the various trends of the day. Selected bibliography (p. 195).

Further bibliography: Hunter (see 156); Keaveney, AMERICAN PAINTING; Whitney, 200 YEARS (see 86).

JONES, HOWARD 1922-

557 Coe, Ralph T. "Post-Pop Possibilities: Howard Jones." ART INTERNA-TIONAL 10 (January 1966): 36-46. Portfolio of illustrations (pp. 41-44).

Traces Jones's artistic development since the early 1960s and discusses, at length, the significance and use of the electric light bulb in his pop-influenced work. (Reprinted, with additions, from the catalog of Jones's "Light Paintings" exhibition at the Nelson Gallery in Kansas City, Missouri, 1965.)

Further bibliography: Whitney-Light, Object, Image (see 260).

JUDD, DONALD 1928-

558 Coplans, John. "An Interview with Don Judd." ARTFORUM 9 (June 1971): 40-50. Illus.

Interview centers on Judd's development, his current work, and his aesthetics, as well as commenting on the artistic community during the early 1960s. Generously illustrated with seventeen photographs.

559 Friedman, Martin. "The Nart-Art of Donald Judd." ART AND ARTISTS 1 (February 1967): 58-61. Illus.

Concise and clear presentation of Judd's minimal sculpture (or Nart-Art), his choice of materials, processes, and configuration.

559a Judd, Donald. "Black, White and Gray." ARTS MAGAZINE 38 (March 1964): 36-38. Illus.

Important critical review of the Black, White and Gray exhibition of minimal artwork held at the Jewish Museum in 1964. See citation 227.

560 _____. "Specific Objects." In ARTS YEARBOOK 8: CONTEMPORARY SCULPTURE, pp. 74-82. New York: Art Digest, 1965. Illus.

> One of Judd's best known critical articles in which he convincingly expresses his enthusiasm for the ability of new sculptural forms to satisfy both pictorial and sculptural needs. See citation 206.

561 Krauss, Rosalind. "Allusion and Illusion in Donald Judd." ARTFORUM 4 (May 1966): 24-26. Illus.

> A discussion of the discrepancy between Judd's anti-illusion/ allusion intent for his works, and this critic's strong response to those qualities in his sculpture of 1965/66.

562 Ottawa. National Gallery of Canada. DONALD JUDD. Ottawa: 1975. 335 p. Illus. Index of Owners. Paperback. Parallel text in English and French.

> A complete catalogue raisonné of Judd's work from 1960 to 1974 was prepared by Dudley DelBalso, Roberta Smith, and Brydon Smith to accompany a fifty-one item Judd exhibition in Ottawa. Each of Judd's 355 works is documented, described, and illustrated in the catalogue raisonné (pp. 91-280). Roberta Smith introduces the volume with a thorough essay on Judd's life and the development of his art and aesthetics. A brief letter from Dan Flavin characterizes Judd's work. Extensive list of exhibitions (pp. 281-310). Selected bibliography (pp. 311-14).

563 Pasadena Art Museum. DON JUDD. Pasedena, Calif.: 1971. 72 p. 44 Illus. Paperback.

> Exhibition catalog which covers work done during the 1960s; John Coplan's essay treats the same period of development. In Coplan's interview with Judd, the artist discusses his attitudes towards his own work as well as providing some technical information about his work. Chronology. List of exhibitions. Selected bibliography.

564 Whitney Museum of American Art (New York). DON JUDD. New York: 1968. 40 p. Illus. Paperback.

> Catalog for an exhibition of thirty works, done during the early 1960s, which helped establish Judd's prime role in the minimal art movement. Introduced by William C. Agee. Text, composed mainly of excerpts from Judd's own writings, provides insight into his aesthetics. Notes by Dan Flavin. Chronology. Exhibition list. Selected bibliography (p. 40).

Further bibliography: Tuchman (see 239); Hunter (see 156); Whitney, 200 YEARS (see 86).

KALISH, MAX 1891-1945

565 Kalish, Max. LABOR SCULPTURE. New York: n.p., 1938. 107 p.
Illus.

> An appreciation of the sculptures of Kalish which depict labor-
> ers. Forty-five photographs of these modeled figures. Intro-
> duced by Emily Grenauer.

KAPROW, ALLAN 1927-

566 Pasadena Art Museum. ALLAN KAPROW. Pasadena, Calif.: 1967.
53 p. Illus. Spiral bound paperback.

> Catalog of an exhibition of Kaprow's art (paintings, collages,
> assemblages, sculptures). An interview with Barbara Berman
> and two essays by the artist outline his involvement with the
> theory and execution of happenings. Chronology. Selected
> list of exhibitions, environments, and happenings. Extensive
> bibliography (pp. 46-51).

See also the Happenings section p. 75.

KATZEN, LILA 1932-

567 Everson Museum of Art (Syracuse, N.Y.) LILA KATZEN: SCULPTURE
AND SITE: 1975. Introduction by Cindy Nemser. Syracuse: 1975.
24 p. Illus. Paperback.

> Small, illustrated catalog of Katzan's sculptural work, 1972-
> 74. Chronology. List of exhibitions. Selected bibliography.

568 Georgia Museum of Art (Athens, Ga.). LILA KATZEN. Athens, Ga.:
1969. 36 p. Illus. Paperback.

> An exhibition of nineteen "light works and small environments,"
> all of which are illustrated. Contains Katzen's notes on the
> "materiality of light."

569 Nemser, Cindy. "Lila Katzen." In her ART TALK: CONVERSATIONS
WITH 12 WOMEN ARTISTS, pp. 230-65. New York: Charles Scribner's
Sons, 1975. Illus.

> This conversation reviews the development of Katzen's work,
> explores her artistic sensibilities, and discusses the difficulty
> she has had as a woman sculptor. Bibliography (pp. 364-65).

570 _____. "Lila Katzen Defines 'Environment'." ARTS MAGAZINE 45
(September/October 1970): 44-45. Illus.

Nemser incorporates Katzen's thoughts and comments into a coherent essay which focuses on "Liquid Stacks" at New York University's Loeb Center.

KAUFFMAN, CRAIG 1932-

571 California. University at Los Angeles. Art Galleries. TRANSPARENCY, REFLECTION, LIGHT, SPACE: FOUR ARTISTS. Los Angeles: 1971. 140 p. Illus.

An exhibition arranged by the artists: Peter Alexander, Larry Bell, Robert Irwin, and Craig Kauffman. Kauffman is interviewed by Frederick S. Wight about his work and aesthetics (pp. 137-39). A brief biographical outline, list of exhibitions, and bibliography accompany the interview.

572 Livingston, Jane. "Recent Work by Craig Kauffman." ARTFORUM 6 (February 1968): 36-39. Illus.

Discusses a 1967 manifestation of Kauffman's plastic and plexiglass images. (Reprinted in the Vancouver, British Columbia catalog LOS ANGELES SIX, 1968.)

Further bibliography: Washington-New Aesthetic (see 258).

KELLY, ELLSWORTH 1923-

573 Coplans, John. ELLSWORTH KELLY. New York: Harry N. Abrams, 1973. 225 p. Illus.

Kelly's sculpture is briefly discussed in relation to his paintings; the independence of his work from traditional sculptural forms is noted. Biographical outline. Bibliography (pp. 295-99).

574 Rose, Barbara. "Ellsworth Kelly as Sculptor." ARTFORUM 5 (June 1967): 51-55. Illus.

Rose praises the "monumentality and formal coherence" of Smith's small sculptural output. She sees in his three-dimensional work the "resolution of certain problems raised by the paintings."

Further bibliography on Kelly's paintings and drawings: Keaveney, AMERICAN PAINTING.

KIENHOLZ, EDWARD 1927-

575 Los Angeles County Museum of Art. EDWARD KIENHOLZ. Los Angeles:

Koltrum Bros., 1966. 54 p. 64 illus.

Catalog accompanying a Kienholz retrospective (works since 1956). In the catalog essay, "A Decade of Edward Kienholz," Maurice Tuchman discusses the artist's moral concerns and his attitude toward the passage of time, in relation to his tableaux (especially "Barney's Beanery"). (The essay is republished, in slightly altered form, in ARTFORUM 4 [April 1966].) Chronology. Extensive bibliography.

576 Secunda, Arthur. "Interview with John Bernhardt, Charles Frazier, and Edward Kienholz." ARTFORUM 1, no. 5 (1962): 30-32. Illus.

Discussion focuses around each artist's intents, materials, motivations, etc.

577 Stockholm. Moderna Museet. EDWARD KIENHOLZ: 11 + 11 [elva och elva] TABLEAUX. Stockholm: 1970. Unpaged. Illus. Text in English and Swedish.

Excellent photographs of the eleven tableaux and the eleven concept tableaux which composed this traveling exhibition. Each of the works is discussed in a short accompanying essay. List of exhibitions. Half-page bibliography.

578 Tillim, Sidney. "The Underground Pre-Raphaelitism of Edward Kienholz." ARTFORUM 4 (April 1966): 38-40. Illus.

Recognizes that the significance of Kienholz's "Barney's Beanery" is its sentimentality, revealing the "virtually maudlin underside of contemporary sensibility."

579 Washington Gallery of Modern Art. EDWARD KIENHOLZ: WORK FROM THE 1960'S. Exhibition and catalog essay by Walter Hopps. Washington, D.C.: 1967. 48 p. 31 illus. Paperback.

Short statements by Marcus G. Raskin and the artist. Hopps's essay stresses Kienholz's interest in the social condition of artists and art. Twenty constructions and tableaux are included as well as eight concept tableaux.

Further bibliography: Tuchman (see 239); UC Irvine (see 217); Whitney, 200 YEARS (see 86).

KIESLER, FREDERICK JOHN 1896-1965

580 Kiesler, Frederick. INSIDE THE ENDLESS HOUSE: ART, PEOPLE, AND ARCHITECTURE: A JOURNAL. New York: Simon & Schuster, 1964. 576 p. Illus.

Lively and revealing journal of Kiesler's life: his thoughts, dreams, poetry, drawings, aesthetic ruminations, etc.

581 _____. "Notes on Architecture as Sculpture." ART IN AMERICA 54 (May/June 1966): 57-68. Illus.

Kiesler, an architect, discusses contemporary architecture in relation to the past and to the evolution of his own revolutionary projects, such as his Endless House concept.

582 _____. "Second Manifesto of Correalism." ART INTERNATIONAL 9 (March 1965): 16-19. Illus.

A statement urging that the art object be considered in a larger context--that of the environment. Several illustrations of his "Last Judgement."

583 Solomon R. Guggenheim Museum (New York). FREDERICK KIESLER: ENVIRONMENTAL SCULPTURE. New York: 1964. 40 p. Illus. Paperback.

An architect, stage designer, interior decorator, and sculptor, Kiesler prefers to let his sculptural works "happen"; hence, this catalog reproduces the details of only two works: "Goya and Kiesler" and "Last Judgement." Includes commentary by Kiesler, "Towards the Endless Sculpture," from his 1964 book INSIDE THE ENDLESS HOUSE. Biography. Six-page selective bibliography.

Further bibliography: Whitney, 200 YEARS (see 86).

KING, WILLIAM DICKEY 1925-

584 Sawin, Martica. "William King." In ARTS YEARBOOK 8: CONTEMPORARY SCULPTURE, pp. 126-29. New York: Art Digest, 1965. Illus.

Critically reviews and characterizes King's figurative work.

Further bibliography: Hirshhorn (see 168); Recent Figure (see 222).

KOHN, GABRIEL 1910-75

585 Newport Harbor Art Museum (Newport, Calif.). WOOD: THE SCULPTURE OF GABRIEL KOHN. Newport: [1971]. 32 p. Illus. Paperback.

Thomas H. Garver introduces this traveling exhibition by outlining Kohn's personal attitudes and his aesthetic development. Excellent photographs of seventeen works. Three-page bibliography and exhibition list.

586 Petersen, Valerie. "Gabriel Kohn Makes a Sculpture--'Azimuth'."

ART NEWS 60 (October 1961): 48-51 and following. Illus.

Relates the facts of Kohn's life and his personal attitudes about sculpture. His own work, "Azimuth," is photographed through its various stages of construction.

Further bibliography: Hirshhorn (see 168); Tuchman (see 239).

KONTI, ISIDORE 1862-1938

587 Hudson River Museum (Yonkers, N.Y.). THE SCULPTURE OF ISIDORE KONTI. By Mary Jean Smith Madigan. Yonkers, N.Y.: 1974. 124 p. Illus. Paperback.

This catalog is a model of documentation of the work of a minor sculptor who lived in the Hudson Valley. Madigan's introduction reconstructs Konti's personal and professional life. The 119 "Known Works" are illustrated and documented. Chronology. One-page selected bibliography.

Further bibliography: Brookgreen (see 141); Craven (see 60).

KOSUTH, JOSEPH 1945-

588 Kosuth, Joseph. "Art After Philosophy." STUDIO INTERNATIONAL 178 (October, November, and December 1969). 3 pts. Illus.

Important to the understanding of Kosuth's art, these philosophical essays propose that the value of art is in its ability to stimulate new ideas and to influence other artists. A parallel between art and language is drawn. Parts 1 and 2 are reprinted in Battcock's IDEA ART (see 267), pp. 70-101.

589 Lucerne. Kunstmuseum. JOSEPH KOSUTH: INVESTIGATIONEN UBER KUNST UND "PROBLEMKREISE" SEIT 1965 [Investigations about art and related problems since 1965]. 5 vols. Lucerne: 1973. Text in English, German, French, and Italian. Paperback.

Documentation for nine projects executed since 1965. The fifth volume is exclusively devoted to biography, photographs of the artist, and bibliography.

LACHAISE, GASTON 1882-1935

590 Goodall, Donald B. "Gaston Lachaise, 1882-1935." MASSACHUSETTS REVIEW 1 (August 1960): 674-84. 8 illus.

Goodall traces the development of Lachaise's sculpture and the evolution of his imagery. The article is followed by Lachaise's

own important artistic statement, "A Comment on My Sculpture" (pp. 693-96), which originally appeared in CREATIVE ART 3 (August 1928).

591* Kramer, Hilton. THE SCULPTURE OF GASTON LACHAISE. New York: Eakins Press, 1967. 150 p. 97 illus.

Beautifully produced volume dedicated to the memory of Lachaise's creative genius. Kramer's essay traces the sculptor's life and his artistic development and achievements; he discusses both the private, sensual works as well as the better-known public works. Also included is an anthology of appreciative essays by Marsden Hartley, Hart Crane, e.e. cummings, Lincoln Kirstein, A. Hyatt Mayor, and Henry McBride. This book "coincided with the organization of a traveling exhibition of sculptures and drawings" circulated by the Lachaise Foundation. Brief chronology. Selected bibliography includes books and one-man exhibition catalogs devoted to Lachaise, and Lachaise's own writings (pp. 43-44).

592 Los Angeles County Museum of Art. GASTON LACHAISE, 1882-1935: SCULPTURE AND DRAWINGS. Los Angeles: [1963]. [64]p. 122 illus. Paperback.

Gerald Nordland's introduction to this major retrospective exhibition consists of a lengthy scholarly essay discussing Lachaise's stylistic development (reprinted in abridged form in ART INTERNATIONAL 8 [March 1964]). The 164-item show (108 sculptures) traveled to the Whitney Museum of American Art in 1964. The catalog of the sculpture and drawings, prepared by the Lachaise scholar Donald B. Goodall, is especially useful since almost every piece in the show is illustrated. Chronology. Bibliography (pp. 19-20).

593* New York. Museum of Modern Art. GASTON LACHAISE: RETROSPECTIVE EXHIBITION. Text by Lincoln Kirstein. New York: 1935. [64]p. 41 illus. Reprint with 4 other catalogs. FIVE AMERICAN SCULPTORS. New York: Arno Press, 1969.

Major retrospective exhibition which preceded, by a few months, Lachaise's death. Lincoln Kirstein's introductory essay has remained a standard analysis of Lachaise's life and work. Many of Lachaise's best known pieces were among the sixty sculptures displayed. Bibliography (p. 22).

594* Nordland, Gerald. GASTON LACHAISE: THE MAN AND HIS WORK. New York: George Braziller, 1974. vii, 184 p. 95 illus.

Published in conjunction with a Lachaise exhibition at Cornell University, UCLA, and elsewhere. This authoritative and readable monograph draws heavily upon material in the Lachaise

Archive (at Yale University). The fifty-eight page biographical section is followed by a more lengthy stylistic and iconographical discussion of nearly one hundred works. The consideration of late, unknown, and/or personal pieces enlarges and enriches the scope of Lachaise scholarship. Several of the smaller pieces have never been reproduced before. Selected bibliography of Lachaise's own writings as well as books, pamphlets, and articles about Lachaise (pp. 183-84).

Further bibliography: Brookgreen (see 141); Craven (see 60); Whitney, 200 YEARS (see 86).

LASSAW, IBRAM 1913-

595 Campbell, Lawrence. "Lassaw Makes a Sculpture." ART NEWS 53 (March 1954): 24-27. Illus.

> Brief review of Lassaw's life, the influences on his career, and the techniques he uses for his sculpture.

596 Lassaw, Ibram. "Perspectives and Reflections of a Sculptor: A Memoir." LEONARDO 1 (October 1968): 351-61. 10 illus.

> Lassaw discusses his sculptural work and the development of his technique, mentioning the artistic and philosophical influences on his work. Parts of this article were excerpted for the catalog of the first Lassaw retrospective at the Heckscher Museum (Huntington, N.Y.) in 1973.

597* Sandler, Irving. "Ibram Lassaw." In THREE AMERICAN SCULPTORS, by E.C. Goossen et al., pp. 45-66. New York: Grove Press, 1959. 13 illus.

> Traces Lassaw's artistic career, noting his specific achievements. Briefly characterizes his personality and his view of life.

Further bibliography: Giedion-Welcker (see 152); Craven (see 60); Whitney, 200 YEARS (see 86).

LAURENT, ROBERT 1890-1970

598 Indiana. University (Bloomington). LAURENT: FIFTY YEARS OF SCULPTURE. Bloomington, Ind.: 1961. 28 p. Illus. Paperback.

> Retrospective exhibition in honor of Laurent at the time of his retirement from the Indiana faculty. The catalog essay by Henry R. Hope discusses the course of Laurent's career since he arrived at Indiana in 1942.

599 Kent, Norman. "Robert Laurent, Master Carver." AMERICAN ARTIST 29 (May 1965): pp. 42-47 and following. Illus. of 12 works.

> Biography outlining the significance of Hamilton Easter Field's patronage of Laurent and his work.

600 New Hampshire. University (Durham). ROBERT LAURENT MEMORIAL EXHIBITION. Durham: 1972. 33 p. 90 illus. Paperback.

> Catalog prepared by Peter V. Moak. Essay by Henry H. Hope, "Robert Laurent at Indiana University." Laurent's major works are discussed and analyzed by Moak in the catalog essay; many works are illustrated. Bibliography (p. 32).

601 Read, Helen Appleton. "Robert Laurent." ARTS 9 (May 1926): 251-59. 9 illus.

> Reviews the modernist basis of Laurent's sculpture (Negro art, Maurice Sterne, etc.) and discusses the plastic characteristics of his style.

602 Vanamee, Esther Ryker. "Robert Laurent." VASSAR JOURNAL OF UNDERGRADUATE STUDIES (Poughkeepsie, N.Y.) 9 (May 1935): 25-39. Illus.

> Extensive stylistic analysis of Laurent's artistic achievements in both wood and stone.

Further bibliography: Index-20th Cent. (see 33), vol. 2, pp. 161-63 and supplement); Brookgreen (see 141); Craven (see 60); Whitney, 200 YEARS (see 86).

LE VA, BARRY 1941-

603 [Béar, Liza, and Sharp, Willoughby.] ". . . a Continuous Flow of Fairly Aimless Movement." AVALANCHE, no. 3 (Fall 1971): 64-75. Illus.

> Discussions with LeVa during the summer of 1971 focusing on specific pieces, the artist's development, etc.

604 Livingston, Jane. "Barry LeVa: Distributional Sculpture." ARTFORUM 7 (November 1968): 50-54. Illus.

> Description of LeVa's concepts and work since 1966.

Further bibliography: Whitney, 200 YEARS (see 86).

LEVINE, LES 1935-

605 Burnham, Jack. "Les Levine: Business as Usual." ARTFORUM 8 (April 1970): 40-43. Illus.

> A critique of the aesthetics behind Levine's art by a noted observer of contemporary art.

606 Levine, Les. "For Immediate Release." ART AND ARTISTS 4 (May 1969): 46-51. 8 illus.

> Levine, a Canadian citizen, presents some of his own theories about environmental art and describes the intent of a few of his works.

607 Newman, Thelma R. "The Artist Speaks: Les Levine." ART IN AMERICA 57 (November/December 1969): 86-93. Illus.

> Through carefully-reasoned answers, Levine articulates his aesthetic position, and the relationship of technology and traditional art forms to his sculpture.

LEWIS, [MARY] EDMONIA c.1843-46-after 1885

608 Dannett, Sylvia G.L. "Mary Edmonia Lewis, 1846-1890: The First Negro to Achieve Recognition in the Field of Sculpture." In PROFILES ON NEGRO WOMENHOOD, vol. 1, pp. 118-23. Yonkers, N.Y.: Educational Heritage, 1964.

> Informal biographical sketch which briefly describes Lewis's works.

609 Tufts, Eleanor M. "Edmonia Lewis, Afro-Indian Neo-classicist." ART IN AMERICA 62 (July/August 1974): 71-72. Illus.

> Using material also found in her 1974 book, OUR HIDDEN HERITAGE: FIVE CENTURIES OF WOMEN ARTISTS (New York: Paddington Press), Tufts outlines Lewis's life in the United States and Rome. Lewis's major sculptural achievements are described and illustrated. Romare H. Bearden challenges several of Tuft's biographical statements in the November/December 1964 issue of ART IN AMERICA (p. 168).

Further bibliography: Gerdts-Neoclassic (see 123).

LE WITT, SOL 1928-

610 The Hague. Gemeentemuseum. SOL LE WITT. The Hague, Netherlands: 1970. 64 p. Illus. Text in English.

Exhibition and catalog organized by Enno Develing. The catalog is an anthology of opinions by critics and friends about LeWitt, his aesthetics, his work, his personality. Includes LeWitt's own writings: "Paragraphs on Conceptual Art" (see 272), "Sentences on Conceptual Art," and "Wall drawings." Biography. List of exhibitions. Bibliography (pp. 63-64).

611 Lippard, Lucy [R.]. "Sol LeWitt: Non-visual Structures." ARTFORUM 5 (April 1967): 42-46. Illus.

Identifies the dichotomy in LeWitt's work between the visual and the theoretical impulses. Analyzes both aspects and decides that the visual is most important to LeWitt. Reprinted in Lippard's CHANGING (see 235), pp. 154-66.

612 Pincus-Witten, Robert. "Sol LeWitt: Word-Object." ARTFORUM 11 (February 1973): 69-72. Illus.

Critically evaluating LeWitt's work exhibited at the Bern Kunsthalle (1972), Pincus-Witten reviews LeWitt's importance to minimal and conceptual art, then questions the direction which his recent work has taken.

Further bibliography: Tuchman (see 239); Hunter (see 156); Whitney, 200 YEARS (see 86).

LIBERMAN, ALEXANDER 1912-

613 Baro, Gene. "Alexander Liberman: Art as Involvement." ART INTERNATIONAL 11 (March 1967): 20-27. Illus.

Reviews Liberman's work since 1960--both the paintings and sculpture--tracing a common imagery and concern throughout. Characterizes the strength of his monumental sculptures.

614 Campbell, Lawrence. "The Great-Circle Route." ART NEWS 69 (April 1970): 52-57. Illus.

At the time of the Corcoran retrospective, Campbell reviews Liberman's artistic training and development prior to 1950.

615 Corcoran Gallery of Art (Washington,D.C.). ALEXANDER LIBERMAN: PAINTING AND SCULPTURE, 1950-1970. Washington, D.C.: 1970. 96 p. Illus. Paperback.

Catalog, introduced by James Pilgrim, for a major retrospective of Liberman's paintings and sculpture. Thomas B. Hess records insights and feelings about the paintings. The sculpture is the focus of a conversation between Walter Hopps and the artist. Over fifty works are illustrated. Chronology. Exhibition list. Selective bibliography (pp. 49-51).

616 Goossen, Eugene C. "Alex Liberman: American Sculptor." ART INTER-
 NATIONAL 15 (October 1971): 20-25. Illus.

> Goossen notes the strong affinities between Liberman's work and
> the classically simple objects/ruins of the Greek civilization.
> This similarity is especially attractive to Goossen, an American
> whose culture is partly derived from the Greek civilization.

Further bibliography: Tuchman (see 239).

LIPCHITZ, JACQUES 1891-1973

617 Arnason, H. Harvard. JACQUES LIPCHITZ: SKETCHES IN BRONZE.
 New York: Praeger Publishers, 1969. 195 p. 161 illus.

> Arnason presents a chronological study of Lipchitz's marquettes
> which have been cast into bronze. James Moore's photographs
> illustrate these "sketches." The foreword by Lipchitz is taken
> from the 1963 catalog for an exhibition at the Otto Gerson
> Gallery (New York). Chronology. Selected bibliography
> (pp. 30-32) intended to supplement the bibliography in the
> 1954 catalog by Henry R. Hope (see 621).

618 Hammacher, A.M. JACQUES LIPCHITZ: HIS SCULPTURE. New York:
 Harry N. Abrams, 1960. 176 p. Illus.

> A stylistic analysis of Lipchitz's development occupies the ma-
> jor part of this rich resource. One hundred photographs of
> Lipchitz's drawings and sculpture illustrate the text. The in-
> troductory statement, "Reflections on Art," is by Lipchitz.
> Other important but difficult to locate statements by the artist
> are included, such as the questionnaire from THE LITTLE RE-
> VIEW (1929); introductions to the 1955 exhibition at the New
> Gallery and the two 1957 exhibitions at the Fine Arts Associ-
> ates; an interview from NBC-TV (1958); and an introduction
> to the 1954 Rodin exhibition at the Curt Valentin Gallery.
> "Excerpts from reactions to Lipchitz's work between 1917-1958"
> provides a barometer to critical reactions over forty years.
> Useful bibliography (pp. 82-85).

619 Lipchitz, Jacques. "The Story of My 'Prometheus'." ART IN AUSTRALIA,
 series 4 (June/July/August 1942): 29-36. 7 illus.

> Enlightening description of Lipchitz's own artistic motivations
> and techniques while creating "Prometheus."

620* Lipchitz, Jacques, with Arnason, H.H[oward]. MY LIFE IN SCULPTURE.
 Documents of 20th Century Art. New York: Viking Press, 1972. 283 p.
 202 illus.

> An informal autobiography marking Lipchitz's eightieth birthday,

which is based on numerous taped interviews. Personal reminis-
cences are interspersed with technical discussions and chronologi-
cal details. Chronology. Extensive bibliography by Bernard
Karpel (pp. 233-49).

621* New York. Museum of Modern Art. THE SCULPTURE OF JACQUES
LIPCHITZ. Text by Henry R. Hope. New York: Museum of Modern
Art in collaboration with Walker Art Gallery and the Cleveland Museum,
1954. 95 p. Illus. Reprint with 4 other catalogs. FIVE AMERICAN
SCULPTORS. New York: Arno Press, 1969.

Important catalog accompanying Lipchitz's first major exhibition,
which established his place in twentieth-century sculpture.
Hope discusses the artist's development in terms of certain key
pieces from the exhibition; several of the works are illustrated.
Chronology. Exhibition list (with catalogs and reviews noted).
Major bibliography by Hannah B. Müller (pp. 93-95) which
includes books, articles, and the artist's own statements up to
1954.

622 Patai, Irene. ENCOUNTERS: THE LIFE OF JACQUES LIPCHITZ. New
York: Funk & Wagnalls, 1961. 438 p. Illus.

A biography which "does not attempt a critical appraisal of
Lipchitz' art." Rather it is an account of the joys and trage-
dies of the artist's life. Sources arranged by Anna Steinman.
Bibliography (pp. 425-30).

623 Van Bork, Bert. JACQUES LIPCHITZ: THE ARTIST AT WORK. Critical
evaluation by Alfred Werner. New York: Crown Publishers, 1966.
220 p. Illus.

Van Bork's biographical history includes brief chapters devoted
to the artist's stylistic development, his portraits, his "mother
and child" theme etc. Werner's critical evaluation (pp. 204-
20) is similarly laudatory. Many photographs of Lipchitz in
his studio.

Further bibliography: Giedion-Welcker (see 152).

LIPPOLD, RICHARD 1915-

624 Campbell, Lawrence. "Lippold Makes a Construction--'The Sun'." ART
NEWS 55 (October 1956): 30-33 and following. Illus.

Describes the progress of a Lippold construction and the tech-
niques used. Brief introduction to Lippold's career and his
artistic philosophy.

Further bibliography: Giedion-Welcker (see 152); Hunter (see 156); UCSB
(see 180); Whitney, 200 YEARS (see 86).

LIPTON, SEYMOUR 1903-

625 Elsen, Albert E. "The Sculptural World of Seymour Lipton." ART INTER-
NATIONAL 9 (February 1965): 12-16. Illus. of 8 works.

> Elsen seeks to illuminate the ways in which Lipton's "artistic
> world is a potential analogue to our own."

626 _____. SEYMOUR LIPTON. New York: Harry N. Abrams, [1972?].
244 p. 214 illus.

> An in-depth presentation of Lipton's career by an outstanding
> Lipton scholar. Richly illustrated and produced. Biographical
> outline. Selected bibliography (pp. 241-44).

627 Kansas. University of. Museum of Art (Lawrence). ["Seymour Lipton"].
REGISTER 2 (April 1962). 47 p. Illus.

> The entire museum bulletin is devoted to Lipton. Included are
> Lipton's own writings ("A Problem in Sculpture: The Question
> of Intensity" and "Total Image") as well as critical essays
> which focus on Lipton's "Avenger" (located at Kansas Univer-
> sity), his place in twentieth-century sculpture, and his biogra-
> phy. An interview with Tal Streeter explores the sources of
> Lipton's artistic inspiration. Bibliographical notes provided by
> Lipton (p. 46).

628 Lipton, Seymour. A DECADE OF RECENT WORK. THE CREATIVE PRO-
CESS. Milwaukee: Arrow Press, 1969. 44 p. Illus.

> A single volume with the catalogs of two concurrent exhibitions:
> "A Decade of Recent Work" at the Milwaukee Art Center and
> "The Creative Process" at the University of Wisconsin, Milwau-
> kee. Introduction written by Tracy Atkinson. The DECADE
> part of the catalog illustrates all twenty-nine works displayed.
> The CREATIVE PROCESS catalog includes six finished works
> and a collection of Lipton's studies and maquettes. Statement
> by the artist. Thorough chronology. Bibliography (pp. 40-42).

629 Ritchie, Andrew C[arnduff]. "Seymour Lipton." ART IN AMERICA 44
(Winter 1956/57): 14-17. 7 illus.

> Describes and discusses Lipton's techniques and the meaning of
> his imagery.

Further bibliography: Hirshhorn (see 168); Craven (see 60); Hunter (see 156);
Whitney, 200 YEARS (see 86).

LYE, LEN 1901-

630 Dandignac, Patricia. "The Visionary Art of Len Lye." CRAFT HORIZONS

21 (May/June 1961): 30-31. Illus. of 1 work.

Short introduction to the technology and aesthetics involved in Lye's motion sculpture.

631 Lye, Len. "Tangible Motion Sculpture." ART JOURNAL 20 (Summer 1961): 226-27. Illus.

Lye explains his interest in motion sculpture and briefly describes some manifestations of his aesthetic. "Roundhead 1" is described (p. 228).

Further bibliography: UC Kinetic (see 215); Tuchman (see 239); Hunter (see 156); Whitney, 200 YEARS (see 86).

McINTIRE, SAMUEL 1757-1811

632 Cousins, Frank, and Riley, Phil M. THE WOOD-CARVER OF SALEM: SAMUEL McINTIRE, HIS LIFE AND WORK. Boston: Little, Brown and Co., 1916. Reprint. New York: AMS Press, 1970. 188 p. 127 illus. Index.

Biographical study of this New England craftsman, known primarily for his distinguished architecture and the decoration of that architecture.

633 Cummings, Abbott L., et al. "Samuel McIntire, A Bicentennial Symposium, 1757-1957." ESSEX INSTITUTE HISTORICAL COLLECTIONS (Salem, Mass.) 93 (April/July 1957). 230 p. Illus.

An article by Nina Fletcher Little, "Carved Figures by Samuel McIntire and His Contemporaries" (pp. 179-99), re-evaluates the sculptural contributions made by McIntire and four other early woodcarvers. Selected bibliography (pp. 222-30).

634 Kimball, Sidney Fiske. MR. SAMUEL McINTIRE, CARVER, THE ARCHITECT OF SALEM. Portland, Maine: The Southworth-Anthaesen Press published for the Essex Institute of Salem, Mass. 1940. 157 p. 373 illus.

The few sculptures created by this early Salem architect/craftsman are discussed, cataloged (pp. 138-41), and illustrated in a concise study. Bibliographical material in the appendices (pp. 146-47).

Further bibliography: Whitney, 200 YEARS (see 86).

MacMONNIES, FREDERICK 1863-1937

635 Cortissoz, Royal. "An American Sculptor: Frederick MacMonnies."

STUDIO 6 (October 1895): 17-26. 5 illus.

> Cortissoz, a prominent critic of the day, sees in MacMonnies's work a "band of Neo-Renaissance temperaments strengthened through appreciation of modern French craftmanship." Cortissoz reviews MacMonnies's career to demonstrate this thesis.

636 Strother, French. "Frederick MacMonnies, Sculptor." WORLD'S WORK 11 (December 1905): 6965-81. Illus.

> Characterizes MacMonnies's ambition to create an American art and his influence in achieving such a goal. Also discusses the influence of his free instruction of American students in Paris. Both sculptures and paintings are illustrated.

Further bibliography: Brookgreen (see 141); Craven (see 60); Whitney, 200 YEARS (see 86).

MALLARY, ROBERT 1917-

637 Mallary, Robert. "Self-Interview." LOCATION 1 (Spring 1963): 58-66. Illus.

> Mallary poses questions to himself concerning his current work, political beliefs, philosophical outlook, choice of materials, and the state of the sculptural arts.

638 New York. State University at Potsdam. Gallery. MALLARY: TWO DECADES OF WORK, 1948-1968. Potsdam: 1970. 23 p. 36 illus. Paperback.

> A retrospective exhibition of sculptures, assemblages, and paintings. Introductory essay by Mark Roskill discusses Mallary's life and work. Chronology. Exhibition list. Bibliography.

639 Robb, Natalie, et al. "Interview with Robert Mallary." ARTFORUM 2 (January 1964): 37-39. Illus.

> Discusses the development of Mallary's work, from painting to reliefs to sculpture. Mallary states his views on contemporary art--especially pop art.

MANSHIP, PAUL HOWARD 1885-1966

640 Casson, Stanley. "Paul Manship." In his XXTH CENTURY SCULPTORS, pp. 41-54. London: Oxford University Press, 1930. Illus.

> Casson characterizes Manship's work from the point of view of an artist rather than a critic or historian. Manship and Archipenko are the only American sculptors Casson considers.

641 Gallatin, Albert Eugene. "An American Sculptor: Paul Manship." STUDIO 82 (October 1921): 137-44. 8 illus.

On the occasion of Manship's exhibition in London, Gallatin praises the sculptor's ability to assimilate the qualities of classical, Egyptian, and Indian art. Brief biographical outline.

642 Minnesota Museum of Art. PAUL HOWARD MANSHIP: AN INTIMATE VIEW. St. Paul, Minn.: 1972. [78]p. Illus. Paperback.

A catalog documenting the Manship collection of sculpture and drawings bequeathed to the Minnesota Museum of Art. Excerpts from Manship's interviews, notebooks, letters, and speeches are arranged by Frederick D. Leach to provide insights into Manship's personality and attitudes toward his art. Numerous photographs. Extensive footnotes and bibliography (p. 44).

643* Murtha, Edwin. PAUL MANSHIP. New York: Macmillan, 1957. 198 p. 206 illus. Index.

A major source for the study of Manship's sculpture. Murtha's essay on Manship's life and work is accompanied by a chronology and a short bibliography (p. 22). "Catalogue of the Sculpture" (pp. 149-92) documents 576 works, of which 206 are illustrated.

644 Smithsonian Institution. A RETROSPECTIVE EXHIBITION OF SCULPTURE BY PAUL MANSHIP. Smithsonian publication no. 4336. Washington, D.C.: 1958. 31 p. Illus. Paperback.

Thomas M. Beggs briefly introduces the achievements of Manship's career. The catalog itself is a checklist of the 173 items displayed. Over twenty-five of the works are illustrated.

Further bibliography: Index-20th Cent. (see 33), vol. 1, pp. 30-36; Brookgreen (see 141); Whitney, 200 YEARS (see 86).

MARISOL 1930-

645 Campbell, Lawrence. "Marisol's Magic Mixtures." ART NEWS 63 (March 1964): 38-41 and following. Illus.

On the occasion of a 1964 gallery exhibition, Campbell reviews the progress of Marisol's work and describes the imagery she uses.

646 Chapman, Daniel. "Marisol--A Brilliant Sculptress Shapes the Heads of State." LOOK (14 November 1967): 78-83. Illus.

Excellent color photographs of works in Marisol's 1967 exhibi-

tion at the Sidney Janis Gallery (New York). Includes constructions representing Lyndon Baines Johnson, Lady Byrd Johnson, Charles de Gaulle, the royal family of England, Harold Wilson, and Francisco Franco.

647 Nemser, Cindy. "Marisol." In her ART TALK: CONVERSATIONS WITH 12 WOMEN ARTISTS, pp. 178-99. New York: Charles Scribner's Sons, 1975. Illus.

Discusses Marisol's artistic development and achievements and the implications of her position as a woman artist. Bibliography (p. 363). Some of this material was published in the FEMINIST ART JOURNAL 2 (Fall 1973).

648 Worcester Art Museum (Worcester, Mass.). MARISOL. Worcester, Mass.: 1971. 48 p. Illus. Paperback.

Catalog for Marisol's first museum exhibition in the United States. The thirty-nine sculptures and drawings were done between 1960 and 1970. Leon Shulman's essay analyzes the imagery and intent of Marisol's wood constructions. Excellent illustrations. Bibliography (p. 43).

MASON, JOHN 1927-

649 Los Angeles County Museum of Art. JOHN MASON: SCULPTURE. Los Angeles: 1966. [24]p. 16 illus. Paperback.

An exhibition catalog in which John Coplans briefly explores the influences on Mason's work and the range of his sculptural experimentation. Two-page bibliography.

650 Pasadena Art Museum. JOHN MASON. Pasadena, Calif.: 1974. 32 p. Illus. Paperback.

Organized by Barbara Haskell, this exhibition includes Mason's work from the past twenty years. Haskell's "Chronology" is an essay summarizing Mason's artistic development since 1954. A personal tribute is paid by R.G. Barnes. Bibliography compiled by Diane Tucker (pp. 27-30).

Further bibliography: Tuchman (see 239); Whitney, 200 YEARS (see 86).

MEADMORE, CLEMENT L. 1929-

651 McCaughey, Patrick. "The Monolith and Modernist Sculpture." ART INTERNATIONAL 14 (November 1970): 19-24. Illus.

Basing his discussion on the work of Maillol, Moore, and

Meadmore, McCaughey explores the forms and aesthetics of modern monolithic sculpture. Four of Meadmore's works are illustrated.

652 Siegel, Jeanne. "Clement Meadmore: Circling the Square." ART NEWS 70 (February 1972): 56-59. Illus. of 10 works.

Based on interviews, Siegel explores and articulates Meadmore's feelings about form, scale, material, etc.

MEFFERD, BOYD 1941-

653 Coe, Ralph T. "Lighting Sculpture: Boyd Mefferd." ART AND ARTISTS 3 (November 1968): 36-41. Illus. of 4 works.

Describes aesthetically and technically, the development of Mefferd's use of light in his sculptures.

Further bibliography: Whitney-Light, Object, Image (see 260).

METCALF, JAMES 1925-

654 Hunter, Sam. JAMES METCALF. Chicago: William and Noma Copley Foundation, [1963?]. [33]p. 25 illus.

An American living in Europe, Metcalf's welded metal sculpture reflects the surrealist and abstractionist influences he has encountered. List of exhibitions.

MILLER, RICHARD A. 1922-

655 Duke University. Museum of Art. HUMAN FORM IN CONTEMPORARY ART. Durham, N.C.: 1971. 48 p. Illus. Paperback.

Miller's sculptural work and Rosemarie Beck's paintings are presented as contemporary examples of artists working with the human form. The essays, by William S. Heckscher and Lola L. Szladits, trace the history of the nude human form through the history of art. Biography, exhibition list, and bibliography for each artist.

656 Tillim, Sidney. "Richard A. Miller: 'Primary' Realist." ARTFORUM 5 (June 1967): 47-50. Illus.

After noting that the figurative subjects chosen by Miller do not, superficially, appear to be in the vanguard of American sculpture, Tillim attempts to demonstrate the many aspects of the contemporary aesthetic which are apparent in Miller's work.

MILLS, CLARK 1815-83

657 Rutledge, Anna Wells. "Cogdell and Mills, Charleston Sculptors."
ANTIQUES 41 (March 1942): 192-93, 205-8. Illus.

> Brief essay which concludes that our interest in Mills centers
> on "his pioneer casting in bronze and the subjects of his casts"
> rather than on his somewhat imitative style. The "Checklist
> of the Works of Cogdell and Mills" (pp. 205-8), lists over
> fifty works by Mills and provides bibliographical information
> when it is available.

Further bibliography: Craven (see 60); Whitney, 200 YEARS (see 86).

MOHOLY-NAGY, LASZLO 1895-1946

658* Kostelanetz, Richard. MOHOLY-NAGY. New York: Praeger Publishers,
1970. 256 p. Illus. Index.

> An anthology of writings, primarily by Moholy-Nagy himself,
> reflecting various aspects of his work and social philosophy.
> Biographical details and critical commentary included. Bibliog-
> raphy includes books and essay by and about Moholy-Nagy
> (pp. 223-33).

659* Moholy-Nagy, László. THE NEW VISION (1928) and ABSTRACT OF AN
ARTIST (1944). 4th rev. ed. New York: George Wittenborn, 1967.
92 p. Illus. Paperback. Documents of Modern Art.

> THE NEW VISION is a definitive analysis of the theory and
> experiments of the Bauhaus movement. These theories have
> had a tremendous influence on the development of modern art,
> especially minimal art. The ABSTRACT, an autobiographical
> sketch, personalizes the principles set out in the 1928 essay.

660 _____. VISION IN MOTION. Chicago: Paul Theobald, 1947. 371 p.
Illus.

> A comprehensive account of Moholy-Nagy's program at the
> Institute of Design. "An extension of my previous book, THE
> NEW VISION, . . . concentrates on the work of the Institute
> of Design in Chicago and presents a broader, more general
> view of the interrelatedness of art and life."

661 Moholy-Nagy, Sibyl. MOHOLY-NAGY: EXPERIMENT IN TOTALITY.
New York: Harper & Row, 1950. ix, 253 p. Illus. Index.

> Introduction by Walter Gropius. A biographical "account of
> Moholy-Nagy's development from early experiments to full
> maturity," related with intimacy and integrity by his wife.

Further bibliography: Giedion-Welcker (see 152).

MORRIS, ROBERT 1931-

662 Corcoran Gallery of Art (Washington, D.C.). ROBERT MORRIS. Washington, D.C.: Corcoran Gallery of Art in collaboration with the Detroit Institute of Arts, 1969. 96 p. Illus.

> Joint catalog for two separate exhibitions of Morris's work: one in Washington, D.C., "focusing upon plywood, steel, and aluminum constructions, the felt pieces, and the waste and earth pieces dating from 1962 to the present"; and the other at the Detroit Institute of Arts focusing "on the work of 1961 through 1965, including early wood constructions, lead pieces, and mixed media works." Also, nine new works were shown at each exhibition. Annette Michelson's definitive article, "Robert Morris: An Aesthetics of Transgression" (pp. 7-75) "develops the critical basis for approaching Morris's work while linking it to twentieth century precedents." Chronology. Exhibition list. Bibliographical footnotes (pp. 77-79). Selective bibliography (pp. 92-93).

663 Goossen, Eugene C. "The Artist Speaks: Robert Morris." ART IN AMERICA 58 (May/June 1970): 104-11. Illus.

> Excerpts of an extensive interview, taped on the occasion of the Whitney retrospective (1970), in which Morris "discusses the intensions and directions of his many-sided work."

Morris, Robert. "Anti-form."

See citation 242.

_____. "Notes on Sculpture," parts 1-4.

See citation 243.

_____. "Some notes on the Phenomenology of Making."

See citation 276.

664 Pennsylvania. University. Institute of Contemporary Art (Philadelphia). ROBERT MORRIS/PROJECTS. Philadelphia: 1974. 24 p. 18 illus. Paperback.

> Catalog documenting an important Morris project--the construction of "Labyrinth" at the Institute of Contemporary Art. Suzanne Delehanty's foreword and Edward Fry's introduction discuss the implications and meanings of Morris's concepts. Chronology of Morris's projects. Selected bibliography (p. 23).

665 Tate Gallery (London). ROBERT MORRIS. By Michael Compton and David Sylvester. London: 1971. 128 p. Illus.

> Exhibition catalog which presents retrospective material on Robert Morris. A "Duologue" between Sylvester and the artist, done in 1967, provides insights about Morris's "process of making decisions." The works are divided into seven groups, according to their media or type, and are commented upon by Morris and Compton.

666* Tucker, Marcia. ROBERT MORRIS. New York: Praeger Publishers for the Whitney Museum of American Art, 1970. 63 p. 38 illus.

> Introduces Morris and his work via photographs and theoretical essays. Since Morris created the five pieces for the Whitney exhibition immediately before the show opened, the book does not contain those particular works. Tucker discusses Morris's minimal objects, earthworks, outdoor pieces/objects/activities, etc. Chronology. List of exhibitions and selected bibliography by Libby Seaberg (pp. 61-63).

Further bibliography: Tuchman (see 239); Hunter (see 156); Whitney, 200 YEARS (see 86).

MURRAY, ROBERT 1936-

667 Cone, Jane Harrison. "New Work by Robert Murray." ARTFORUM 7 (September 1968): 36-39. Illus.

> Critical commentary on the recent work by Murray. Color photographs.

668 Rose, Barbara. "An Interview with Robert Murray." ARTFORUM 5 (October 1966): 45-47. Illus.

> Explores Murray's ideas about his sculpture, which uses industrial materials and forms.

669 Vancouver Art Gallery (Vancouver, British Columbia). RONALD BLADEN/ ROBERT MURRAY. Vancouver, B.C., Canada: 1970. 50 p. 35 illus. Spiral-bound paperback.

> Introduction by Doris Schadbolt with statements by each artist and by selected critics. Works are photographed informally-- under construction, with people walking around, etc. Short biographies. Extensive bibliographies.

Further bibliography: Tuchman (see 239).

Individual Sculptors

NADELMAN, ELIE 1882-1946

670* Kirstein, Lincoln. ELIE NADELMAN. New York: Eakins Press, 1973. 358 p. 215 illus. Index.

> Comprehensive study of Nadelman's life and work by the outstanding Nadelman scholar. Includes photographs of lost or destroyed works as well as sketches, clippings, etc., from Nadelman's own file. Statements by the artist are included. A draft catalogue raisonné (pp. 285-320) is an indispensable research tool. A bibliography and exhibitions list, compiled by Ellen Grand, is included (pp. 321-41).

671* New York. Museum of Modern Art. THE SCULPTURE OF ELIE NADELMAN. Text by Lincoln Kirstein. New York: 1948. 64 p. Illus. Reprint with 4 other catalogs. FIVE AMERICAN SCULPTORS. New York: Arno Press, 1969. Paperback.

> The catalog for this memorial exhibition contains Lincoln Kirstein's pioneering study of Nadelman's life and work. The bibliography includes exhibition notices and reviews (pp. 63-64).

672 Spear, Athena T. "Elie Nadelman's Early Heads, 1905-1911." ALLEN MEMORIAL ART MUSEUM BULLETIN (Oberlin College, Yellow Springs, Ohio) 28 (Spring 1971): 201-22.

> A thorough analysis of the stylistic development of Nadelman's early sculptured heads. Spear examines the forms and details in order to establish a valid chronology for these early, undated pieces. Bibliographical footnotes.

673 Whitney Museum of American Art (New York). THE SCULPTURE AND DRAWINGS OF ELIE NADELMAN, 1882-1946. New York: 1975. 119 p. 144 illus. Paperback.

> A brief introduction by J.I.H. Baur and a lengthy chronology precede this fully illustrated exhibition catalog. All of the 103 sculptures and forty-one drawings shown are beautifully photographed and briefly documented.

Further bibliography: Index-20th Cent. (see 33), vol. 3, pp. 250-61 and supplement; Brookgreen (see 141); Craven (see 60); Hunter (see 156); Whitney, 200 YEARS (see 86).

NAKIAN, REUBEN 1897-

674 Arnason, H.H[oward]. "Nakian." ART INTERNATIONAL 7 (April 1963): 36-43. Illus.

> Thorough analysis of the circumstances which led to Nakian's "exuberant outburst" of work in the early 1950s. The startling

changes at that time in his style, technique, and output are
discussed. Many illustrations.

675 Goldwater, Robert. "Reuben Nakian." QUADRUM, no. 11 (1961):
95-102. 7 illus.

> Describes the character and development of Nakian's work from
> 1952 to 1961, noting its "monumentality, vigor, and movement."
> Reprinted in the 1962 Nakian exhibition at the Los Angeles
> County Museum of Art.

676 New York. Museum of Modern Art. NAKIAN. By Frank O'Hara.
New York: 1966. 56 p. Illus. Paperback.

> Catalog documenting an important retrospective exhibition.
> O'Hara's sensitive essay discussing Nakian's life and work fo-
> cuses directly on the objects illustrated in the catalog. Naki-
> an's development of style and content is clearly and percep-
> tively traced. Extensive biographical outline by W. Berkson
> incorporates illustrations of the major sculptures not exhibited.
> Extensive bibliography by Elita Taylor (pp. 48-53).

Further bibliography: Index-20th Cent. (see 33), vol. 2, pp. 165-66 and supple-
ment; Tuchman (see 239); Craven (see 60); Hunter (see 156); Whitney, 200
YEARS (see 86).

NAUMAN, BRUCE 1941-

677 Danieli, Fidel A. "The Art of Bruce Nauman." ARTFORUM 6 (December
1967): 15-19. Illus.

> Brief introduction to the variety of Nauman's sculptural experi-
> mentation. Thirteen works illustrated.

678 Harlen, Jurgen. "T for Technics, B for Body." Translated by John
Thwaites. ART AND ARTISTS 8 (November 1973): 28-33. 5 illus.

> Careful analysis of Nauman's work which takes into considera-
> tion the critical opinions of other writers.

679 Livingston, Jane, and Tucker, Marcia. BRUCE NAUMAN: WORK FROM
1965-1972. New York: Praeger Publishers for Los Angeles County Mu-
seum of Art, 1973. 172 p. Illus.

> Catalog to accompany a 117 item exhibition which traveled
> from Los Angeles to the Whitney Museum and to several other
> museums. Independently prepared critical essays by Livingston
> and Tucker provide comparative opinions on many aspects of
> Nauman's work and its relationship to contemporary art. Chro-
> nology. Bibliography (pp. 167-71).

680 Pincus-Witten, Robert. "Bruce Nauman: Another Kind of Reasoning."
 ARTFORUM 10 (February 1972): 30-37. Illus.

> Incisive review of Nauman's work which contends that the artist
> "has exchanged elitism for the populism" of behavioral phenom-
> enology. Philosophical essay relates Nauman's art to that of
> Duchamp, noting those points of divergence which characterize
> Nauman's conceptual works. Bibliographical footnotes.

681 Sharp, Willoughby. "Nauman Interview." ARTS MAGAZINE 44 (March
 1970): 22-27. Illus.

> After an introductory review of Nauman's development, the in-
> depth interview focuses on Nauman's use of videotape, his use
> of his body, and his sculptural works.

682 Tucker, Marcia. "PheNAUMANology." ARTFORUM 9 (December 1970):
 38-43. Illus.

> Reviews the 1970 exhibition at Wilder Gallery (New York) and
> concludes that Nauman's environments seem to re-evaluate and
> restructure man's relationship to the distinct phenomena of light,
> sound, temperature, etc. Comments by the artist are also in-
> cluded.

Further bibliography: Tuchman (see 239); Hunter (see 155); Whitney, 200 YEARS
(see 86).

NEVELSON, LOUISE 1900-

683 Friedman, Martin. NEVELSON: WOOD-SCULPTURES. New York:
 E.P. Dutton & Co. for the Walker Art Center, 1973. 80 p. Illus.
 Paperback.

> Exhibition catalog which reviews Nevelson's career and ana-
> lyzes the major forms of her work, i.e., boxes, columns,
> walls. Numerous photographs document the work. Combined
> biography and bibliography (pp. 75-79).

684* Glimcher, Arnold B. LOUISE NEVELSON. New York: Praeger Pub-
 lishers, 1972. [180]p. Illus.

> Ninety-three excellent photographs amplify Glimcher's lively
> presentation of Nevelson's work and personality. The principle
> stages of her work are described, explained and abundantly
> illustrated. The prologue consists of a statement by Nevelson
> on her life, her artistic passion, and her position in the cur-
> rent art world. "Selected Works, 1930-1972" documents
> seventy-five other pieces.

685 Nemser, Cindy. "Nevelson." In her ART TALK: CONVERSATIONS

WITH 12 WOMEN ARTISTS, pp. 52-79. New York: Charles Scribner's Sons, 1975. Illus.

A free-flowing conversation which ranges from Nevelson's career and the development of her sculpture, to the current art scene and her position as a woman in that scene. Bibliography (pp. 360-61). Some of this material appeared in the FEMINIST ART JOURNAL (Fall 1972).

686 Seckler, Dorothy Gees. "The Artist Speaks: Louise Nevelson." ART IN AMERICA 55 (January/February 1967): 32-43. Illus.

Based on an interview with the artist, Seckler reviews Nevelson's life and her artistic achievements. Nevelson's personal outlook on life and art is vividly characterized and punctuated by her own comments. Photographs by Ugo Mulas.

687 Whitney Museum of American Art (New York). LOUISE NEVELSON. Text by John Gordon. New York: 1967. 67 p. Illus.

Monographic catalog to accompany the first Nevelson retrospective. Exhibition includes over one hundred sculptures done since 1933 (includes finished works as well as models). Biographical essay. Chronology. Selected bibliography.

Further bibliography: Hirshhorn (see 168); Tuchman (see 239); Hunter (see 156).

NEWMAN, BARNETT 1905-70

688 Hess, Thomas B. BARNETT NEWMAN. New York: Museum of Modern Art, 1971. 160 p. 175 illus. Paperback.

Although known principally for his two-dimensional work, Nauman's aesthetics lead him to experiment with sculptural forms. This monograph, published to accompany the large Newman retrospective at the Museum of Modern Art, presents Newman's architectural models and sculptures in a single chapter (pp. 109-47). Extensive bibliography (pp. 151-59).

689 Rosenberg, Harold. BARNETT NEWMAN: "BROKEN OBELISK" AND OTHER SCULPTURES. Index of Art in the Pacific Northwest, vol. 2. Seattle: University of Washington Press for the Henry Art Gallery, 1971. 48 p. Illus. Paperback.

Published for the dedication of the "Broken Obelisk" at the University of Washington, Rosenberg analyzes this work in relationship to the rest of Newman's sculpture and painting.

Further bibliography: Whitney, 200 YEARS (see 86); (on Newman as painter) Keaveney, AMERICAN PAINTING.

NOGUCHI, ISAMU 1904-

690* Gordon, John. ISAMU NOGUCHI. New York: Praeger Publishers for
the Whitney Museum of American Art, 1968. 68 p. Illus.

> A brief, informal essay on Noguchi's life and work introduces
> this exhibition catalog for the first Noguchi retrospective.
> Numerous illustrations document the variety of work exhibited.
> Chronology. List of exhibitions. Selected bibliography by
> Patricia FitzGerald Mandel (pp. 65-68).

691 Gruen, John. "The Artist Speaks: An Interview." ART IN AMERICA
56 (March/April 1968): 28-31.

> Noguchi briefly presents his thoughts on sculpture and discusses
> the role of the artist in contemporary society.

692 Michelson, Annette. "Noguchi: Notes on a Theater of the Real." ART
INTERNATIONAL 8 (December 1964): 21-25. Illus. of 13 works.

> "Suggests a series of coordinates and themes which may facili-
> tate, in a very general way indeed, an approach to the com-
> plexity and force of an Oeuvre."

693 Noguchi, Isamu. A SCULPTOR'S WORLD. New York: Harper & Row,
1968. 259 p. Illus. Index.

> Autobiography which is generously interspersed with illustra-
> tions of Noguchi's work. Chapters deal with the artist's life,
> his pieces for the theater, and his thoughts about incorporat-
> ing sculpture into the environment.

Further bibliography: Index-20th Cent. (see 33), vol. 2, pp. 167-68 and sup-
plement; Giedion-Welcker (see 152); Craven (see 60); UCSB (see 180).

O'HANLON, RICHARD 1906-

694 San Francisco Museum of Art. THE SCULPTURE OF RICHARD O'HANLON.
San Francisco: 1961. [24]p. Illus. Paperback.

> Brief exhibition catalog with photographs of twenty-two of
> O'Hanlon's works. Brief introduction by Herschel Chipp.
> Chronology.

Further bibliography: Whitney, 200 YEARS (see 86).

OLDENBURG, CLAES 1929-

695 Johnson, Ellen H. CLAES OLDENBURG. Baltimore: Penguin Books,

1971. 64 p. Illus. Paperback.

Brief survey of Oldenburg's life and work with representative illustrations. A chronology and selected bibliography (pp. 61-62).

696 [Oldenburg, Claes.] CLAES OLDENBURG: PROPOSALS FOR MONUMENTS AND BUILDINGS, 1965-1969. Chicago: Big Table, 1969. 196 p. Illus.

Clever, often satiric, proposals for monuments in public places such as Times Square, the Thames River, etc. In an interview with Paul Carroll, Oldenburg discusses the origins and intents of his proposals. His feeling for "scale" is the justification for many of the proposals. A catalog of "Drawings of Proposals for Monuments and Buildings" is included (pp. 179-96). Bibliography (pp. 173-75).

697 _____. STORE DAYS. New York: Something Else Press, 1967. Unpaged. Illus.

Texts from and scripts for two of Oldenburg's environments/theaterpieces ("The Store" and "Ray Gun Theater") reflect Oldenburg's concepts of reality and fantasy as they relate to art and to the "real" world. Photographs by Robert R. McElroy.

698 Pasadena Art Museum. CLAES OLDENBURG: OBJECT INTO MONUMENT. Pasadena, Calif.: 1971. 136 p. 160 illus.

Catalog of a large exhibition of Oldenburg's soft sculptures and proposals for monuments. Essay by Barbara Haskell discusses the psychological implications and intentions of Oldenburg's subject matter and his soft materials. Oldenburg comments on the origins of his concepts and constructions. Chronology. Exhibition list. Bibliography compiled by Yoland Hershey (p. 135).

699* Rose, Barbara. CLAES OLDENBURG. New York: Museum of Modern Art, 1969. 221 p. 276 illus.

Monograph published on the occasion of Oldenburg's retrospective at the Museum of Modern Art, which presents a thorough exploration of the artist's life and work. Appendix includes some of Oldenburg's own writings from his notebooks. Comprehensive bibliography (pp. 206-14).

699a Walker Art Center (Minneapolis, Minn.). OLDENBURG: SIX THEMES. Minneapolis: 1975. 100 p. Illus. Paperback.

Exhibition catalog which concentrates on the genesis and evolution of six themes often employed by Oldenburg in his work:

Geometric Mouse, Three-Way Plug, Fagends, Clothspin, Type-writer Eraser, and Standing Mitt with Ball. A broad collection of drawings, soft sculptures, cardboard mock-ups, and metal fabrications of each theme are included. Martin Friedman's introduction precedes his interview with Oldenburg. Chronology. Bibliography (p. 99).

Further bibliography: Tuchman (see 239); Craven (see 60); Whitney, 200 YEARS (see 86).

OLITSKI, JULES 1922-

700 Moffett, Kenworth. "The Sculpture of Jules Olitski." METROPOLITAN MUSEUM OF ART BULLETIN (New York) 27 (April 1969): 365-71. 7 illus.

Following Olitski's brief statement on sculpture, Moffett discusses the importance of the sculpture which Olitski, a painter, executed in 1968 and 1969. Olitski's interest in surface and color is recognized as the "first authentic attempt in the history of art to realize pure color in three dimensions." The essence of this essay can also be found in ART AND ARTISTS 4 (September 1969) and ARTFORUM 7 (April 1969).

Further bibliography on Olitski as painter: Keaveney, AMERICAN PAINTING.

PALMER, ERASTUS DOW 1817-1904

701 Palmer, Erastus Dow. "Philosophy of the Ideal." CRAYON 3 (January 1856): 18-20. Reprint. AMERICAN ART REVIEW 2 (May/June 1975): 70-77.

A declaration of faith, published as a short essay in the leading art journal of the day, which reveals Palmer's prejudices, beliefs, and limitations.

702 Richardson, Helen Ely. "Erastus Dow Palmer, American Craftsman and Sculptor." NEW YORK HISTORY 27 (July 1946): 324-40. Illus.

Outlines Palmer's life and career based on the scant documentation which exists. Discusses his artistic and personal philosophy.

703 Webster, J. Carson. "Erastus D. Palmer: Problems and Possibilities." AMERICAN ART JOURNAL 4 (November 1972): 34-43. Illus.

Webster examines Palmer's work (cameos, ideal pieces, portraits) in order to demonstrate the artist's exceptionally convincing use of personality and "identity" for his sculptures.

His principal works, including the "White Captive," exemplify Webster's thesis.

Further bibliography: Gerdts-Neoclassic (see 123); Whitney, 200 YEARS (see 86).

PARIS, HAROLD PERSICO 1925-

704 California. University at Berkeley. Art Museum. HAROLD PARIS: THE CALIFORNIA YEARS. Edited by Peter Selz. Berkeley: 1972. 66 p. Illus. of 34 works. Paperback.

This exhibition catalog contains essays by Kneeland McNulty, Lawrence Dinnean, and Herschel B. Chipp. Selz's essay characterizes Paris's work during the 1960s: its poetic imagery, powerful conceptualization, theatricality, and technical sophistication. (Selz's essay is also in ART INTERNATIONAL 16 [April 1972].) Biographical chronology includes a list of exhibitions. Some writings by Paris included. Selected bibliography (p. 65).

705 Selz, Peter [H.]. "The Final Negation: Harold Paris' Koddesh-Koddashim'." ART IN AMERICA 57 (March/April 1969): 62-67. Illus.

Briefly outlines the artist's development and describes his completely sealed room, "Koddesh-Koddashim."

Further bibliography: Tuchman (see 239).

PARTRIDGE, WILLIAM ORDWAY 1861-1930

706 Langdon, William Chauncy. "William Ordway Partridge, Sculptor." NEW ENGLAND MAGAZINE n.s. 22 (June 1900): 382-98. Illus.

Reviews the life and career of Partridge by focusing on the major works done before 1900. Characterizes the style and meaning in many of Partridge's works.

Partridge, William Ordway. "The American School of Sculpture."
See citation 140.

707 _____. THE WORKS IN SCULPTURE OF WILLIAM ORDWAY PARTRIDGE, M.A. New York: John Lane, 1914. xii p. 67 plates.

Published by the sculptor in a limited edition in order to meet the frequent requests for photographs of his work. Includes a biographical sketch.

Further bibliography: Craven (see 60).

PAVIA, PHILIP 1912-

708 IT IS. New York: Second Half Publishing Co., Spring 1958-Autumn
1968. Irregular.

> Pavia established and edited five issues of this magazine (from
> 1958-60), which presented discussions and controversies
> among artists. Pavia wrote a four-part "Manifesto-in-Progress"
> (volumes 1-4), stating his concerns and beliefs about abstract
> sculpture. Pavia also participated in the "Sculpture Panel:
> Part 1" (volume 5). Pavia's work is occasionally illustrated.
> In the autumn of 1968, a sixth volume of IT IS was published
> (by different editors) which focused solely on sculpture. Pavia
> was a conspicuous and articulate member of the "Waldorf
> Panel Discussions" found in this final volume.

709 Washington Gallery of Modern Art. PHILIP PAVIA. Organized by
Gerald Nordland. Washington, D.C.: 1966. 19 p. 10 illus. Paperback.

> Pavia's biography and stylistic development are briefly discussed
> by Gerald Nordland. Ten of Pavia's light-reflecting, abstract
> marble stones from the early 1960s are illustrated.

PEALE, CHARLES WILLSON 1741-1827

710 Sellers, Charles Coleman. "Charles Willson Peale as Sculptor." AMERI-
CAN ART JOURNAL 2 (Fall 1970): 5-12. Illus.

> Using documentary evidence, Sellers proposes that the painter,
> Peale, occasionally sculpted portrait heads as a technical
> exercise. Some of these pieces appear as background decora-
> tion for paintings of and by the Peale family. Sellers pro-
> poses that Peale and William Rush--through their long and
> friendly association--influenced each other significantly.

Further bibliography on Peale as painter: See Keaveney, AMERICAN PAINTING.

PEPPER, BEVERLY 1924-

711 Marlborough-Gerson Gallery (New York). BEVERLY PEPPER: RECENT
SCULPTURE. New York: 1969. 34 p. 21 illus.

> Traveling exhibition of Pepper's polished and painted steel,
> box-like sculpture. Jan Van der Marck's preface outlines the
> sculptor's career and her aesthetics. List of exhibitions.

POWERS, HIRAM 1805-73

712 Bellows, Rev. Henry W. "Seven Sittings with Powers the Sculptor."

APPLETON'S JOURNAL 1 (1869): 342-43, 359-61, 402-4, 470-71, 595-97; 2 (1869): 54-55, 106-8.

> An entertaining account of Powers's lifestyle, his artistic philosophy and abilities, and his reaction to Italy, as recorded by Bellows, who sat for Powers seven times.

713 Crane, Sylvia E. WHITE SILENCE: GREENOUGH, POWERS, AND CRAWFORD, AMERICAN SCULPTORS IN NINETEENTH CENTURY ITALY. Coral Gables, Fla.: University of Miami Press, 1972. Illus.

> A biography of Powers (pp. 169-269) which indicates the influence of Italian neoclassicism upon the realistic sculpture of Powers. Appendix includes manuscript sources as well as a complete bibliography of secondary sources. A list of works also included. (See citation 121).

Hawthorne, Nathaniel. PASSAGES FROM THE FRENCH AND ITALIAN NOTEBOOKS. 3 vols. Boston: Houghton Mifflin Co., 1871. (See citation 127).

> Some of the passages dealing with Hawthorne's visits to Powers's studio have been excerpted in McCoubrey's AMERICAN ART, 1700-1900 (see 72), pp. 85-89.

714 Wunder, Richard P. "The Irascible Hiram Powers." AMERICAN ART JOURNAL 4 (November 1972): 10-15. Illus.

> Drawing on correspondence and documentary sources, Wunder outlines the personality conflicts which beset the American artistic community in Rome when Powers was the leading sculptor there.

Further bibliography: Craven (see 60); Thorpe-Literary Sculptors (see 133); Gerdts-Neoclassic (see 123).

PRESTINI, JAMES LIBERO 1908-

715 San Francisco Museum of Art. JAMES PRESTINI: SCULPTURE FROM STRUCTURAL STEEL ELEMENTS. San Francisco: 1969. 32 p. 23 Illus. Paperback.

> Exhibition of Prestini's nickel-plated sculptures, which use standard steel components. Introduced by Gerald Nordland. List of exhibitions and a "Curriculum Vitae."

PRICE, KENNETH 1935-

716 Los Angeles County Museum of Art (in cooperation with the Museum's Contemporary Arts Council). ROBERT IRWIN/KENNETH PRICE. Text by Lucy R. Lippard. Los Angeles: 1966. [30]p. Illus. Paperback.

Exhibition from which seventeen works by Price are illustrated. The essay discusses the origins and evolution of the forms used by Price. Chronology. List of exhibitions.

717 Zack, David. "Is Kenneth Price a Nut?" ART AND ARTISTS 4 (February 1970): 46-47. Illus.

Brief description of Price's ceramic works and his relationship to other fringe "nut" artists.

Further bibliography: Tuchman (see 239); Whitney, 200 YEARS (see 86).

PROCTOR, ALEXANDER PHIMISTER 1862-1950

718 Paladin, Vivian A. "A. Phimister Proctor: Master Sculptor of Horses." MONTANA, MAGAZINE OF WESTERN HISTORY 14 (January 1964): 10-24. Illus.

Traces Proctor's life and career--stressing the strength and encouragement of his wife and family. Describes and illustrates many of his major works.

719 Proctor, Alexander P. ALEXANDER PHIMISTER PROCTOR, SCULPTOR IN BUCKSKIN: AN AUTOBIOGRAPHY. Organized and edited by Hester Elizabeth Proctor. Norman: University of Oklahoma Press, 1971. 283 p. Illus. Index.

Lively autobiography of a popular American artist who was known for his realistic sculptures of "western horses, Indians, elk, deer, and buffalo." Photographs of the sculptures are gathered on forty-seven pages at the end of the book. The appendix contains a list of "major sculpture."

Further bibliography: Brookgreen (see 141); Craven (see 60); Broder (see 58); Whitney, 200 YEARS (see 86).

RAUSCHENBERG, ROBERT 1925-

720 Forge, Andrew. ROBERT RAUSCHENBERG. New York: Harry N. Abrams, 1969. 87 p. Illus.

Forge's critical discussion focuses on Rauschenberg's paintings; however, the excellent illustrations include several sculptural pieces. The "Autobiography" is factually informative. Bibliography (pp. 85-87).

721 Jewish Museum (New York). ROBERT RAUSCHENBERG. Organized by Alan Solomon. New York: 1963. [64]p. 46 illus. Paperback.

Catalog accompanying Rauschenberg's first one-man museum
show. Includes paintings, sculpture, and "combines" from the
late 1950s and early 1960s. Reflects the influence of pop art.
List of exhibitions. Bibliography (pp. 63-64).

Further bibliography on Rauschenberg as painter: Hunter (see 156); Keaveney,
AMERICAN PAINTING; Whitney, 200 YEARS (see 86).

REAM, VINNIE 1847-1914

722 [Hoxie, Richard Leveridge, comp.] VINNIE REAM. Washington, D.C.:
Gibson Bros., 1908. Reprint, with additions, 1915. 64 p. Illus.

A useful, if scarce, compilation of documents and reminiscences
related to the personality, work, and career of Vinnie Ream,
a member of the "white marmorean flock." Thirteen works
are photographed, including her well-known "Lincoln" in the
Capitol Rotunda, and the controversial "Farragut" in Washing-
ton, D.C.

Further bibliography: Gerdts-Neoclassic (see 123).

REDER, BERNARD 1897-1963

723 Rewald, John. SCULPTURES AND WOODCUTS OF REDER. Florence,
Italy: Sansoni Editore, 1957. 14 p. Illustrations of 36 sculptures and
10 woodcuts.

Short essay by Rewald on Reder's achievement of artistic matu-
rity. Works illustrated date from 1954 through 1957. List of
exhibitions.

724 Whitney Museum of American Art (New York). BERNARD REDER. New
York: 1961. 44 p. Illus. Index.

Exhibition catalog by Patricia Westlake, which accompanied a
large retrospective of Reder's sculptures, drawings, woodcuts,
and architectural projects. John I.H. Baur's biographical essay
amplifies Rewald's SCULPTURES AND WOODCUTS. Chronology.
Bibliography by Rosalind Irvine.

Further bibliography: Hirshhorn (see 168).

REMINGTON, FREDERIC 1861-1909

725* Hassrick, Peter H. FREDERIC REMINGTON. New York: Harry N.
Abrams in association with the Amon Carter Museum of Western Art,
[1973]. 218 p. Illus.

Fifteen bronzes in the Amon Carter Museum and Sid W.
Richardson collections are illustrated with color plates. Each
work is documented and described. Bibliography (pp. 215-18).

726 McCracken, Harold. FREDERIC REMINGTON: ARTIST OF THE OLD
WEST. Philadelphia: J.B. Lippincott Co., 1947. 157 p. 48 plates.
Index.

The standard biography of Remington by a noted Remington
enthusiast. Extensive bibliographic checklist (pp. 123-55) is
not included in McCracken's 1966 book. Nine pieces of
sculpture are illustrated.

727 _____. THE FREDERIC REMINGTON BOOK: A PICTORIAL HISTORY
OF THE WEST. Garden City, N.Y.: Doubleday, 1966. 285 p. Illus.
Index to the illustrations.

After treating various aspects of Remington's career, McCracken
devotes a chapter to "Broncos in Bronze" (pp. 255-73) in which
he describes and praises the major works.

728 Wear, Bruce. THE BRONZE WORLD OF FREDERIC REMINGTON.
Tulsa, Okla.: Gaylord, 1966. 149 p. Illus.

Information about Remington's sculptural works, his process of
casting, and the number of bronzes cast of each piece.
Twenty-one works are discussed specifically, with a chapter
on how to detect forgeries of these works. One biographical
chapter. (Wear is the art curator of the Thomas Gilcrease
Institute of American History and Art "housing the greatest col-
lection of Remington bronzes ever assembled.")

Further bibliography: Brookgreen (see 141); Craven (see 60); Broder (see 58);
Whitney, 200 YEARS (see 86).

RICKEY, GEORGE 1907-

729 Boston. Institute of Contemporary Art. GEORGE RICKEY/KINETIC
SCULPTURE. Boston: 1964. [16]p. Illus. Paperback.

Includes excerpts from the writings of the artist. Fifteen kine-
tic pieces are illustrated. Selected bibliography. Chronology
and list of one-man exhibitions.

730 Corcoran Gallery of Art (Washington, D.C.). GEORGE RICKEY: SIX-
TEEN YEARS OF KINETIC SCULPTURE. Washington, D.C.: 1966.
[24]p. 27 illus. Paperback.

Rickey's first major retrospective, which included seventy-five
works. The introduction by Peter Selz traces Rickey's develop-

ment and analyzes his relationship to other kinetic artists of the
past and the present. Two pages contain excerpts from the artist's
writings. Chronology. List of exhibitions. Biographical out-
line. One-page bibliography of items written by Rickey.

Rickey, George. CONSTRUCTIVISM. 1967. See citation 161.

_____. "Morphology of Movement." See citation 162.

Further bibliography: Tuchman (see 239); UC-Kinetic (see 215); Craven (see
60); Hunter (see 156); Whitney, 200 YEARS (see 86).

RIMMER, WILLIAM 1816-79

731 Bartlett, Truman H. THE ART LIFE OF WILLIAM RIMMER; SCULPTOR,
 PAINTER, AND PHYSICIAN. 1881. Reprint of 1890 ed. New York:
 Kennedy Graphics and DaCapo Press, 1970. 168 p. Illus.

 This is the basic biography of Rimmer; it records virtually all
 we know about the artist from his family's recollections and
 documents. Includes letters, newspaper advertisements, "recol-
 lections and anecdotes," and Rimmer's "observations on art and
 life." The reprint also includes an introduction by Leonard
 Baskin.

732 Whitney Museum of American Art (New York). WILLIAM RIMMER, 1816-
 1879. Organized by Lincoln Kirstein. New York: 1946. 47 p. Illus.

 Catalog for an exhibition of ninety-four works (including six
 sculptures) by Rimmer. The exhibition and catalog trace Rim-
 mer's life and art, noting the successes and difficulties of his
 career. Chronology. Bibliography (pp. 33-34).

Further bibliography: Craven (see 60); Whitney, 200 YEARS (see 86).

RINEHART, WILLIAM HENRY 1825-74

733 Ross, Marvin Chauncey, and Rutledge, Anna Wells. A CATALOGUE OF
 THE WORK OF WILLIAM HENRY RINEHART, MARYLAND SCULPTOR,
 1825-1875. Baltimore, Md.: Walters Art Gallery, 1948. 74 p. 48
 illus.

 "Published in connection with an exhibition of Rinehart's works
 held at the Walters Art Gallery and the Peabody Institute."
 The introduction briefly sketches Rinehart's years as a practic-
 ing sculptor (largely in Italy) and provides a chronology of his
 life and work. The catalog itself "lists all known works that
 can in any way be attributed to Rinehart," and provides a

thorough documentation for each piece. Bibliography (pp. 72-74).

734 _____. "William H. Rinehart's Letters to Frank B. Mayer, 1856-1870." MARYLAND HISTORICAL MAGAZINE 43 (June 1948): 127-38; 44 (March 1949): 52-57.

A group of thirteen letters from Rinehart (while in Europe) to Mayer (a Maryland painter and friend) which reflect the sculptor's opinions about life in Europe and reveal his social and artistic contacts with individuals of Baltimore.

735 Rusk, William Sener. WILLIAM HENRY RINEHART, SCULPTOR. Baltimore, Md.: Norman T.A. Munder, 1939. 156 p. Illus.

A detailed biography, supplemented by Letters of Rinehart, a list of his works (with extensive notes for each known piece), excerpts from critical opinions of Rinehart's work, and a listing of the younger sculptors who have been awarded the prized Rinehart Scholarship. Much of this material was originally published in the MARYLAND HISTORICAL MAGAZINE (volumes 19 (1924), 20 (1925), and 31 (1936). Extensive bibliography (pp. 107-12).

Further bibliography: Gerdts-Neoclassic (see 123).

RIVERA, JOSE DE. See DE RIVERA, JOSE

RIVERS, LARRY 1923-

736 Berkson, William. "Sculpture of Larry Rivers." ARTS MAGAZINE 40 (November 1965): 49-52. 6 illus.

Analyzes "the strengths and weaknesses of a maverick painter's assault on a third dimension." Characterizes Rivers's sculptural work; its sources and its meanings.

Further bibliography of Rivers as painter: Keaveney, AMERICAN PAINTING.

ROBUS, HUGO 1885-1964

737 Robus, Hugo. "The Sculptor As Self Critic." MAGAZINE OF ART 36 (March 1943): 95-98. 7 illus.

Robus reviews his own artistic development and reaches "conclusions" about his own work.

738 Rothschild, Lincoln. HUGO ROBUS. New York: American Federation

of Arts, 1960. [52]p. Illus.

> Issued to accompany a circulating exhibition, this small monograph traces Robus's artistic conversion from painting to sculpture. All seventeen works in the exhibition are illustrated. Chronology. Selected bibliography includes writings by and about Robus (pp. 30-34).

Further bibliography: Whitney, 200 YEARS (see 86).

ROCKBURNE, DOROTHEA

739 ["Dorothea Rockburne."] ARTFORUM 10 (March 1972): 28-36. Illus.

> Three critics comment on Rockburne's work. Mel Bochner poses aesthetic questions regarding Rockburne's art (p. 28). Robert Pincus-Witten presents illustrations of her work and edits the artist's brief comments (pp. 29-33). Jennifer Licht's interview with Rockburne focuses on the artist's working methods, her interest in set theory, and influences on her work (pp. 34-36).

740 Licht, Jennifer. "Work and Method: Dorothea Rockburne Discusses Her Recent Work." ART AND ARTISTS 6 (March 1972): 32-35. 3 illus.

> Interview which focuses on Rockburne's work--its development and its physical characteristics. Rockburne also expresses herself on the inspiration and intent of her work.

RODIA, SIMON 1879-1965

741 Los Angeles County Museum of Art. SIMON RODIA'S TOWERS IN WATTS. Los Angeles: 1962. 48 p. Illus. Paperback.

> A photographic exhibition by Seymour Rosen illustrating Rodia's Towers. A brief text describes the towers, Rodia, and the importance of preserving this Watts landmark. Selected bibliography by Kate Steinitz.

742 Steinitz, Kate T. "A Visit with Sam Rodia." ARTFORUM 1 (May 1963): 32-33.

> Poignant record of a visit with the charming, but aging, Rodia. A glimpse of his unique character.

ROGERS, JOHN 1829-1904

743 Bleier, Paul, and Bleier, Meta. JOHN ROGERS' GROUPS OF STATUARY; A PICTORIAL AND ANNOTATED GUIDE FOR THE COLLECTOR. Woodmere, N.Y.: 1971. 132 p. Illus. Spiralbound paperback.

A description of the artist's life, methods of production, and sales records precede a catalog of over eighty of Rogers's groups. Intended for the collector.

744 Smith, Mr. and Mrs. Chetwood. ROGERS GROUPS: THOUGHT AND WROUGHT BY JOHN ROGERS. Boston: Charles E. Goodspeed, 1934. 143 p. Illus.

All sculptures known to the Smiths are fully cataloged and illustrated. An alphabetical listing of the sculptures is included. Mrs. Smith's narrative on Rogers's life and career usefully draws on family papers, scrapbooks, and catalogs. Rogers's family genealogy is included.

745 Wallace, David H. "The Art of John Rogers: 'So Real and So True'." AMERICAN ART JOURNAL 4 (November 1972): 59–83. Illus.

Outlines Rogers's life and his artistic philosophy. The importance of his everyday subject matter and his simple sculptural techniques are discussed in relationship to the tastes of the general public and to those of the artistic/critical community.

746* _____. JOHN ROGERS, THE PEOPLE'S SCULPTOR. Middletown, Conn.: Wesleyan University Press, 1967. 341 p. 154 illus. Index.

Thoroughly researched yet entertaining biography which focuses on Rogers's position in the American popular culture of the nineteenth century. Wallace outlines the course of Rogers's career, his unique production and marketing techniques, and his effect on the appreciation of popular realistic art. An extensive catalog of the 208 known pieces by Rogers supplements the Smith's 1934 study (see entry above). Photographs of some of the early work and most of the groups are included. Appendices provide specific information on "Making a Rogers' Group," a checklist of the works, and "Notes for Collectors."

Further bibliography: Craven (see 60); Whitney, 200 YEARS (see 86).

ROGERS, RANDOLPH 1825-92

747 Rogers, Millard F., Jr. "Nydia, Popular Victorian Image." ANTIQUES 97 (March 1970): 374–77. Illus.

Discusses the inspiration for and the execution of Rogers's most famous work.

748* _____. RANDOLPH ROGERS, AMERICAN SCULPTOR IN ROME. Amherst: University of Massachusetts Press, 1971. 237 p. 88 illus. Index.

The major scholarly biography of this nineteenth-century ex-
patriate sculptor. Millard Rogers carefully traces the sculptor's
life and reviews achievements of his career. The sculptural
works and the critical response to them are discussed at
length. The "Catalogue of Sculptures" is a valuable resource.
Chronology. Extensive notes (pp. 169-86) and bibliography
(pp. 187-92).

Further bibliography: Gerdts-Neoclassic (see 123).

ROOD, JOHN 1902-74

749 Minnesota. University. University Gallery (Minneapolis). WORKS BY
JOHN ROOD: A MEMORIAL EXHIBITION. Minneapolis: 1974. [56]p.
35 illus. Paperback.

An exhibition catalog which contains a brief comment by the
artist. An essay by Charles C. Eldredge outlines Rood's artis-
tic development.

750 Schneider, Bruno F. JOHN ROOD'S SCULPTURE. Translated from the
German. Minneapolis: University of Minnesota Press, 1958. 112 p.
80 pages of plates.

Primarily a visual resource, this book contains an appreciative
essay on Rood's sculpture and drawings. Schneider also out-
lines the course of Rood's career. List of exhibitions. Bibliog-
raphy (p. 29).

ROSATI, JAMES 1912-

751 Brandeis University. Poses Institute of Fine Arts. JAMES ROSATI:
SCULPTURE 1963-1969. Waltham, Mass.: 1969. 43 p. 30 illus.
Paperback.

Catalog for an exhibition at the Rose Art Museum (Brandeis
University) held in collaboration with the Marlborough-Gerson
Gallery (New York). (The exhibition traveled also to the
Albright-Knox Gallery and to Yale University.) The introduc-
tion by William C. Seitz reviews the development of Rosati's
sculpture and the critical reactions to it. Seitz discusses the
forms of Rosati's mature work, encouraging its use in public
architectural spaces. (Reprinted in ART INTERNATIONAL 14
[January 1970]).

752 Kramer, Hilton. "The Sculpture of James Rosati." ARTS MAGAZINE 33
(March 1959): 26-31. 8 illus.

Kramer characterizes the sensitivity and "purity" which he finds

in Rosati's work. Brief outline of Rosati's career also included.

Further bibliography: Hirshhorn (see 168).

ROSENTHAL, BERNARD 1914-

753 Danes, Gibson. "Bernard Rosenthal." ART INTERNATIONAL 12 (March 1968): 45-48. Illus.

Brief history of Rosenthal's personal struggles and his sculptural development. Major works are illustrated and described.

754 M. Knoedler and Co. (New York). ROSENTHAL: SCULPTURES. New York: 1968. 24 p. Illus. Paperback

Exhibition catalog which is briefly introduced by Sam Hunter and contains a conversation with the artist about his work. Biographical outline.

ROSZAK, THEODORE 1907-

755 Arnason, H.H[oward]. "Growth of a Sculptor . . . Theodore Roszak." ART IN AMERICA 44 (Winter 1956): 21-23, 61-64. Illus.

Reviews the development of Roszak's style and technique.

756 Roszak, Theodore. "In Pursuit of an Image." QUADRUM, no. 2 (November 1956: 49-60. 8 illus.

An articulate study by Roszak of his own development and the "meaning of sculpture" as it relates to his work.

757 _____. "Problems of Modern Sculpture." 7 ARTS (Garden City, N.Y.), no. 3 (1955), pp. 58-68. Illus.

An interview focusing on the role of materials and techniques in contemporary sculpture. Considers the influence of painting on these forms and methods. Some of the text is excerpted from Roszak's earlier essay "Some Problems of Modern Sculpture." (This short-lived periodical was edited by Fernando Puma.)

758 _____. "Some Problems of Modern Sculpture." MAGAZINE OF ART 42 (February 1949): 53-56. Illus.

Roszak discusses the varieties of contemporary sculptural forms and the appropriate role for a sculptor in today's society.

759 Walker Art Center (Minneapolis, Minn.). THEODORE ROSZAK. Min-
neapolis: Walker Art Center in collaboration with the Whitney Museum
of American Art, 1956. 55 p. Illus.

> Using an outline of biographical facts, H.H. Arnason evaluates
> the development of Roszak's painting and sculpture. Roszak's
> own articulate self-evaluations are critically reappraised by
> Arnason. Chronology. List of exhibitions. Selected bibliog-
> raphy (p. 54).

Further bibliography: Giedion-Welcker (see 152); Hirshhorn (see 168); Craven
(see 60); Whitney, 200 YEARS (see 86).

RUSH, WILLIAM 1756-1833

760 Marceau, Henri. WILLIAM RUSH, 1756-1833: THE FIRST NATIVE
AMERICAN SCULPTOR. Philadelphia: Philadelphia Museum of Art, 1937.
85 p. Illus. Paperback.

> Marceau documents and justifies Rush's claim to the title of
> "first native American sculptor." The accomplishments of his
> career and the course of his life are traced and verified. The
> catalog attempts to provide a complete list of known, attributed,
> and doubtful works by Rush. The eighty-five items are thor-
> oughly discussed and twenty-eight are illustrated.

Further bibliography: Newark-American Folk Sculpture (see 110).

RUSSELL, CHARLES MARION 1864-1926

761 Amon Carter Museum of Western Art (Fort Worth, Texas). CHARLES M.
RUSSELL; PAINTINGS, DRAWINGS, AND SCULPTURE IN THE AMON G.
CARTER COLLECTION. Text by Frederic G. Renner. Rev. ed. New
York: Harry N. Abrams, 1974. 296 p. 248 illus. Index.

> Redesigned edition of Renner's 1966 book of the same title.
> The 1974 edition includes additional and more luxurious illus-
> trations. Renner, a personal friend of Russell, authoritatively
> discusses Russell's life and art. Each illustration is also the
> subject of a brief, but informed, commentary. Russell's sculp-
> tural output in bronze is discussed and illustrated in a separate
> chapter (pp. 64-105). His original models, however, are
> treated in a later chapter (pp. 138-52). Selected bibliography
> (pp. 291-92).

Further bibliography: Broder (see 58); Whitney, 200 YEARS (see 86).

SAINT-GAUDENS, AUGUSTUS 1848-1907

762 Cortissoz, Royal. AUGUSTUS SAINT-GAUDENS. Boston: Houghton
Mifflin Co., 1907. 86 p. 24 illus.

> This essay, written shortly after Saint-Gaudens's death, is a
> tribute to the work and personality of this famous American
> sculptor. Cortissoz, a close friend and noted critic, discusses
> Saint-Gaudens's major sculptural pieces.

763 Cox, Kenyon. "Augustus Saint-Gaudens." CENTURY MAGAZINE
n.s. 13 (November 1887): 28-37. Illus.

> For Cox, the work of Saint-Gaudens reflects an energy and
> inventiveness not evidenced in sculpture since the Renaissance.
> The styles and skills of the earlier period are identified in
> Saint-Gaudens's work. A short description by M.G. van Rens-
> selaer of Saint-Gaudens's "Lincoln" follows (pp. 37-39).

764 Hind, O. Lewis. AUGUSTUS SAINT-GAUDENS. London: International
Studio and John Lane Co., 1908. [47]p. 51 plates.

> The text consists of a chronology of Saint-Gaudens's life and
> work, and an "Appreciation" by Hind. The plates illustrate
> forty-three free-standing and relief works, and six models for
> U.S. coinage.

765 National Portrait Gallery. Smithsonian Institution. AUGUSTUS SAINT-
GAUDENS: THE PORTRAIT RELIEFS. Prepared by John Dryfhout and
Beverly Cox. Washington, D.C.: 1969. Unpaged. Paperback.

> Catalog for the Saint-Gaudens exhibition (the first since
> 1910). Each of the nearly sixty reliefs is illustrated, described,
> and documented; the personality of each subject is also sketched.
> Dryfhout, the curator of the Saint-Gaudens National Historic
> Site (Cornish, N.H.), briefly introduces the portrait reliefs.
> (He reorganized this material into an article entitled "Portraits
> in Bas-Relief" in the AMERICAN ART JOURNAL 4 [November
> 1972].)

766 Saint-Gaudens, Homer, ed. REMINISCENCES OF AUGUSTUS SAINT-
GAUDENS. New York: Century, 1913. 2 vols. Illus. Index in vol.
2.

> Saint-Gaudens's own memoirs (written the year before his death)
> are arranged, edited, and substantially amplified by his son,
> Homer. The sculptor was especially helpful with the biographi-
> cal details of his life but leaves it to Homer to supply "what
> is missing concerning his attitude toward art and artists." No
> documentation or bibliography.

767 Tharp, Louise Hall. SAINT-GAUDENS AND THE GUILDED ERA. Boston: Little, Brown and Co., 1969. 419 p. Illus.

>An entertaining and popular biography, constructed from such sources as letters and diaries of Saint-Gaudens's family and friends. Vividly reflects the cultural and social milieu in which Saint-Gaudens lived and worked. Bibliographical information in the chapter notes.

Further bibliography: Index-20th Cent. (see 33), vol. 1, pp. 113-23.

SAMARAS, LUCAS 1936-

768 Friedman, Martin. "The Obsessive Images of Lucas Samaras." ART AND ARTISTS 1 (November 1966): 20-23. Illus.

>Discusses the possible sources and impetus for Samaras's imagery.

769 Levin, Kim. LUCAS SAMARAS. New York: Harry N. Abrams, 1975. 248 p. 268 illus. Index.

>An important monograph, written and designed by the filmmaker Levin, which "probes the intricacies, and delves into the privacies of Samaras' iconography." Abundantly illustrated with lavish photographs, this major study attempts to relate the bizarre forms and images of Samaras's work to the events of his life. Biographical outline. Bibliography (pp. 245-46).

770 Pace Gallery (New York). SAMARAS: SELECTED WORKS, 1960-1966. New York: 1966. 56 p. 35 illus. Paperback.

>The text for this gallery catalog by Lawrence Alloway perceptively analyzes Samaras's development and discusses the interrelationships of his images and his aesthetics. The significance of "Peephole" and "Labyrinth" is discussed. Includes a statement by the artist. Biographical outline. Exhibition list. Bibliography (p. 52).

771 Samaras, Lucas. SAMARAS ALBUM: AUTOINTERVIEW, AUTOBIOGRAPHY, AUTOPOLAROID. New York: Whitney Museum of American Art and Pace Editions, 1971. 104 p. Chiefly illustrations.

>Samaras obsessively explores (with a polaroid camera) the variety of configurations and appearances which his body can take. The photographs, presented in groups or series, record Samaras's bizarre imagery. Self-interviews and psychological autobiographies provide an invaluable glimpse into Samaras's mind. Some of the autopolaroids and one of the autointerviews are featured in ART IN AMERICA 58 (November/December 1970): 66-83.

772 Solomon, Alan. "An Interview with Lucas Samaras. ARTFORUM 5 (October 1966): 39-44. 13 illus.

> Revealing interview focusing on Samaras's imagery, his use of objects and his recent works. Brief biographical details are included.

773 Whitney Museum of American Art (New York). LUCAS SAMARAS BY LUCAS SAMARAS. New York: 1972. 72 p. 107 illus. Paperback.

> Catalog accompanying "the most exhaustive record to date" of Samaras's work since 1959. Exhibition directed by Robert Doty. The abundant illustrations, with comments by the artist, comprise this catalog and provide insight into Samaras's complex imagery. Extensive four-page selected bibliography by Libby Seaberg.

Further bibliography: Tuchman (see 239); Hunter (see 156); Whitney, 200 YEARS (see 86).

SCHIMMEL, WILHELM 1817-90

774 Abby Aldrich Rockefeller Folk Art Collection (Williamsburg, Va.). WILHELM SCHIMMEL AND AARON MOUNTZ, WOODCARVERS. Williamsburg, Va.: 1965. 24 p. Illus. Paperback.

> Milton E. Flower discusses the life and work of each of these folk carvers. There are nine entries for Mountz and eighty-three for Schimmel (including his famous eagles, roosters, and parrots). Selected bibliography.

775 Flower, Milton E. "Schimmel the Woodcarver." ANTIQUES 44 (October 1943): 164-66. Illus.

> Biographical sketch of this eccentric folk carver who is best known for his rough-hewn pine eagles and his painted toys. The characteristics of his style are described and illustrated.

SCHMIDT, CLARENCE 1898-

776 Lipke, William C., and Blasdel, Gregg. SCHMIDT. Burlington, Vt.: Robert Hull Fleming Museum (University of Vermont), 1975. 112 p. Illus.

> "Published in conjunction with a traveling exhibition surveying the work of the grass-roots artist, Clarence Schmidt." Attempts to reconstruct (with descriptions, objects, and photographs) the fantastic environment created by Schmidt between 1952 and 1972. Essay by Lipke on "The Perception of Primitivism." Comments from Schmidt. Bibliography (pp. 111-12).

SCUDDER, JANET 1873-1940

777 Scudder, Janet. MODELING MY LIFE. New York: Harcourt, Brace & Co., 1925. viii, 297 p. Illus.

 Illuminates the difficulties, successes, and personal strength of Scudder. Useful for the record of her work.

Further bibliography: Brookgreen (see 141).

SEGAL, GEORGE 1924-

778 Chicago. Museum of Contemporary Art. GEORGE SEGAL: 12 HUMAN SITUATIONS. Chicago: 1968. 28 p. 68 illus. Paperback.

 Catalog for an exhibition of twelve works done between 1962 and 1967. Essay, by Jan Van der Marck, discusses the techniques, aesthetics, and psychological impact of Segal's work. Additional photographs amplify the catalog essay. Biographical outline. Exhibition list. "List of Cast Works, 1961-1967." Bibliography.

779 Lipke, William C., and Segal, George. "'Sense of Why Not': George Segal on His Sculpture." STUDIO INTERNATIONAL 174 (October 1967): 146-49. Illus.

 As introduced by Lipke, these remarks by Segal emphasize "his intense concern for the surfaces of his figures" as well as the "sense of balance and design governing an entire work." (These remarks are also included in the catalog for the 1971 Segal exhibition at the Kunsthaus in Zurich.)

780 Seitz, William C. SEGAL. New York: Harry N. Abrams, 1972. 95 p. 86 illus.

 Seitz outlines Segal's career and discusses the impact of Segal's realistic human subjects and his technical innovations. List of exhibitions. Bibliography (pp. 90-93).

781 Tuchman, Phyllis. "Interview with George Segal." ART IN AMERICA 60 (May/June 1972): 74-81. Illus.

 Lengthy and informative interview in which Segal discusses the sculptural work he has done since 1957.

782 Wisconsin. University. Union Art Gallery (Milwaukee). THE PRIVATE WORLD OF GEORGE SEGAL. Milwaukee: 1973. 24 p. Illus. Paperback.

 Introduction by John Lloyd Taylor. Essay by José L. Barrio-

Garay focuses on the development of Segal's enigmatic "Costume Party" (1966-72), the major piece in this exhibition. Other works exhibited dramatize the personal, nonpop aspects of Segal's sculpture.

Further bibliography: Recent Am (see 226); Tuchman (see 239); Walker-8 (see 255); Recent Figure (see 222); Hunter (see 156); Whitney, 200 YEARS (see 86).

SELEY, JASON 1919-

783 Colgate University. Dana Arts Center. Picker Gallery. FIGURES AND OBJECTS: JASON SELEY. Hamilton, N.Y.: 1974. 12 p. Illus. of 9 works. Paperback.

 Essay by Edward Bryant discusses Seley's use of the automobile bumper to construct witty images. An exhibition of recent work which includes a biographical outline and a list of exhibitions.

784 Cornell University. Andrew Dickson White Museum of Art. JASON SELEY. Ithaca, N.Y.: 1965. 32 p. Illus. Paperback.

 Retrospective catalog which illustrates twenty-nine of Seley's works. Essay by Peter Selz outlines the events of Seley's life and his artistic achievements. Chronology. List of exhibitions. Short bibliography.

SERRA, RICHARD 1939-

785 Baker, Elizabeth C. "Critic's Choice: Serra." ART NEWS 68 (February 1970): 26-27. Illus.

 Evaluation and description of Serra's lead slab and cylinder sculptures. Discusses the evolution of his art and his aesthetics.

786 Krauss, Rosalind. "Richard Serra: Sculpture Redrawn." ARTFORUM 10 (May 1972): 38-43. Illus.

 Analyzes how Serra's sculpture uses the line and the plane to avoid defining space or occupying space. Based on outdoor pieces done for Joseph Pulitzer.

787 Pincus-Witten, Robert. "Slow Information: Richard Serra." ARTFORUM 8 (September 1969): 34-39. Illus.

 Reviews Serra's development emphasizing his dedication to the concrete physical object rather than to theoretical or literary justifications.

788 Serra, Richard. "Play It Again, Sam." ARTS MAGAZINE 44 (February 1970): 24-27. Illus.

> Discusses the recent attempts by himself and others to avoid the traditional criticisms and concerns associated with painting and architecture.

Further bibliography: Whitney, 200 YEARS (see 86).

SKILLINS FAMILY late eighteenth century

789 Thwing, Leroy L. "The Four Carving Skillins." ANTIQUES 33 (June 1938): 326-28.

> Thwing condenses the biographical material relating to the Skillins of Boston (Simeon, 1716-78; John, 1746-1800; Simeon, Jr., 1756/57-1806; and Samuel, d. 1816). He updates the brief article by Mabel M. Swan which dealt with the attributions of numerous woodcarvings (ANTIQUES 20 [December 1931]).

Further bibliography: Craven (see 60); Whitney, 200 YEARS (see 86).

SMITH, ANTHONY. See SMITH, TONY

SMITH, DAVID 1906-65

790 Conè, Jane Harrison. "David Smith." ARTFORUM 5 (Summer 1967): 72-78. Illus.

> Analytical essay which attempts to show "that Smith, especially in his Zig and Cubi series, was exploring and finding new ways to project material forms in space, make them inhabit space by means solely of their structural rhythms and the opticality of their surfaces."

791 "David Smith." ARTS MAGAZINE 34 (February 1960): special issue. Profusely illus.

> Critic Hilton Kramer reviews Smith's work since the 1930s, noting the changes in concern and style (pp. 22-41). Several small illustrations, documenting each phase of Smith's work, accompany the essay. Smith contributes "Notes on My Work" (pp. 44-49).

792 Gray, Cleve, ed. DAVID SMITH BY DAVID SMITH. New York: Holt, Rinehart and Winston, 1968. 176 p. Profusely illus.

> Excerpts from the David Smith Papers (located at the Archives of American Art) are organized to complement and explain the

abundant photographs of Smith and his work. The selected writings deal with the events of Smith's life, his sculptural techniques, his interest in color, his fascination with dreams, etc.

793 Harvard University. William Hayes Fogg Art Museum. DAVID SMITH, 1906-1965. Cambridge, Mass.: 1966. 107 p. 83 illus. Paperback.

Fully illustrated and documented catalog to accompany this Smith retrospective which traveled to the Washington Gallery of Modern Art (Washington, D.C.). The important introductory essay by Jane Harrison Cone carefully details the stylistic development of Smith's work. Cone discusses the influences of other artists upon Smith and analyzes Smith's use of color. The catalog also includes a 544-item "Partial Handlist" of Smith's work, an interview with Katharine Kuh, the text of four of Smith's articles, a chronology by W. Berkson, and an extensive selected bibliography (pp. 90-94).

794 Krauss, Rosalind. "The Essential David Smith. ARTFORUM 7 (February and April 1969): 2 pts. Illus.

Part 1 traces Smith's conscious opposition to the formal principles of cubism and constructivism. Part 2 thoroughly analyzes Smith's relationship to surrealism.

795* _____. TERMINAL IRONWORKS: THE SCULPTURE OF DAVID SMITH. Cambridge, Mass.: M.I.T. Press, 1971. 246 p. 148 illus. Index.

An aggressive formalist analysis of Smith's work which goes "beyond the historical context" when examining the content and imagery of Smith's sculpture. Krauss documents her controversial statements with references to the Smith Papers, the artist's published statements, secondary commentary, and, most crucially, her own thorough analysis of forty major works. The bibliography (pp. 189-95) consists solely of an annotated list of all Smith's public statements. Secondary sources are indicated only in the footnotes.

796 Los Angeles County Museum of Art. DAVID SMITH: A MEMORIAL EXHIBITION. Los Angeles: 1965. 50 p. 32 illus. Paperback.

In the introduction to this exhibition catalog, Hilton Kramer relates the significance of Smith's sculpture to the history of modern art. The biography includes a selection of autobiographical statements by Smith. Extensive bibliography by Ed Cornachio (pp. 43-46).

797* McCoy, Garnett. DAVID SMITH. Documentary Monographs in Modern Art. New York: Praeger Publishers, 1973. 231 p. Illus. Index.

A well-organized anthology of Smith's writings, interviews, and letters deposited in the Archives of American Art. Modest, but useful, illustrations. Critical commentary by E. McCausland, W.R. Valentiner, and Clement Greenberg. Chronology. Bibliography (pp. 225-28).

798 New York. Museum of Modern Art. "David Smith." MUSEUM OF MODERN ART BULLETIN 25 (1957). New York: 1957. 36 p. Illus. of 28 works. Paperback.

The catalog for this retrospective exhibition was published as part of the MOMA BULLETIN. Sam Hunter's introductory essay clearly traces the influences on and development of Smith's sculpture up to 1956. Chronology. Selected bibliography by Bernard Karpel (p. 36).

799 Solomon R. Guggenheim Museum (New York). DAVID SMITH. New York: 1969. 182 p. Illus. Paperback.

Lengthy explanatory captions accompany photographs of the ninety-seven pieces in this retrospective exhibition. Edward Fry, in the introductory essay, examines each work closely in an attempt to clarify the artist's intention and to analyze the influence of European styles on Smith's work. A "Selected List of Exhibitions" (pp. 172-82). The bibliography (pp. 170-71) does not duplicate other lists and hence includes only minor articles.

Further bibliography: Giedion-Welcker (see 152); Hirshhorn (see 168); Tuchman (see 239); Craven (see 60).

SMITH, TONY 1912-

800 Green, Eleanor. "The Morphology of Tony Smith's Work." ARTFORUM 12 (April 1972): 54-59. 10 illus.

Green carefully describes and characterizes Smith's work in order to prove that it is not "reductive" in inspiration or intent. Photographs of works from all phases of Smith's career support Green's thesis.

801* Lippard, Lucy R. TONY SMITH. New York: Harry N. Abrams, 1972. 86 p. 77 illus.

Lippard's thorough analysis of Smith's forms and techniques is based on (and incorporates sections of) two of her earlier articles: "Tony Smith: The Ineluctable Modality of the Visible" (ART INTERNATIONAL 11 [Summer 1967]) and "Escalation in Washington" (ART INTERNATIONAL 12 [January 1968]). Biographical outline includes exhibition list. Selected bibliography (pp. 85-86).

802 Newark Museum. NINE SCULPTURES BY TONY SMITH. Newark, N.J.:
1970. [44]p. Illus.

> Traveling exhibition of nine works. Introduction by Eugene C.
> Goossen outlines Smith's artistic and aesthetic innovations and
> achievements. Smith contributes his own "Account of Career."
> List of exhibitions.

803 Wadsworth Atheneum (Hartford, Conn.) and the Institute of Contemporary
Art (University of Pennsylvania, Philadelphia). TONY SMITH: TWO
EXHIBITIONS OF SCULPTURE. Hartford, Conn.: 1966. [28]p. Illus.
Paperback.

> Catalog for Smith's first one-man show, displayed simultaneously
> at two institutions. Introduced by Samuel Wagstaff, Jr., the
> catalog consists primarily of Smith's own commentary on his
> work. These statements by Smith reflect his attitude toward
> materials, techniques, etc. (An expanded version of Smith's
> comments are in ARTFORUM 5 [December 1966].) This exhibi-
> tion prompted important critical commentary in the art world--
> including Lippard's "Ineluctable Modality of the Visible" (see
> above).

Further bibliography: Tuchman (see 239); Hunter (see 156); Whitney, 200 YEARS
(see 86).

SMITHSON, ROBERT 1938-73

804 Alloway, Lawrence. "Robert Smithson's Development." ARTFORUM 11
(November 1972): 52-61. Illus.

> Discusses the period between 1962 and 1972 during which
> Smithson moved from sculpture to earthworks "without any
> break in the continuity of his generating ideas." Contends
> that Smithson's work is not a part of the minimal art move-
> ment. Thorough bibliography of Smithson's writings and a
> listing of his "Major Nonsites, 1968" (p. 61).

805 Coplans, John. "Robert Smithson: The 'Amarillo Ramp'." ARTFORUM
12 (April 1974): 36-45. Illus.

> A detailed description of the evolution and execution of the
> "Amarillo Ramp"--an earthwork brought to completion after the
> artist's untimely death in 1973.

806 "Discussions with Heizer, Oppenheim, Smithson." AVALANCHE 1 (Fall
1970): 48-71. 32 illus.

> Based on discussions held in the winter of 1968/69, this tran-
> script reflects each artist's view of his work and its relevance
> to the rest of contemporary art.

807 Robbins, Anthony. "Smithson's Non-Site Sights." ART NEWS 67 (February 1969): 50-53. Illus.

> A clear, understandable explanation of Smith's "Non-site" works by a sympathetic fellow artist. Brief interview also.

Smithson, Robert. "Entropy and the New Monuments." See citation 253.

808 _____. "A Sedimentation of the Mind: Earth Projects." ARTFORUM 7 (September 1968): 44-50.

> Explains and justifies art being made from the earth.

Further bibliography: Tuchman (see 239); Hunter (see 156); Whitney, 200 YEARS (see 86).

SNELSON, KENNETH D. 1927-

809 Battcock, Gregory. "Kenneth Snelson." ARTS MAGAZINE 42 (February 1968): 27-29. Illus. of 5 works.

> Discusses the properties and implications of Snelson's work at the Dwan Gallery (New York) exhibition (1968).

810 Coplans, John. "An Interview with Kenneth Snelson." ARTFORUM 5 (March 1967): 46-49. 9 illus.

> Traces the evolution of Snelson's tension/compression structural concept and explores his ideas about space and materials.

811 Hanover, Germany. Kunstverein. KENNETH SNELSON. Hanover, Germany: 1971. 170 p. Profusely illustrated. Paperback. Text in English and German.

> Catalog documenting Snelson's work from 1960 to 1971. The two essays in English, by Grégoire Müller and Stephen A. Kurtz, discuss Snelson's concepts and influences. Snelson's project, "United States Patent Number 3.276.148, October 4, 1966" is reproduced. List of exhibitions. Biography. Bibliography (pp. 102-3).

812 Kurtz, Stephen A. "Kenneth Snelson: The Elegant Solution." ART NEWS 67 (October 1968): 48-51. Illus.

> A sympathetic evaluation of Snelson's technological and artistic achievements since 1964.

813 Müller, Grégoire. "Kenneth Snelson." ARTS MAGAZINE 45 (May 1971): 25-26. Illus.

Reviews Snelson's work in terms of its technological and philosophical implications.

Further bibliography: Tuchman (see 239).

STANKIEWICZ, RICHARD 1922-

814 Porter, Fairfield. "Stankiewicz Makes a Sculpture--'Soldier'." ART NEWS 54 (September 1955): 36-39. Illus.

Descriptive presentation of Stankiewicz's method of working, i.e., the welding together of metal found-objects.

815 Stankiewicz, Richard. "An Open Situation." ARTS YEARBOOK 8, 1965, pp. 156-59. Illus.

Stankiewicz reviews his own artistic concerns and his relationship to the art world of 1965.

816 Walker Art Center (Minneapolis, Minn.). RICHARD STANKIEWICZ, ROBERT INDIANA. Minneapolis: 1963. 16 p. Illus. Paperback.

An exhibition which traveled to the Institute of Contemporary Art in Boston, presenting the recent works of both artists. The essay on Stankiewicz by Jan Van der Marck discusses the work from 1961 to 1963 in terms of contemporary attitudes. Biographical outline. Exhibition list.

Further bibliography: Hirshhorn (see 168); Recent Am. (see 236); Craven (see 60).

STEINER, MICHAEL 1945-

817 Boston. Museum of Fine Arts. MICHAEL STEINER. Boston: 1974. 24 p. 17 illus. Paperback.

Exhibition catalog in which Kenworth Moffett analyzes the style and derivation of Steiner's work. His lengthy, articulate essay focuses on Steiner's work--its expressiveness and its relationship to other modernist sculpture. Brief biographical note. One page bibliography.

818 Fenton, Terry. "Michael Steiner." ART INTERNATIONAL 14 (Christmas 1970): 34-36. Illus.

Analyzing Steiner's recent work in terms of traditional sculptural concerns, Fenton praises Steiner's scale, content, and execution. This article is an "expanded, updated version" of the catalog text for the Steiner exhibition at the Norman MacKenzie Art Gallery in Regina, Saskatchewan, Canada (1970).

STERNE, MAURICE 1878-1957

819 New York. Museum of Modern Art. MAURICE STERNE: A RETROSPEC-
TIVE EXHIBITION, 1902-1932: PAINTINGS, SCULPTURE, DRAWINGS.
New York: 1933. 62 p. Illus.

> Sterne was the first American to be given a one-man show at
> the newly-established Museum of Modern Art. H.M. Kallen's
> introduction discusses Sterne's artistic development chronologi-
> cally. A "Note by the Artist." Chronology. Bibliography
> (pp. 19-20).

820 Sterne, Maurice. SHADOW AND LIGHT: THE LIFE, FRIENDS, AND
OPINIONS OF MAURICE STERNE. Edited by Charlotte Leon Mayerson.
New York: Harcourt, Brace & World, 1965. 288 p. Illus. Index.

> An edited (and occasionally amplified) transcription of the
> autobiographical notes which Sterne wrote during the long ill-
> ness preceding his death. Entertaining and evocative of the
> art world in the 1920s and 1930s. George Biddle's personal
> memories comprise the lengthy introduction.

Further bibliography: Index-20th Cent. (see 33), vol. 1, pp. 72-77.

STORRS, JOHN HENRY BRADLEY 1885-1956

821 Bryant, Edward. "Rediscovery: John Storrs." ART IN AMERICA 57
(May/June 1969): 66-71. Illus.

> Storrs, an expatriot, was impressively active in the avant-garde
> between the world wars. He maintained his contacts in this
> country by making frequent journeys across the ocean. Illus-
> trations of works from 1910-40.

822 Davidson, Abraham A. "John Storrs, Early Sculptor of the Machine Age."
ARTFORUM 13 (November 1974): 41-45. Illus.

> Reviews Storr's life, his major works, and his erratic artistic
> development. His relationship to cubist sculpture, as well as
> to industrially derived forms is traced.

Further bibliography: Craven (see 60); Whitney, 200 YEARS (see 86).

STORY, WILLIAM WETMORE 1819-95

823 Gerdts, William H., Jr. "William Wetmore Story." AMERICAN ART
JOURNAL 4 (November 1972): 16-33. Illus.

Attempts to stimulate renewed interest in Story by reviewing his life, working methods, and artistic achievements. The major works are described, illustrated, and criticized; their importance to Story's oeuvre and to nineteenth-century sculpture is analyzed.

824 James, Henry. WILLIAM WETMORE STORY AND HIS FRIENDS. Boston: Houghton Mifflin Co., 1903. 2 vols. Reprint. New York: Kennedy Galleries and DaCapo Press, 1970.

In the guise of a biography, James captured the lively social and artistic milieu surrounding Story in America, England, and finally in his Roman studio. More of a cultural history than an accurate biography of Story.

825 Phillips, Mary E. REMINISCENCES OF WILLIAM WETMORE STORY, THE AMERICAN SCULPTOR AND AUTHOR. Chicago: Rand McNally and Co., 1897. 305 p. Illus. Index.

An entertaining anthology, chronologically arranged, of incidents and anecdotes related to Story's life, his associations with famous people, and his principal works in literature and sculpture. The listing of sculptural works is the most complete available, although dated (pp. 295-98).

826 Story, William Wetmore. CONVERSATIONS IN A STUDIO. Boston: Houghton Mifflin Co., 1890. 2 vols. Index.

A fictional "conversation" between two men is used as the device for Story to present and explore aesthetic, historic, religious, and scientific questions of the day. The index locates the discussions on a particular issue.

Further bibliography: Craven (see 60); Gerdts-Neoclassic (see 123); Whitney, 200 YEARS (see 86).

SUGARMAN, GEORGE 1912-

827 Goldin, Amy. "Beyond Style." ART AND ARTISTS 3 (September 1968): 32-35. Illus.

Proposes that "the fact that Sugarman's work resists style categories . . . derives from the fact that he proceeds from an aesthetic that is indifferent to style and un-historical in focus." Goldin credits Sugarman with, in some respects, "inventing a style."

828 Simon, Sidney. "George Sugarman." ART INTERNATIONAL 11 (May 1967): 22-26. Illus.

Reviews Sugarman's work since 1960, especially noting his influence on other sculpture of the 1960s.

Further bibliography: Recent Am. (see 226); Tuchman (see 239); Whitney, 200 YEARS (see 86).

TAFT, LORADO 1860-1936

829 Moulton, Robert H. "Lorado Taft, Dean of Chicago Sculptors." ART AND ARCHAEOLOGY 12 (December 1921): 242-52. 8 works illus.

Recognized primarily as an author and teacher, Taft also produced a significant body of sculptural work. This summary of his work, while dated, is useful for the reproductions and the biographical information.

830 Taft, Ada (Bartlett). LORADO TAFT, SCULPTOR AND CITIZEN. Greensboro, N.C.: [Mary T. Smith], 1946. vii, 88 p. Illus.

Affectionate, sometimes anecdotal, retelling of Taft's life and career by his wife. Excerpts from the artist's writings also included. List of Taft's "Important Sculptural Works" (pp. 87-88).

Further bibliography: Index-20th Cent. (see 33), vol. 4, pp. 409-15 and vol. 3, no. 6, supplement; Brookgreen (see 141); Craven (see 60); Whitney, 200 YEARS (see 86).

THEK, PAUL 1933-

831 Pincus-Witten, Robert. "'Thek's Tomb.'" ARTFORUM 6 (November 1967): 24-25. Illus.

Description of the details which make "Thek's Tomb" such an evocative image of death. Pincus-Witten puzzles over the meaning of Thek's work in a drug-oriented society.

832 Wilson, William. "Paul Thek: Love-Death." ART AND ARTISTS 3 (April 1968): 22-25. Illus.

Describes the "consciousness of feeling" which sustains Thek's work. The imagery of the "Dead Hippie" (1967) is analyzed.

TODD, MIKE 1935

833 California. University at Los Angeles. Art Galleries. [MIKE TODD] RECENT SCULPTURE, 1969-1970. Los Angeles: 1969. 28 p. Illus. Paperback.

Catalog for an exhibition of Todd's work which was shown at the Salk Institute in San Diego, California. The works are photographed at the Salk Institute, among buildings designed by Louis Kahn. The analysis of Todd's recent work is provided by Thomas H. Garver. Todd reflects on his own sculpture. Chronology.

834 Swenson, G.R. "An Interview." ART AND ARTISTS 1 (November 1966): 24-27. Illus. of 4 works.

Explores the sexual imagery and impetus to Todd's sculpture.

Further bibliography: Tuchman (see 239).

TROVA, ERNEST 1927-

835 Miller, Donald. "Ernest Trova as Neo-Surrealist." ART INTERNATIONAL 14 (September 1970): 66-70. Illus.

Records the development and variety of forms which the Falling Man theme has taken since the early 1960s.

836 Pace Gallery (New York). TROVA: NEW SCULPTURE. New York: 1971. 28 p. Chiefly illus. Paperback.

Excellent reproductions of seventeen pieces done in 1970. Brief essay by A[rnold]. G[limcher]. traces the development of the Falling Man theme through the hinged figures of 1970. Exhibition list. Selected bibliography.

837 _____. TROVA: PROFILE CANTOS. New York: 1973. [20]p. Illus. Paperback.

This completely new style for Trova is introduced by Udo Kultermann in a two-page essay. Exhibition list. Selective bibliography.

838 _____. TROVA: SELECTED WORKS, 1953-1966. New York: 1966. 55 p. 16 illus. Paperback.

Important exhibition catalog describing, with illustrations, Trova's changing style and the evolution of the Falling Man theme. An in-depth discussion by Lawrence Alloway of Trova's imagery, its origin, and its development. Alloway evaluates Trova's attitude toward his machine-made objects. This exhibition traveled to the Hayden Gallery at Massachusetts Institute of Technology in 1967. Extensive bibliography by Susan Tumarkin (pp. 53-55).

839 Trova, Ernest. ARTIST SLAIN; PICTURE YEARBOOK 1973: TROVA 1947/72; OTHER WORKS/OTHER TIMES. [St. Louis?]: 2:30 Productions, 1973. 220 photographs. Paperback.

> An elegant photographic album of Trova's work since 1947; traces the development, refinement, and variations of the Falling Man theme. Almost no text.

840 Van der Marck, Jan. "Ernest Trova: Idols for the Computer Age." ART IN AMERICA 54 (November/December 1966): 64-67. Illus.

> Describes the Falling Man and speculates on its meaning and symbolism--for viewers, for Trova.

Further bibliography: Walker-8 (see 255); Tuchman (see 239); Hunter (see 156).

TRUITT, ANN 1921-

841 Corcoran Gallery of Art (Washington, D.C.). ANNE TRUITT; SCULPTURE AND DRAWINGS, 1961-1973. Washington, D.C.: 1974. 63 p. Illus. Paperback.

> Catalog for an important exhibition of Truitt's work since 1960. The introductory essay by Walter Hopps attempts to convey "some of the experiences, feelings, interests, and techniques I know to be of importance to Anne Truitt." A biographical sketch is included. The "Artist's Comprehensive Official Listing of Sculptural Works Undertaken Between 1961 and 1973" provides a useful reference tool. Sixty-four drawings are similarly listed. List of exhibitions. Bibliography (pp. 22-23).

Further bibliography: Whitney, 200 YEARS (see 86).

VALENTINE, DEWAIN 1926-

842 Danieli, Fidel [A.]. "DeWain Valentine." ART INTERNATIONAL 13 (November 1969): 36-39. Illus.

> Reviews the forms, materials, and surface treatment which Valentine has used in his work since the mid-1960s.

843 Pasadena Art Museum. DEWAIN VALENTINE, RECENT SCULPTURE. Pasadena, Calif.: 1970. [20]p. Illus. Paperback.

> An interview with John Coplans forms the text of this exhibition catalog. Chronology. Exhibition list. One-page bibliography.

844 Taylor, John Lloyd. "DeWain Valentine." ART INTERNATIONAL 17

(September 1973): 21-24 and following. Illus.

> Prompted by a gallery exhibition in 1973, Taylor explores at length the development of Valentine's polyester resin sculptures done since 1966. Light, color, and space are identified as continuing concerns of the artist.

845 Von Meier, Kurt. "An Interview with DeWain Valentine." ARTFORUM 7 (May 1969): 55-58. Illus.

> Valentine outlines the technical procedures and problems involved in casting polyester resin. He discusses the sculptors and the environments which have affected his work.

Further bibliography: Tuchman (see 239).

VOLLMER, RUTH

846 Everson Museum of Art (Syracuse, N.Y.). RUTH VOLLMER; SCULPTURE AND PAINTING, 1962-1974. Syracuse, N.Y.: 1974. [20]p. Illus. of 13 works. Paperback.

> Coordinated and edited by Peg Weiss, this exhibition catalog contains a perceptive introduction by Richard Tuttle and a descriptive essay by Lee Hall on Vollmer's sculpture. Occasional comments by Vollmer. List of exhibitions. Bibliography (p. 20).

847 Friedman, B.H. "The Quiet World of Ruth Vollmer." ART INTERNA-TIONAL 9 (March 1965): 26-28. 5 illus.

> A personal tribute to Vollmer's quiet, sympathetic personality, and her unobtrusive, but evocative, sculptures. Aspects of her biography are included.

848 LeWitt, Sol. "Ruth Vollmer: Mathematical Forms." STUDIO INTERNA-TIONAL 180 (December 1970): 256-57. 7 illus.

> The geometrical aesthetic and basis for Vollmer's work is briefly and directly presented.

VON SCHLEGELL, DAVID 1920-

849 Brandeis University. Poses Institute of Fine Arts. DAVID VON SCHLE-GELL. Waltham, Mass.: 1968. 16 p. 11 illus. Paperback.

> Catalog for an exhibition held at the Rose Art Museum at Brandeis University. Foreword by Russell Connor outlines Von Schlegell's development and reviews the criticism of his work. Chronology. Exhibition list. One-page selected bibliography.

850 Jacobs, Jay. "The Artist Speaks: David Von Schlegell." ART IN
 AMERICA 56 (May/June 1968): 50-59. Illus.

> An informal discussion with VonSchlegell focusing on his life
> and work. Chronology (p. 58).

Further bibliography: Tuchman (see 239).

VOULKOS, PETER 1924-

851 Los Angeles County Museum of Art. PETER VOULKOS' SCULPTURE. Los
 Angeles: 1965. 4 p. 12 plates. Paperback.

> Demonstrates a change in Voulkos's interests away from totemic
> ceramic and clay work toward simplified bronze forms. Bibliog-
> raphy through March 1965.

852 San Francisco Museum of Art. PETER VOULKOS; BRONZE SCULPTURE.
 San Francisco: 1972. [16]p. Illus. of 17 works. Paperback.

> Gerald Nordland's introduction to this exhibition catalog de-
> scribes Voulkos's artistic development and his use of the bronze
> casting technique. Chronology. One-page bibliography relat-
> ing solely to the "artist's bronzes and his casting techniques."

Further bibliography: Tuchman (see 239); Whitney, 200 YEARS (see 86).

WARD, JOHN QUINCY ADAMS 1830-1910

853 Adams, Adeline [Valentine Pond]. JOHN QUINCY ADAMS WARD, AN AP-
 PRECIATION. New York: National Sculpture Society, 1912. 79 p. Plates.

> A testimonial reflecting Ward's importance to his contemporaries.
> A list of his works (similar to a list in INTERNATIONAL STU-
> DIO 40 [June 1910], p. lxxxiii) admits incompleteness.

854 Sharp, Lewis I. "John Quincy Adams Ward; Historical and Contemporary
 Influences." AMERICAN ART JOURNAL 4 (November 1972); 71-83.
 Illus.

> Reconsiders the importance of "classical, Renaissance, and
> nineteenth century French sculpture" to the development of
> Ward's naturalistic "realism." Brief outline of Ward's career.

855 Sheldon, G.W. "An American Sculptor." HARPER'S MAGAZINE 57
 (June 1878): 62-68. Illus.

> Sheldon interviews Ward about his techniques and his aesthetic
> beliefs and seeks Ward's advice to young artists on the matters
> of drapery and of formal artistic training.

856 Sturgis, Russell. "The Work of John Quincy Adams Ward." SCRIBNER'S
 MAGAZINE 32 (October 1902): 385-99. Illus.

 Proposes that Ward is the first American sculptor to demonstrate
 a good sense of composition and design. Sturgis defends his
 thesis by discussing and illustrating Ward's principal works.

Further bibliography: Brookgreen (see 141); Broder (see 58); Whitney, 200 YEARS
(see 86).

WARNEKE, HEINZ 1895-

857 Hutchings, Emily Grant. "The Simple Genius of Heinz Warneke." IN-
 TERNATIONAL STUDIO 83 (February 1926): 35-38. 7 illus.

 Noting Warneke's "sincerity and underlying sense of the ab-
 stract," Hutchings outlines the sculptor's biography and his
 artistic achievements.

858 Warneke, Heinz. "First and Last a Sculptor." MAGAZINE OF ART 32
 (February 1939): 74-80. 7 illus.

 Autobiographical account of Warneke's youth, the course of his
 career, and his relationship to architectural commissions.

Further bibliography: Index-20th Cent. (see 33), vol. 3, pp. 263-64 and supple-
ment); Brookgreen (see 141).

WARNER, OLIN LEVI 1844-96

859 Brownell, W.C. "The Sculpture of Olin Warner." SCRIBNER'S MAGA-
 ZINE 20 (October 1896): 429-41. Illus.

 Characterizes the fine modeling of Warner's works and praises
 his sense of beauty. The portraits especially are thoroughly
 described and discussed.

Further bibliography: Craven (see 60); Broder (see 58); Whitney, 200 YEARS
(see 86).

WEINMAN, ADOLPH ALEXANDER 1870-1952

860 ADOLPH A. WEINMAN. American Sculptors Series, no. 12. Athens:
 Georgia University Press in collaboration with The National Sculpture
 Society, [1950]. 62 p. Chiefly illus. Paperback.

 A brief statement by the artist precedes this album of photo-
 graphs illustrating the varieties of Weinman's work: sculpture,

portraiture, architectural work, and medallions. Biographical sketch.

Further bibliography: Brookgreen (see 141); Broder (see 58); Whitney, 200 YEARS (see 86).

WESTERMANN, HORACE CLIFFORD 1922-

861 Adrian, Dennis. "The Art of H.C. Westermann." ARTFORUM 6 (September 1967): 16-22. Illus.

> Traces the development of Westermann's sculpture artistically and technically; major pieces are described and eighteen are illustrated.

862 Los Angeles County Museum of Art. H.C. WESTERMANN. Los Angeles: 1968. 48 p. 50 illus. Paperback.

> Catalog for the first museum retrospective of Westermann's constructions, assemblages, and drawings. Max Kozloff discusses the psychological and formal paradoxes which he finds in Westermann's work. Biographical data. Exhibition list. Selected bibliography (p. 47).

Further bibliography: Selz's New Images (see 250); Walker-8 (see 255); Tuchman (see 239); Whitney, 200 YEARS (see 86).

WHITNEY, ANNE 1821-1915

863 Payne, Elizabeth Rogers. "Anne Whitney; Art and Social Justice." MASSACHUSETTS REVIEW 12 (Spring 1971): 245-60. 8 illus.

> Outlines Whitney's life and the circumstances which encouraged her dedication to the causes of social justice. Her sculptural work, embodying such social principles, is described and illustrated.

864 _____. "Anne Whitney, Sculptor." ART QUARTERLY 25 (Autumn 1962): 244-61. 12 illus.

> Payne's brief biographical introduction precedes an "Incomplete List of Sculpture by Anne Whitney" (pp. 248-61). The Wellesley College Anne Whitney Collection of papers and documents provided much of the information for this list.

Further bibliography: Gerdts-Neoclassic (see 123); Whitney, 200 YEARS (see 86).

WHITNEY, GERTRUDE VANDERBILT 1877-1942

865 DuBois, Guy Pène. "Mrs. Whitney's Journey in Art." INTERNATIONAL
STUDIO 76 (January 1923): 351-54. 6 illus.

> Artistic and philosophical defense of Whitney's work. Points
> out the depth and emotional restraint found in this society
> matron's sculpture.

866 Whitney Museum of American Art (New York). MEMORIAL EXHIBITION:
GERTRUDE VANDERBILT WHITNEY. New York: 1943. [20]p. 22 illus.

> Biographical note and an essay by Juliana Force which out-
> lines Whitney's artistic achievements.

Further bibliography: Brookgreen (see 141); Broder (see 58); Whitney, 200 YEARS
(see 86).

WILFRED, THOMAS 1889-1968

867 Corcoran Gallery of Art (Washington, D.C.). THOMAS WILFRED:
LUMIA. Washington, D.C.: 1971. 102 p. Illus. Paperback.

> A major survey of Wilfred's over sixty years of exploration
> with light as an artistic medium, described in the text by
> Donna M. Stein. Diagrams of the construction principles for
> Lumia are included. Excerpts from the artist's writings further
> illuminate the works displayed. List of exhibitions and "com-
> positions." Extensive chronology. Selective bibliography
> (pp. 94-97).

868 Wilfred, Thomas. "Composing in the Art of Lumia." JOURNAL OF
AESTHETICS AND ART CRITICISM 7 (December 1948): 79-93. Illus.

> The artistic possibilities of this "new" medium--light--are ex-
> plained and extolled. The construction and programming of
> Lumia are described.

WILMARTH, CHRISTOPHER M. 1943-

869 Ashton, Dore. "Radiance and Reserve: The Sculpture of Christopher
Wilmarth." ARTS MAGAZINE 45 (March 1971): 31-33. Illus. of 5
works.

> A favorable review of Wilmarth's glass sculptures. Ashton also
> outlines Wilmarth's artistic development and provides a techni-
> cal explanation of his work.

870 Pincus-Witten, Robert. "Christopher Wilmarth, a Note on Pictorial
Sculpture." ARTFORUM 9 (May 1971): 54-56. Illus. of 6 works.

A short critical review comparing Wilmarth's works to those of Richard Serra.

871 Wadsworth Atheneum (Hartford, Conn.). CHRISTOPHER WILMARTH: NINE CLEARINGS FOR A STANDING MAN. Hartford, Conn.: 1974. 48 p. Illus.

Exhibition catalog documenting (in sculpture, watercolor, and pencil) one experimental phase of Wilmarth's development. The catalog essay by Joseph Masheck discusses "Wilmarth's New Reliefs" in depth. Informative statement by the artist. Biographical outline. Bibliography (p. 18).

Further bibliography: Whitney, 200 YEARS (see 86).

WINSOR, JACKIE 1941-

872 Béar, Liza. "An Interview with Jackie Winsor." AVALANCHE, no. 4, (Spring 1972): 10-17. Illus.

The artist explains the significance of the materials she uses (rope and timbers). She also discusses her process of making compositional decisions. Eight pieces are illustrated; two are photographed sequentially in various stages of completion.

873 Lippard, Lucy R. "Jackie Winsor." ARTFORUM 12 (February 1974): 56-58. Illus.

Characterizes Winsor's work and illustrates ten of her pieces.

WRIGHT, PATIENCE LOVELL 1725-86

874 Lesley, Everett Parker. "Patience Lovell Wright, America's First Sculptor." ART IN AMERICA 24 (October 1936): 148-54 and following. 4 illus.

Biography of an acclaimed modeller of wax portraits and effigies in New York and London. Article summarizes her life as an artist and as a political spy.

875 Long, J.C. "Patience Wright of Bordentown." NEW JERSEY HISTORICAL SOCIETY PROCEEDINGS 79 (April 1961): 118-23. 3 illus.

Review of the career and personality of this early wax modeller. Biographical details incorporated into the text. Bibliographical footnotes.

Further bibliography: Gerdts-Neoclassic (see 123).

YOUNG, MAHONRI M. 1877-1957

876 Addison Gallery of Art (Andover, Mass.). MAHONRI M. YOUNG: RETROSPECTIVE EXHIBITION. Andover, Mass.: Phillips Academy, 1940. 57 p. Illus.

> In the catalog essay, "The Art of Mahonri Young," Frank Jewett Mather, Jr., praises Young's varied artistic accomplishments. Twenty-five sculptures are listed in the catalog (seven are illustrated). Autobiographical notes by Young (pp. 47-56). Biographical outline.

877 Lewine, J. Lester. "The Bronzes of Mahonri Young." INTERNATIONAL STUDIO 47 (October 1912): lv-lix. Illus.

> Praises the technique and sympathetic spirit of Young's sculpture. Recognizes Young's gift for "close observations of distinguishing traits" of physiognomy and his expressive response to "the delicate charm of feminine types."

878 [Young, Mahonri.] "Life as Mahonri Sees It." TOUCHSTONE 4 (October 1918): 8-16. Illus.

> Revealing commentary by Young on his life in the west; the landscape and the people. Article illustrated by Young's own drawings, paintings, and sculptures.

Further bibliography: Index-20th Cent. (see 33), vol. 2, pp. 45-48 and supplement); Brookgreen (see 141); Broder (see 58); Whitney, 200 YEARS (see 86).

ZAJAC, JACK 1929-

879 Fine Arts Gallery of San Diego and the Santa Barbara Museum of Art. JACK ZAJAC: RETROSPECTIVE EXHIBITION. San Diego, Calif.: 1975. [36]p. 24 illus. Paperback.

> This exhibition was displayed in two parts: work from 1955-74 was displayed at San Diego; work from 1966-74 was exhibited at Santa Barbara. The introduction by Henry J. Seldis characterizes the poetic inspirations implicit in Zajac's sculpture throughout the twenty-year period. List of exhibitions. Biographical information.

880 Seldis, Henry J. "Zajac." ARTFORUM 1 (June 1962): 30-31. Illus.

> Outlines Zajac's biography and describes his work and its emotional power.

Further bibliography: Hirshhorn (see 168).

ZOGBAUM, WILFRID 1915-65

881 San Francisco Museum of Art. WILFRID ZOGBAUM; SCULPTURE, 1955-1964. San Francisco: 1973. [20]p. 13 illus. Paperback.

> Catalog essay by John Humphrey explores the development of Zogbaum's sculptural forms between 1960 and 1964. The chronology includes biographical data, exhibitions, and bibliographic citations.

882 Tabak, May Natalie. "Zogbaum Makes a Sculpture--'Santa Barbara'." ART NEWS 63 (December 1964): 42-45 and following. Illus.

> Describes how Zogbaum determines the forms and materials he uses. The studio is well described.

Further bibliography: Tuchman (see 239).

ZORACH, WILLIAM 1887-1966

883* Baur, John I.H. WILLIAM ZORACH. New York: Praeger Publishers for the Whitney Museum of American Art, 1959. 116 p. 90 illus. Index.

> Published at the time of the 1959 Zorach retrospective at the Whitney Museum, this book provides a much "fuller account of Zorach's life and work . . . and many more illustrations than the catalogue of that exhibition." The text and the bibliography focus on material and works after 1938. Chronology. Bibliography by Rosalind Irvine (pp. 112-14).

884 Wingert, Paul S. THE SCULPTURE OF WILLIAM ZORACH. New York: Pitman Publishing, 1938. 74 p. 49 plates.

> The text, a standard source, analyzes Zorach's sculpture and its place in the art of the twentieth century. Catalogue Raisonné (pp. 59-65). List of exhibitions. Bibliography (pp. 66-68).

885 Zorach, William. ART IS MY LIFE: AUTOBIOGRAPHY OF WILLIAM ZORACH. Cleveland, Ohio: World Publishing Co., 1967. 205 p. Illus.

> Autobiography which provides insight into the personality and character of Zorach. Biographical details and artistic philosophy are intermingled in candid reflections.

886 _____. "The New Tendencies in Art." ARTS 2 (October 1921): 10-15. Reprint. AMERICAN ART REVIEW 2 (May/June 1975): 115-22.

> A gently persuasive presentation of the goals and aesthetics of

"modern art" (in 1921). Zorach describes the creative act in
general, using examples from both painting and sculpture.

887 _____ . ZORACH EXPLAINS SCULPTURE, WHAT IT MEANS AND HOW
IT IS MADE. New York: American Artists Group, 1947. 316 p. Illus.
Index.

A unique handbook on sculpture which integrates information
from art history with technical discussion about materials, etc.
Zorach's personal and artistic philosophy make this book essen-
tial for the Zorach scholar as well as the studio student.

Further bibliography: Index-20th Cent. (see 33), vol. 1, pp. 124-26); Whitney,
200 YEARS (see 86).

APPENDIX

Appendix
PUBLIC INSTITUTIONS WITH EXTENSIVE
COLLECTIONS OF AMERICAN SCULPTURE

Public museums with major collections of American sculpture are listed below. If an illustrated handbook or catalog of the collection has been published, it is noted. Private collections have been excluded. THE OFFICIAL MUSEUM DIRECTORY (see 56) and the AMERICAN ART DIRECTORY (see 53) provide fuller information about each institution included here, as well as listing many more museums.

Note should also be taken of the following descriptive guidebooks which introduce the highlights and ambience of major public, college, and university collections.

Faison, S. Lane, Jr. ART TOURS AND DETOURS IN NEW YORK STATE. New York: Random House, 1964. 303 p. Illus.

_____. A GUIDE TO THE ART MUSEUMS OF NEW ENGLAND. New York: Harcourt, Brace, 1958. 287 p. 405 illus. Index.

Spaeth, Eloise. AMERICAN ART MUSEUMS: AN INTRODUCTION TO LOOKING. 3d ed., exp. New York: Harper & Row, 1975. Index. Bibliography (pp. 445-46.

ARIZONA

Phoenix

Phoenix Art Musuem, 1625 North Central Avenue, Phoenix, Arizona 85004.

PAINTINGS, DRAWINGS AND SCULPTURE IN THE PHOENIX ART MUSEUM COLLECTION. Compiled by James Harithas, curator. Phoenix, Ariz.: 1965. 225 p. Illus. Index.

Although the largest part of the collection is "French School," there are significant works by Archipenko, Caesar, Huntington, Manship, Nadelman, and Voulkos.

Appendix

Tempe

Arizona State University Art Collections, Matthews Center, Tempe, Arizona 85281.

> ARIZONA STATE COLLEGE COLLECTION OF AMERICAN ART.
> Text and research by Paula R. Kloster. Tempe, Ariz.: 1954.
> 109 p. Illus. Index.
>
> > The catalog for the sculptors (pp. 84-97) lists twenty-one artists including DeCreeft, DerHarootian, Flannagan, Laurent, Lipchitz, Roszak, Warner, and Zorach.

Tucson

University of Arizona Museum of Art. Olive and Speedway, Tucson, Arizona 85721.

CALIFORNIA

Berkeley

University of California Art Museum, 2626 Bancroft Way, Berkeley, California 94720.

Los Angeles

Los Angeles County Museum of Art, 5905 Wilshire Boulevard, Los Angeles, California 90036.

> ILLUSTRATED HANDBOOK OF THE LOS ANGELES COUNTY
> MUSEUM OF ART. Los Angeles: 1965. 184 p. Illus.

University of California at Los Angeles (UCLA) Art Galleries, 405 Hilgard Avenue, Los Angeles, California 90024.

> Sculpture garden with forty-five works from the nineteenth and twentieth centuries.

Oakland

Oakland Museum, 1000 Oak Street, Oakland, California 94607.

> The Art Division of this museum is especially concerned with California art and artists.

San Francisco

California Palace of the Legion of Honor, Lincoln Park, San Francisco, California 94121.

M.H. DeYoung Memorial Museum, Golden Gate Park, San Francisco, California 94118.

ILLUSTRATIONS OF SELECTED WORKS. San Francisco: M.H. DeYoung Memorial Museum, 1950. 157 p. Illus.

San Francisco Museum of Modern Art, McAllister Street at Van Ness Avenue, San Francisco. California 94102.

Sponsors important exhibitions as well as an annual exhibition of current art.

COLORADO

Colorado Springs

Colorado Springs Fine Arts Center (incorporating the Taylor Museum), 30 West Dale Street, Colorado Springs, Colorado 80903.

Contains an important collection of Santos (see citations 116 and 112).

Denver

Denver Art Museum, 100 West Fourteenth Avenue Parkway, Denver, Colorado 80204.

GUIDE TO THE COLLECTION. Denver: 1965. 210 p. Illus. Paperback.

The large collection of Santos is represented by eight illustrations and a brief introduction. Sculpture by Archipenko and Bertoia is also illustrated.

CONNECTICUT

Hartford

Wadsworth Atheneum, 600 Main Street, Hartford, Connecticut 06103.

WADSWORTH ATHENEUM HANDBOOK. Hartford, Conn.: 1958. 193 p. Illus. Index. Paperback.

This handbook reflects the rich diversity of the collection; sculptures by Bartholomew, Lachaise, Lippold, and Lipton are illustrated.

New Haven

Yale University Art Gallery, 1111 Chapel Street, New Haven, Connecticut 06520.

A research collection, rich in all periods of art history. Includes the collection of the Société Anonyme, which collected the "most complete and representative expressions of the various modern movements in European and American art from 1909 to 1949."

Appendix

THE COLLECTION OF THE SOCIÉTÉ ANONYME: MUSEUM OF
MODERN ART, 1920. Edited by George Heard Hamilton. New Ha-
ven, Conn.: Yale University Art Gallery, 1950. 247 p. Illus. Index.

> This catalog documents the work of 169 artists (including
> Archipenko, Calder, Diller, Duchamp, Gabo, Lipchitz,
> Moholy-Nagy, and Storrs) whose work was collected by
> Katherine S. Dreier and Marcel Duchamp for the
> Société Anonyme and is now owned by Yale.

DELAWARE

Winterthur

Henry Francis DuPont Winterthur Museum, Winterthur, Delaware 19735.

> An extraordinary collection of American decorative arts from the
> seventeenth century to the middle of the nineteenth century. Folk
> sculpture and painting have been collected since the 1920s. In
> 1964 the museum began the annual publication of the WINTERTHUR
> PORTFOLIO, a scholarly journal in the field of early American
> arts. The museum library's catalog has been published in book form
> (see 18).

DISTRICT OF COLUMBIA

Corcoran Gallery of Art, Seventeenth Street and New York Avenue, N.W.,
Washington, D.C. 20006.

> The Corcoran owns a major collection of American paintings and
> sculpture from the eighteenth to the twentieth century. It also
> sponsors many one-man shows of contemporary American artists.

> ILLUSTRATED HANDBOOK OF PAINTINGS, SCULPTURE AND
> OTHER ART OBJECTS (exclusive of the W.A. Clark Collection).
> Washington, D.C.: 1933. 152 p. Illus. Index.

> > The chapter on sculpture (pp. 114-29) lists the Corcoran's
> > holdings in 1933. Works by French, Hoffman, Mac-
> > Neil, Manship, Powers, and Saint-Gaudens are illus-
> > trated.

Phillips Collection, 1600-12 Twenty-first Street, N.W., Washington, D.C.
20007.

> Phillips, Marjorie. DUNCAN PHILLIPS AND HIS COLLECTION.
> Boston: Little, Brown and Co., 1970. 363 p. Illus. Index.

> > Anecdotal memoir by Phillips's wife which relates stories
> > about their married life and the development of the col-
> > lection. Illustrations are arranged by date of acquisition.

THE PHILLIPS COLLECTION, A MUSEUM OF MODERN ART AND
ITS SOURCES. CATALOGUE. Washington, D.C.: 1952. 140 p.
264 plates. Index.

Smithsonian Institution, Hirshhorn Museum and Sculpture Garden, Eighth Street
and Independence Avenue, S.W., Washington, D.C. 20560.

HIRSHHORN MUSEUM AND SCULPTURE GARDEN. SMITHSONIAN
INSTITUTION. New York: Harry N. Abrams, 1974. 770 p.
Over 1,000 illus. Index.

An elaborate catalog introducing this major collection
of nineteenth and twentieth-century art given in 1966
to the Smithsonian. Essays by six noted critics (Linda
Nochlin, Alfred Frankenstein, John I.H. Baur, Milton
Brown, Irving Sandler, and Dore Ashton) discuss the de-
velopment of modern art in Europe and the United
States. A complete detailed "Catalogue of the Collec-
tion" is reproduced on pages 657-761. This catalog
supercedes the catalog which was published when Hirsh-
horn's collection was displayed at the Guggenheim Mu-
seum in 1962 (see 168).

Smithsonian Institution, National Collection of Fine Arts, Eighth and G Streets,
N.W., Washington, D.C. 20560.

The repository for the bulk of the nation's collection of American
painting and sculpture.

Smithsonian Institution, National Gallery of Art, Constitution Avenue at Sixth
Street, N.W., Washington, D.C. 20565.

AMERICAN PAINTINGS AND SCULPTURE: AN ILLUSTRATED
CATALOGUE. Washington, D.C.: 1970. 192 p. Illus. Index.
Paperback.

Includes the five pieces of American sculpture owned by
the National Gallery. Recent acquisition announce-
ments indicate, however, that more American sculpture
is being acquired.

U.S. Capitol Building, Washington, D.C. 20540.

COMPILATION OF WORKS OF ART AND OTHER OBJECTS IN
THE UNITED STATES CAPITOL. 88th Cong., 2d sess., 1965,
H. Document 362. 450 p. Illus. Index.

See also Fairman, Charles E. ART AND ARTISTS OF THE CAPI-
TOL OF THE UNITED STATES OF AMERICA, 1929 (see 63) and
Murdock, Myrtle Cheney. NATIONAL STATUARY HALL IN THE
NATION'S CAPITOL, 1955 (see 76).

Appendix

See also Goode's THE OUTDOOR SCULPTURE OF WASHINGTON, D.C.; A COMPREHENSIVE HISTORICAL GUIDE (see 67).

ILLINOIS

Champaign

University of Illinois, Krannert Art Museum, College of Fine and Applied Arts, 500 Peabody Drive, Champaign, Illinois 61820.

Houses the Lorado Taft collection of sculpture as well as a selection of contemporary American paintings and sculpture. Sponsors the widely-recognized biennial exhibition: CONTEMPORARY AMERICAN PAINTING AND SCULPTURE (1948-) for which excellent, illustrated catalogs are issued. Sculpture has been included in these exhibitions only since 1953.

Chicago

Art Institute of Chicago. Michigan Avenue at Adams Street, Chicago, Illinois 60603.

A major museum with a broad collection of art from all periods and cultures. An exhibition of contemporary painting and sculpture is held annually. The Ryerson Art Library in the Institute has published its extensive INDEX TO ART PERIODICALS (see 3).

KANSAS

Lawrence

University of Kansas Museum of Art, Lawrence, Kansas 66044.

HANDBOOK: THE MUSEUM OF ART. Lawrence, Kans.: 1962. 144 p. Illus. Paperback.

American art selections presented (pp. 114-33) and four pieces of sculpture are illustrated.

See also citation 629, 640.

Wichita

Wichita Art Museum, 619 Stackman Drive, Wichita, Kansas 67203.

Includes the Roland P. Murdock Collection of American art and a large collection of Charles M. Russell's work.

MAINE

Portland

Portland Museum of Art, 111 High Street, Portland, Maine 04101.

Includes American paintings and sculpture since 1880.

Waterville

Colby College Art Museum, Waterville, Maine 04901.

Major collections of American folk art as well as other examples of American art from the eighteenth, nineteenth, and twentieth centuries.

MARYLAND

Baltimore

Baltimore Museum of Art, Art Museum Drive, Wyman Park, Baltimore, Maryland 21218.

200 OBJECTS IN THE BALTIMORE MUSEUM OF FINE ARTS--A PICTURE BOOK. Baltimore: 1955. 92 p. Illus. Paperback.

The highlights of this broadly based collection are illustrated. Sculptures by Gabo, Lachaise, Lipchitz, and Nadelman are included.

Maryland Historical Society, 201 West Monument Street, Baltimore, Maryland 21201.

A rich resource of documents dealing with American history as it relates to Maryland. (See Rinehart citations, 733-35).

MASSACHUSETTS

Amherst

Amherst College, Mead Art Building, Amherst, Massachusetts 01002.

The bulk of the collection is devoted to American art.

Andover

Addison Gallery of American Art, Phillips Academy, Andover, Massachusetts 01810.

HANDBOOK OF PAINTINGS, SCULPTURE, PRINTS, AND DRAWINGS IN THE PERMANENT COLLECTION. Andover, Mass.: Phillips Academy, 1939. x, 133 p. Illus.

Appendix

Sculptures by Faggi, Flannagan, Haseltine (two), La-
chaise, and Manship (three) are illustrated and identified.

Boston

Boston Athenaeum, 10-1/2 Beacon Street, Boston, Massachusetts 02108.

"Portrait Busts in the Library of the Boston Athenaeum." ANTIQUES
103 (June 1973): 1141-56. Illus.

Excellent illustrations of half (thirty-two) of the portrait
busts displayed at the Athenaeum. Sculptors represented
include Frazee, Clevenger, and Ball.

Museum of Fine Arts, Huntington Avenue, Boston, Massachusetts 02115.

See also Whitehill's BOSTON STATUES (see 85).

Cambridge

Harvard University, William Hayes Fogg Art Museum, 32 Quincy Street, Cam-
bridge, Massachusetts 02138.

AMERICAN ART AT HARVARD. Cambridge: Harvard University
Press, 1972. ix, 186 p. 186 illus.

Exhibition catalog which illustrates and documents the
variety of American art housed not only in the Fogg Art
Museum, but throughout the university. Includes work
by G. Borglum, Calder, Davidson, Henry Dexter, Duve-
neck, Huntington, Lachaise, Lewis, Nadelman, Powers,
John and Randolph Rogers, Saint-Gaudens, and Charles
Schreyvogel. A ten page "Abbreviated Inventory of
American Art in the Collections of Harvard University"
is appended.

Williamstown

Sterling and Francine Clark Art Institute, South Street, Williamstown, Massa-
chusetts 01267.

MICHIGAN

Detroit

Detroit Institute of Arts, 5200 Woodward Avenue, Detroit, Michigan 48202.

DETROIT INSTITUTE OF ARTS ILLUMINATED HANDBOOK. Edited
by Frederick J. Cummings and Charles H. Elam. Detroit: Wayne
State University Press for the Detroit Institute of Arts, 1971. 215 p.
Illus. Index.

Illustrates and describes selected pieces in the collec-

tion. One work each by Calder, Chamberlain, Rimmer, and David Smith are illustrated.

MINNESOTA

Minneapolis

Minneapolis Institute of Arts, Minneapolis Society of Fine Arts, 2400 Third Avenue, S., Minneapolis, Minnesota 55404.

FIFTIETH ANNIVERSARY EXHIBITION, 1915-1965. Minneapolis: 1965. [56]p. Chiefly illus.

Includes work by Charles M. Russell.

Walker Art Center, Vineland Place, Minneapolis, Minnesota 55403.

TWENTIETH CENTURY SCULPTURE; SELECTIONS FROM THE COLLECTION. Minneapolis: 1969. 96 p. Illus.

Reflecting the status of the collection as of December 1968, this catalog illustrates and provides a brief commentary on one of two works by each of eighty-nine sculptors. "Artists' Biographies and Object Histories" (p. 72).

NEBRASKA

Lincoln

Sheldon Memorial Art Gallery, University of Nebraska, Lincoln, Nebraska 68508.

A SELECTION OF WORKS FROM THE ART COLLECTIONS AT THE UNIVERSITY OF NEBRASKA. Lincoln: 1963. [38]p. 105 p. of illus.

Published upon the occasion of the inauguration of the Sheldon Memorial Art Gallery. A selection of 105 items including work by Baizerman, Baskin, Calder, Cremean, Nadelman, and Zorach.

NEW HAMPSHIRE

Hanover

Dartmouth College Museum and Galleries, Dartmouth College, Hanover, New Hampshire 03755.

Appendix

Manchester

Currier Gallery of Art, 192 Orange Street, Manchester, New Hampshire 03104.

NEW JERSEY

Newark

Newark Museum, Newark Museum Association, 49 Washington Street, Newark, New Jersey 07101.

> FIFTY YEARS OF THE NEWARK MUSEUM. Newark: 1959. 135 p. Illus. Paperback.
>
> > A history of the museum and each of its departments. Sculptures by Powers ("Greek Slave"), DeRivera, Gross, and Lachaise are illustrated.
>
> "Sculpture By Nineteenth Century American Artists in the Collection of the Newark Museum." Compiled by William Gerdts. MUSEUM (Newark), n.s. 14 (Fall 1962): 1–25. Illus.
>
> > This issue of MUSEUM serves as a catalog of the nineteenth-century holdings of the Newark Museum. It also supplements the material presented in the 1962 SURVEY OF AMERICAN SCULPTURES (see 77). The work of nineteen artists (born before 1875) is cataloged and illustrated. Excludes folk sculpture.
>
> See also "Newark's Sculpture" (see 8).

Princeton

Princeton University, Art Museum, Princeton, New Jersey 08540.

> "Sculpture at Princeton." ART JOURNAL 30 (Fall 1970): 55–56. Illus.
>
> > Brief description of the bequest in honor of Lt. John B. Putnam, Jr. to purchase modern sculpture for the Princeton grounds. Works by Lachaise, Lipchitz, David Smith, and Tony Smith are illustrated.

NEW MEXICO

Albuquerque

University of New Mexico, University Art Museum, Fine Arts Center, Albuquerque, New Mexico 87131.

> The collection includes contemporary American sculpture as well as Spanish-American Santos.

NEW YORK

Albany

Albany Institute of History and Art, 125 Washington Avenue, Albany, New York 12210.

> Focuses on artists of the area; a particularly fine collection of work by Erastus Dow Palmer.

Buffalo

Albright-Knox Art Gallery, Buffalo Fine Arts Academy, 1285 Elmwood Avenue, Buffalo, New York 14222.

> CATALOGUE OF THE CONTEMPORARY PAINTINGS AND SCULPTURE. Edited by Andrew C. Ritchie. Buffalo, N.Y.: 1946. 212 p. Illus.

> > This catalog illustrates and fully discusses the work of Ahron Ben-Shmuel, Anna Glenny Dunbar, Lachaise, Lipchitz, Noguchi, and Zorach, among others.

> CONTEMPORARY ART, 1942-1972: COLLECTION OF THE ALBRIGHT-KNOX ART GALLERY. New York: Praeger Publishers in association with the Albright-Knox Art Gallery, 1973. 479 p. Illus. Index.

> > The first of a two-volume set which will document the outstanding contemporary holdings of the Albright-Knox Gallery. Among the American sculptors in the collection are Bontecou, Calder, Chamberlain, Cornell, Indiana, Judd, Marisol, Oldenburg, Rickey, Samaras, Segal, and Stankiewicz. Each work is illustrated and criticized. A "Complete Catalog" is provided (pp. 442-79).

Cooperstown

New York State Historical Association, Fenimore House-Central Quarters, Cooperstown, New York 13326.

> An outstanding collection of American art and objects dating from the late eighteenth century to the mid-nineteenth century. Includes the collection of life masks by John H.I. Browere.

Elmira

Arnot Art Museum, 235 Lake Street, Elmira, New York 14901.

> CATALOGUE OF THE PERMANENT COLLECTION. Elmira: 1973. 175 p. Illus. Index.

> > "American Sculpture" (pp. 144-51) illustrates the work of Ernfred Anderson as well as a few others.

Appendix

New York City

Brooklyn Museum, 188 Eastern Parkway, Brooklyn, New York 11238.

BROOKLYN MUSEUM HANDBOOK. New York: Brooklyn Museum, 1967. vii, 551 p. Illus. Paperback.

> A substantial, selective catalog with illustrations and brief descriptions of several works, including sculptures by Lachaise, Lipton, and Powers ("Greek Slave").

Metropolitan Museum of Art, Fifth Avenue at 82nd Street, New York, New York 10028.

*Gardner, Albert Ten Eyck. AMERICAN SCULPTURE: A CATALOGUE OF THE COLLECTION OF THE METROPOLITAN MUSEUM OF ART. New York: 1965. Distributed by the New York Graphic Society, Greenwich, Conn. xii, 192 p. Illus. Index. Paperback.

> Excellent catalog presenting the extensive holdings of the Metropolitan Museum. The collection encompasses the early nineteenth-century work of the American neoclassicists as well as the contemporary sculpture of Gross, Lippold, Noguchi, and D. Smith. Each artist's work is accompanied by a biographical sketch.

Museum of Modern Art, 11 West 53rd Street, New York, New York 10019.

> Organized in 1929, the Museum of Modern Art (MOMA) has focused exclusively on modern art created since 1875. The BULLETIN (published between 1933 and 1961) is an important record of the 1930s and 1940s. MOMA has consistently published excellent, well-illustrated, thoroughly-documented catalogs to accompany its exhibitions.

MASTERS OF MODERN ART. Edited by Alfred H. Barr, Jr. New York: MOMA, 1954. Distributed by Simon & Schuster, New York. 239 p. Index.

> A history of modern art written for the layman. The profuse illustrations, all drawn from MOMA's collection, include works by Calder, Cornell, Duchamp, Lachaise, Lassaw, Lipchitz, Lippold, Nadelman, Roszak, and Zorach.

PAINTING AND SCULPTURE IN THE MUSEUM OF MODERN ART. Edited by Alfred H. Barr, Jr. New York: MOMA, 1948. Distributed by Simon & Schuster, New York. 327 p. Illus. Index by nationality.

> Catalog of MOMA's collection, with 380 items illustrated. This list is updated by Barr's 1958 catalog (see below).

PAINTING AND SCULPTURE IN THE MUSEUM OF MODERN ART: A CATALOGUE. Edited by Alfred H. Barr, Jr. New York: 1958. 71 p. Paperback. Index by nationality.

> Alphabetical listing, without illustrations, of works in MOMA's collection in 1958. Includes lists of MOMA's publications, donors, bequests, purchase funds, lenders, and works sold to the Metropolitan Museum of Art.

National Sculpture Society, 75 Rockefeller Plaza, New York, New York 10020.

> An organization established in 1896 to "foster the development and appreciation of sculpture in the United States." Once a very influential group, the society is now quite conservative in its outlook and in the membership it attracts. The society publishes the NATIONAL SCULPTURE REVIEW (vol. 1-, 1951-), a quarterly journal devoted to the interests of its membership. The Annual Exhibitions of 1923 and 1929 were especially influential; they included the work of such noted sculptors as Adams, Barnard, the Borglums, Flannagan, Fraser, French, Hoffman, Longman, Laurent, MacMonnies, Manship, Proctor, Scudder, Storrs, Vonnah, G. Whitney, and Young, among others.

Sculptors Guild, 122 East 42nd Street, New York, New York 10017.

> Founded in 1937, the guild holds annual exhibitions of contemporary sculpture. It has also held several outdoor exhibitions of large works.

Sculpture Center, 167 East 69th Street, New York, New York 10021.

> Established in 1929 as the Clay Club of New York, the center is intended to be a gathering place for professional and student sculptors. The Clay Club was founded by Calder, Lassaw, Nevelson, Noguchi, Rosenthal, and Zorach, among others.

Solomon R. Guggenheim Museum, 1071 Fifth Avenue, New York, New York 10028.

> SELECTED SCULPTURE AND WORKS ON PAPER. Selected and documented by Edward F. Fry and Diane Waldman. New York: 1969. 156 p. Illus. Paperback.
>
> > The "sculpture and reliefs presented in this catalogue [were selected] as being particularly important and outstanding with the overall collection of the museum." Works by Calder, Chryssa, Cornell, Gabo, Kiesler, Lipchitz, Morris, Noguchi, Roszak, Stankiewicz, and Tovish are included.
>
> SELECTIONS FROM THE GUGGENHEIM MUSEUM COLLECTION, 1900-1970. New York: Solomon R. Guggenheim Foundation, 1970. 437 p. Illus. Paperback.
>
> > An extensive, thorough, scholarly catalog illustrating the work of Archipenko, Alexander Calder, Cornell,

Gabo, Lipchitz, Morris, Noguchi, D. Smith, and Trova in the Guggenheim collection.

Whitney Museum of American Art, 945 Madison Avenue, New York, New York 10021.

An extremely important collection of American art (mainly twentieth century) which recently has expanded its holdings of American sculpture. Since 1932 the Whitney has been the sponsor of an annual or biennial exhibition of American painting, sculpture, and drawing. Currently a biennial, the exhibition always prompts a healthy amount of criticism for its selection of artists. For a reasonable analysis of the exhibition see Lawrence Alloway's "Institution: Whitney Annual" in ARTFORUM 11 (March 1973): 32-35. The Goodrich and Baur book AMERICAN ART OF OUR CENTURY (see 154) was illustrated exclusively with items from the Whitney's collection.

CATALOGUE OF THE COLLECTION. New York: 1975. 237 p. including 123 p. of illus. Index. Paperback.

A brief introduction to the collection by John I.H. Baur. The "Paintings," "Watercolors and Drawings," and "Sculpture" catalogs were compiled by Margaret McKellar. One hundred twenty-three pages of illustrations precede the catalog itself. Includes work in the collection as of 30 June 1973.

See also NEW YORK CITY PUBLIC SCULPTURE BY 19TH CENTURY AMERICAN ARTISTS (see 79).

Ogdensburg

Frederic Remington Museum, 303 Washington Street, Ogdensburg, New York 13669

The most extensive collection of Remington paintings and sculptures.

Rochester

Memorial Art Gallery, University of Rochester, 490 University Avenue, Rochester, New York 14607.

HANDBOOK. Rochester, N.Y.: 1961. 119 p. Illus. Paperback.

The chapter on American art (pp. 99-119) includes some carved folk objects in addition to illustrations of work by Calder, DeRivera, Lachaise, Nadelman, and Noguchi.

Syracuse

Everson Museum of Art, 401 Harrison Street, Syracuse, New York 13202.

Utica

Munson-Williams-Proctor Institute, 310 Genesee Street, Utica, New York 13502.

> PAINTINGS, DRAWINGS, AND SCULPTURE IN THE MUSEUM OF ART. Utica, N.Y.: 1961. 45 p. 5 illus. Paperback.
>
> > Lists over twenty American sculptors whose work is included in the museum.

OHIO

Cincinnati

Cincinnati Art Museum, Eden Park, Cincinnati, Ohio 45202.

> SCULPTURE COLLECTION OF THE CINCINNATI ART MUSEUM. Cincinnati: 1970. 166 p. Illus. Index.
>
> > The section on "American Art after 1700" (pp. 138-58) includes illustrations of works by Ball, Clevenger, Manship, Powers, J. Rogers, Vonnah, and Ward.

Cleveland

Cleveland Museum of Art, 11150 East Boulevard, Cleveland, Ohio 44106.

> HANDBOOK OF THE CLEVELAND MUSEUM OF ART. Cleveland: 1966. 320 p. Illus. Paperback.
>
> > Excellent handbook of the highlights of the collection including works by Cornell, Lipchitz, Noguchi, and Roszak.

Oberlin

Allen Memorial Art Museum, Oberlin College, Oberlin, Ohio 44074.

> Stechow, Wolfgang. EUROPEAN AND AMERICAN PAINTINGS AND SCULPTURE IN THE ALLEN MEMORIAL ART MUSEUM. Oberlin, Ohio: 1967. 359 p. Illus.
>
> > Catalog of the entire collection. Illustrates the work of Davidson, Flannagan, Dorothea Greenbaum, and Powers.

Appendix

OKLAHOMA

Tulsa

Thomas Gilcrease Institute of American History and Art, 2500 West Newton Street, Tulsa, Oklahoma 74127.

Includes art and artifacts from midwestern America, from colonial times to the present.

PENNSYLVANIA

Philadelphia

Pennsylvania Academy of the Fine Arts, Broad and Cherry Streets, Philadelphia, Pennsylvania 19102.

Founded in 1805, the academy has an important collection of American painting and sculpture from the eighteenth and nineteenth centuries.

Henderson, Helen W. THE PENNSYLVANIA ACADEMY OF THE FINE ARTS AND OTHER COLLECTIONS OF PHILADELPHIA. Boston: Page, 1911. 399 p. Illus.

A history of the academy covering all aspects of the early collections, of which sculpture was a relatively small part. Bibliography (pp. 367-70).

Rutledge, Anna Wells, comp. PENNSYLVANIA ACADEMY OF THE FINE ARTS, SOCIETY OF ARTISTS, AND ARTISTS' FUND SOCIETY [Philadelphia], 1811-1870. Memoirs, vol. 38. Philadelphia: American Philosophical Society, 1955. 450 p.

A valuable index by artist, owner, and subject of works exhibited at the academy, etc., between 1811 and 1870. Includes sculptors and foreign artists who exhibited in Philadelphia.

Philadelphia Museum of Art, Benjamin Franklin Parkway at 26th Street, Philadelphia, Pennsylvania 19101.

"Sculpture Checklist of the 19th and 20th Centuries at the Philadelphia Museum of Art." Compiled by Henry Gardiner. Entire issue. BULLETIN (Philadelphia Museum of Art) 56 (Spring 1961). 22 p. 22 illus.

Among the American sculptors included are Davidson, Eakins, Flannagan, Gross, Lachaise, Lipchitz, and Rush.

See also Fairmount Park Art Association's SCULPTURE OF A CITY: PHILADELPHIA'S TREASURES IN BRONZE AND STONE, 1974 (see 64).

RHODE ISLAND

Providence

Rhode Island School of Design, Museum of Art, 224 Benefit Street, Providence, Rhode Island 02903.

SOUTH CAROLINA

Brookgreen

Brookgreen Gardens, Murrells Inlet, South Carolina 29576.

See citation 141.

TEXAS

Dallas

Dallas Museum of Fine Arts, Fair Park, Dallas, Texas 75226.

Forth Worth

Amon Carter Museum of Western Art, 3501 Camp Bowie Boulevard, Fort Worth, Texas 76101.

> CATALOGUE OF THE COLLECTION, 1972. Fort Worth, Tex.: 1973. 600 p. Illus. Index. Paperback.
>
>> The section devoted to sculpture (pp. 183-239) includes illustrations and brief descriptions of works by Baskin, A.S. Calder (5 pieces), Fraser (see 4), Harry Jackson, Nadelman, Remington (see 24), Russell (see 95), and Zorach.
>
> See also the catalogs devoted entirely to the works of Frederic Remington and Charles Russell in the Amon Carter Museum (see 725, 761).

VERMONT

Shelburne

Shelburne Museum, Shelburne, Vermont 05482.

> Albright-Knox Art Gallery. AMERICAN FOLK ART FOR THE SHELBURNE MUSEUM. Text by Ethel Moore. Buffalo, N.Y.: 1965. 36 p. 40 illus. Paperback.
>
>> An exhibition catalog of 155 items loaned from the Shelburne Museum, which includes carvings, tradesigns,

weathervanes, bandboxes, etc. Each work is dated and commented upon.

VIRGINIA

Williamsburg

Abby Aldrich Rockefeller Folk Art Collection, South England Street, Williamsburg, Virginia 23185.

See citation 88.

INDEXES

AUTHOR INDEX

This index includes authors, editors, translators, photographers, and any other contributors to works cited in the text. Alphabetization is letter by letter. Index numbers refer to entry numbers except where preceded by "p."

Author Index

TITLE INDEX

This index lists titles of books and catalogs cited in the text. In some cases titles have been shortened. Numbers refer to entry numbers unless preceded by the letter p. which signifies page numbers. Alphabetization is letter by letter.

A

Abby Aldrich Rockefeller Folk Art Collection 88
Abstract Art since 1945 175
Abstract of an Artist 659
Abstract Painting and Sculpture in America 200
Adolph A. Weinman 860
Afro-American Artists 23
Age of the Avant-Garde 157
Air Art 251
Alexander Archipenko 301
Alexandre Archipenko, Son Oeuvre 302
Alexander Calder 366
Alexander Calder (Sweeney) 368
Alexander Calder: A Retrospective Exhibition 368
Alexander Calder: A Retrospective Exhibition, Work from 1925-1974 364
Alexander Liberman 615
Alexander Phimister Proctor, Sculptor in Buckskin 719
Allan Kaprow 566
Allgemeines Lexikon der Bildenden Kunstler 39
Allgemeines Lexikon der Bildenden Kunstler des XX 41
Almost Complete Works of Marcel Duchamp, The 431

American Art 155
American Art: A Historical Survey 69
American Art; 1700-1900 72
American Art Annual 20, 43, 53
American Art at Harvard p. 212
American Art Directory 20, 53
American Art Museums p. 205
American Art of Our Century 154, 218
American Art of the 20th Century p. xii, 156
American Art since 1900 164, 165
American Art Today 196
American Bird Decoys 109
American Figureheads and Their Carvers 113
American Folk Art: The Art and Spirit of a People 114
American Folk Art; The Art of the Common Man in America, 1750-1900 111
American Folk Art for the Shelburne Museum p. 221
American Folk Art in Wood, Metal and Stone 106
American Folk Sculpture 90
American Folk Sculpture; The Work of Eighteenth and Nineteenth Century Craftsmen p. xii, 110
American Masters of Sculpture 137

237

Title Index

Title Index

Title Index

SUBJECT INDEX

Subject Index

Subject Index

Subject Index

Rush, William 64, 83, 93, 113, 710, 760, p. 218
Russell, Carles Marion 761, p. 208, p. 211
Ryman, Robert 278

S

Saint-Gaudens, Augustus 59, 64, 80-81, 85, 136-37, 139, 142, 173, 762-67, p. 206, p. 210
St. Leger, Abastenia 550
Saints in art. See Sculpture, religious
Samaras, Lucas 254-55, 259, 768-73, p. 213
San Francisco Museum of Art p. 205
Santos 92, 112, 116, p. 207, p. 214
Scale in sculpture 247, 297, 348, 377, 485-86, 652, 696, 817
Scaravaglione, Concetta 199, 202
Schimmel, Wilhelm 774-75
Schmidt, Clarence 117, 194, 776
Schools of art 46, 48, 52, 144. See also names of specific movements and schools of art
Schreyvogel, Charles p. 210
Science and art 151, 209, 224, 472, 607
Scrimshaw 90
Scudder, Janet 139, 777, p. 215
Sculptors, black 23, 61, 436, 608-9. See also names of individual sculptors
Sculptors, women 120, 133-34, 138, 143, 158, 539. See also names of individual sculptors
Sculptors Guild, New York p. 215
Sculpture, American
 bibliographies, catalogs, and indexes 1-19, 44, 47, 51, 73, 79-80, 86, 88, 93a, 107, 110-11, 141, 144, 152, 154-56, 163, 168, 180, 183-84, 214, 216-17, 225-27, 239, 250, 255-60, 273
 biographical sources 20-43, 61-62
 collections of personal papers on 34
 directories 53-56
 encyclopedias, dictionaries, and glossaries 44-52, 148

foreign influence on 65, 79, 87, 119, 121, 123, 126-27, 133, 137, 147-48, 323, 360, 401, 493-94, 614, 635-36, 641, 712-14, 748, 854
by period
 17th century 96, 99, 108, 130
 18th century 88, 91-92, 94-95, 99, 107-8, 110-11, 119, 130
 19th century 91-92, 94-95, 100, 102, 107, 110-11, 119-35
 late 19th century to early 20th century 136-45
 20th century 73, 103, 144-203 since 1960 204-78
philosophy of 128-29, 144, 149-50, 152-53, 169, 182, 199, 202, 205, 207, 211, 229, 232, 240-41, 243, 255, 258, 268, 271, 349, 360, 636
prices of 21, 54, 100
relationship to other art forms 163, 170, 186, 263, 304, 353, 573-74, 601, 703, 757
surveys of 57-87
See also Architectural sculpture; Busts; Carvers and carvings; Cemetery sculpture; Collage; Color in sculpture; Composition in sculpture; Conceptual art; Earth art; Environmental sculpture; Folk sculpture; "Found-object" art; Happenings (art form); Imagery in sculpture; Literary sculpture; Masks (sculpture); Monuments and memorials; Relief (sculpture); Scale in sculpture; Ship carvers and carvings; Space, utilization of in sculpture; Statues; Symbolism in sculpture; Terracottas; Wax figures; names of individuals sculpted (i.e., George Washington); names of individual sculptors;

Subject Index

names of items sculpted or
depicted (i.e., Toys; Animals,
depiction of in art); names of
movements and schools of art
(i.e., Abstract expressionism);
types of sculpture by materials
used (i.e., Plastic sculpture)
Sculpture, classical 171, 179. See
also Sculpture, foreign in-
fluence on
Sculpture, European 234, 240, 254
Sculpture, fabrication of 247, 347
Sculpture, French 142
Sculpture, German 142
Sculpture, Japanese 234
Sculpture, neoclassical 66, 81, 122-
25, 128, 130, 135, 360,
554, 609, 713
Sculpture, religious 46, 92, 93a-94,
103, 108, 112, 116, p. 205,
p. 212
Sculpture Center, N.Y. p. 215
Segal, George 157, 222, 226, 228,
255-56, 778-82, p. 213
Seley, Jason 191, 783-84
Sepulchral monuments. See Cemetery
sculpture
Serial art 273-74
Serra, Richard 244, 270, 785-88
Sex, depiction of in sculpture 834.
See also Eroticism, depiction
of in sculpture; Nude in
sculpture
Shaw, Richard 542
Shelburne Museum, Shelburne, Vt.
p. 219
Sheldon Memorial Art Gallery. See
University of Nebraska. Shel-
don Memorial Art Gallery
Ship carvers and carvings 93, 94-95,
105, 107, 113, 333-34
Show figures 100
Siemering, Rudolf 64
Signs as sculpture 94, 105, p. 219
Skillins family 93, 113, 789
Slobodkin, Louis 202
Smith, Anthony. See Smith, Tony
Smith, David 34, 150, 155, 157,
161, 168, 180, 182, 185,

187, 197, 201, 213, 230,
259, 790-99, p. 211,
p. 212, p. 214, p. 216
Smith, Fred 117
Smith, Tony 213, 221, 223, 227,
340, 800-803, p. 212
Smithson, Robert 221, 241, 244,
270-71, 524, 804-8
Smithsonian Institution 104, 168,
p. 207
Snelson, Kenneth D. 213, 809-13
Société Anonyme pp. 205-6
Society and art 149, 171, 177, 197,
259, 441, 516, 579, 660,
691, 758, 767, 813, 822,
863
Sonfist, Alan 151
Sonnier, Keith 244, 270
Sound in art 682
Space, utilization of in sculpture
86, 153, 169, 201, 223-34,
253, 291, 414, 472, 485-
86, 541, 551, 751, 790,
810, 844
Stankiewicz, Richard 150, 194, 224,
226, 814-16, p. 213,
p. 215
Statuary Hall. See U. S. Capitol
Building
Statues 59, 86-87, 96, 100, 136,
316-17, 359, 463, 470,
535, 763
Boston 85
Newark 84, 237
New York City 78, 545
Philadelphia 64, p. 218
Washington, D.C. 63, 67, 76,
123, 402, 722, pp. 207-8
See also Busts; Figure, depiction
of in sculpture; Marble sculp-
ture; Monuments and memori-
als; Nude in sculpture; Stone
sculpture and sculptors
Stebbins, Emma 134
Stein, Gertrude 406
Steiner, Michael 221, 817-18
Sterling and Francine Art Institute
p. 212
Sterne, Maurice 80, 601, 819-20

Subject Index